AGAINST THE MODERN

D0218369

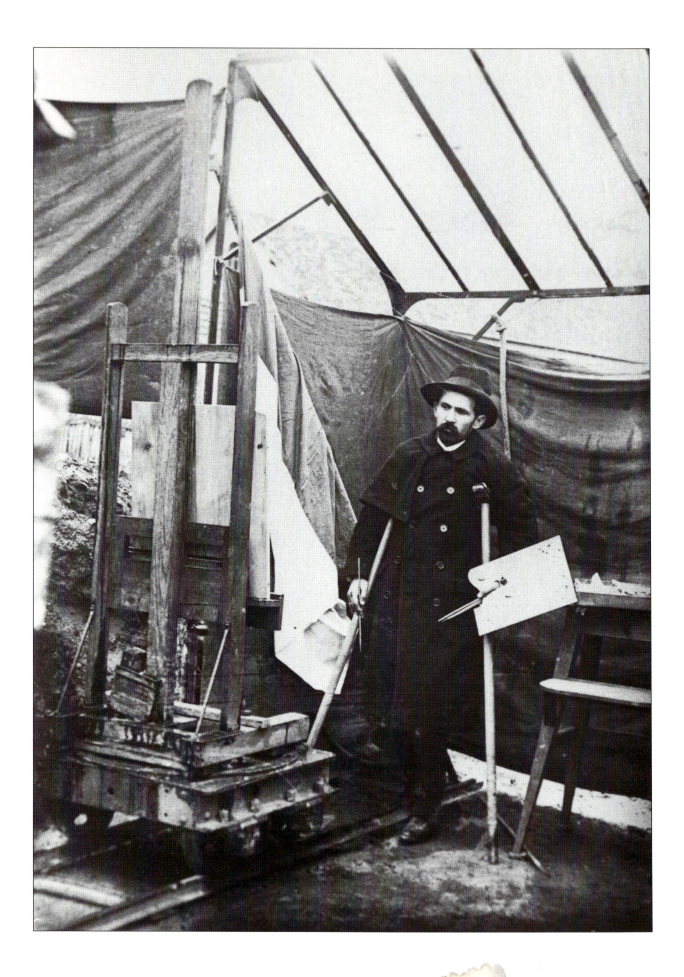

Against the Modern

Dagnan-Bouveret
and the Transformation
of the Academic Tradition

Gabriel P. Weisberg

DAHESH MUSEUM OF ART
New York

and

RUTGERS UNIVERSITY PRESS
New Brunswick, New Jersey, and London

FRONTISPIECE

Photographer unknown, *P.-A.-J. Dagnan-Bouveret Painting in His Outdoor Studio at Ormoy,* 1887.
(The artist is working on one of his painted studies for *Breton Women at a Pardon*.) Archives Départementales
de la Haute-Saône, Vesoul.

LIBRARY OF CONGRESS CATALOGING-IN-PUBLICATION DATA

Weisberg, Gabriel P.
 Against the modern : Dagnan-Bouveret and the transformation of the academic tradition /
Gabriel P. Weisberg.
 p. cm.
 To accompany an exhibition of his work at the Dahesh Museum of Art.
 Includes bibliographical references and index.
 ISBN 0-8135-3155-1 (cloth : alk. paper) — ISBN 0-8135-3156-X (pbk. : alk. paper)
 1. Dagnan-Bouveret, Pascal-Adolphe-Jean, 1852–1929—Exhibitions. I. Dagnan-Bouveret,
Pascal-Adolphe-Jean, 1852–1929. II. Dahesh Museum of Art. III. Title.
 ND553.D2 A4 2002
 759.4—dc21

 2002020158

British Cataloging-in-Publication information is available from the British Library.

Copyright © 2002 by Dahesh Museum of Art

All rights reserved

No part of this book may be reproduced or utilized in any form or by any means, electronic or mechanical, or by any information storage and retrieval system, without written permission from the publisher. Please contact Rutgers University Press, 100 Joyce Kilmer Avenue, Piscataway, NJ 08854–8099. The only exception to this prohibition is "fair use" as defined by U.S. copyright law.

Manufactured in China

CAL
ND
553
D2
A4
2002

 CONTENTS

 ILLUSTRATIONS

 FOREWORD

RECENT YEARS have seen a healthy reappraisal of the art of the nineteenth century. The acknowledged giants and movements of that century retain their significant status in the history of art, but scholars and museums have increasingly documented the importance and quality of a vast body of work hitherto lumped under the somewhat imprecise and formerly pejorative term *academic art.* Research, publications, and exhibitions are adding immeasurably to our historical picture of an era that, as we can now see, was far richer and more diverse than previously considered. Academic art, in fact, encompasses by far the largest segment of production in all media during that time. Gabriel Weisberg has been a pioneer in revealing this "other nineteenth century" and in changing the perception of the term *academic* from negative to positive. The Dahesh Museum of Art, dedicated to collecting, exhibiting, and interpreting nineteenth-century European academic art, is pleased to collaborate for the second time with Professor Weisberg on an exhibition that explores neglected territory and reintroduces an exceptionally talented but largely forgotten artist.

Professor Weisberg proposed an exhibition of works by Pascal-Adolphe-Jean Dagnan-Bouveret several years ago, when we were working together on *Overcoming All Obstacles: The Women of the Académie Julian,* the first museum exhibition on the topic of this important private art academy. Reviewing the art and career of Dagnan-Bouveret was a revelation to the staff of the museum. How could Jean-Léon Gérôme's favorite and gifted pupil have been ignored for so long? Here was a brilliant artist who had lived through one of the most tumultuous times in art history—the decades surrounding the *fin du dix-neuvième siècle*—and developed interesting and ingenious alternatives to modernism. The time was certainly right to reopen the dossier on Dagnan-Bouveret, whose last exhibition in the United States was in 1901 at the Art Institute of Chicago and whose final retrospective in Paris in 1930, following his death, seemed to close that dossier, according to Professor Weisberg.

This exhibition and catalog are the fruit of extraordinary research by the author and his wife, Yvonne, involving the discovery of documentation and the rediscovery of artworks in far-flung public and private collections. While some museums have valued and proudly exhibited their paintings by Dagnan-Bouveret, others have relegated them to deep storage. Important private collections were detected that agreed

to lend works that were largely unknown or lost to sight for many years. And the artist's biography had to be reconstructed, most particularly documentation of the artist's search for the means to maintain the vitality of the academic tradition, which he valued above all. The result is this fine monograph, published by the Rutgers University Press, and the exhibition, which will add another name to the constellation of rediscovered artists. I am especially pleased that Dagnan-Bouveret's work will be properly seen for the first time in many decades in this museum and, additionally, at the Society of the Four Arts, Palm Beach, Florida.

Finally, I want to thank The A. W. Mellon Foundation for its very generous support of this exhibition at a particularly important moment for the Dahesh Museum of Art. I am also grateful to W. M. Brady and Company and Schiller and Bodo for their additional financial support of this exhibition.

<div style="text-align: right">

J. David Farmer
Past Director (1993–2001)
Dahesh Museum of Art

</div>

 ACKNOWLEDGMENTS

THE ORGANIZERS of this exhibition are indebted to the many individuals and institutions that have lent works of art, provided information, and cooperated in all ways imaginable. First, the organizers gratefully thank the lenders, who have shared their valuable works of art.

In Russia: Irina Antonova, Director, and Maria Kostoki, Chief Foreign Relations Department, the State Pushkin Museum of Fine Arts, Moscow; and Dr. Mikhail Piotrovsky, Director, and Vladimir Matveev, Deputy Director for Exhibition and Development, the State Hermitage Museum, St. Petersburg. Professor Alexander Shedrinsky, Conservation Center, Institute of Fine Arts, New York University, New York, provided valuable consultation and assistance.

In France: Henry-Claude Cousseau, Directeur, Annie Jacques, Conservateur en Chef du Patrimoine Chargée des Collections, Emmanuel Schwartz, Conservateur du Patrimoine, and Joëlla de Couëssin, Conservateur, Ecole Nationale Supérieure des Beaux-Arts, Paris; Henri Loyrette, former Directeur Président, Françoise Viatte, Conservateur Général, Chargée du Département des Arts Graphiques, Musée du Louvre, and Marie-Pierre Salé, Conservateur du Département des Arts Graphiques du Louvre, Fonds Orsay, Paris; Jacques Fischer, Paris; Benoît Bruant, Conservateur des Musées Municipaux, Mulhouse; Claude Fournet, Conservateur en Chef du Patrimoine, Directeur des Musées, and Chantal Fernex de Mongex, Conservateur du Patrimoine, Musées d'Art et d'Histoire de Chambéry; Clara Gelly-Saldias, Conservateur du Patrimoine, Chargée du Musée des Beaux-Arts, and Patricia Pedracini, Conservateur, Musée des Beaux-Arts, Nancy; René le Bihan, Conservateur, Musée des Beaux-Arts, Brest; Marie-Hélène Lavallée, Conservateur en Chef du Patrimoine, Directeur des Musées de Besançon; Annie-Claire Lussiez, Conservateur, Musée Municipal, Melun; and Vincent Pomarède, Conservateur du Patrimoine, Directeur du Musée des Beaux-Arts de Lyon. In addition, the organizers are grateful for the special help and assistance of the *maires* of the cities of Besançon, Brest, Chambéry, Mulhouse, Melun, Nancy, and Vesoul.

In Germany: Cornelia Sayre, Director, and Professor Dr. Christian Lenz, Bayerische Staatsgemäldesammlungen, Munich.

In Canada: Guy Cogeval, Director, and Nathalie Bondil-Poupard, Curator, American and European Art, 1840–1945, Musée des Beaux-Arts de Montréal; and the Collection Joey and Toby Tanenbaum.

In Great Britain: Alan and Mary Hobart, Pyms Gallery, London.

In the United States: Richard Armstrong, the Henry Heinz II Director, Carnegie Museum of Art, Pittsburgh; DeCourcy E. McIntosh, former Director, Frick Art and Historical Center, Pittsburgh; James E. Wood, Director, and Larry J. Feinberg, Patrick G. and Shirley W. Ryan Curator in the Department of European Painting, the Art Institute of Chicago; Laura Coyle, Curator of European Art, the Corcoran Gallery of Art, Washington, D.C.; Anne d'Harnoncourt, Director, and Joseph Rishel, Curator of European Painting before 1900, the Philadelphia Museum of Art; William Hennessy, Director, and Jefferson C. Harrison, Chief Curator, the Chrysler Museum of Art, Norfolk, Virginia; Philippe de Montebello, Director, and Gary Tinterow, Engelhard Curator, Department of European Paintings, the Metropolitan Museum of Art, New York; George T. M. Shackelford, Chair, Art of Europe, Museum of Fine Arts, Boston; William R. Johnston, Associate Director and Curator of Eighteenth- and Nineteenth-Century Art, the Walters Art Museum, Baltimore; Fred and Sherry Ross Collection; M. R. Schweitzer Family Collection; and Edward Wilson Collection/Fund for Fine Arts, Chevy Chase, Maryland. Polly Sartori, Senior Vice-President, Sotheby's New York, provided consultation and assistance.

In addition, the organizers are grateful to private collectors in France and other countries who did not hesitate to part with their treasured artworks but who wished to remain anonymous.

Very special mention must be noted of two lenders who have played additional and exceptionally important roles in the development of the exhibition. In addition to providing loans of major works of art, Sabine Ganji, Attachée de Conservation, Musée Georges Garret, Vesoul, France, gave of her time and expertise almost from the beginning of the preparation for this exhibition, to make research easier and more fruitful. Thanks to her efforts and hard work, the Musée Georges Garret, which is the depository of many works, not only by Dagnan-Bouveret but also by his friend Jules-Alexis Muenier and his mentor, Jean-Léon Gérôme, has become a prime destination for those who want to learn about these artists' work. Jean-Pierre Babelon, Président de la Fondation Jacquemart-André, Institut de France, and Nicholas Sainte Fare Garnot, Conservateur, Musée Jacquemart-André, expressed strong interest and support for the exhibition from the beginning.

The author also thanks Ervin S. Duggan, President, and Nancy Mato, Vice President, at the Society of the Four Arts, Palm Beach, Florida, who readily scheduled a second showing in the United States in their distinguished institution.

In addition to thanking the directors, curators, and private collectors who made this exhibition possible by agreeing to lend to it, the organizers gratefully recognize the individuals who helped in finding and providing documentation about the works

and who were instrumental in gathering the visual material necessary for the completion of this publication. These include the dedicated staffs in the painting and drawing departments, the offices of the registrar, and the rights and reproduction departments of each of the museums.

Photographers Jean-Loup Charmet and Suzanne Nagy-Kirchhofer in Paris, Christian Kempf in Colmar, Bruno Cohen for Chaalis, and Phox Photo Simon in Vesoul provided many excellent photographs and transparencies. Mireille Requiston, an excellent conservator in Paris, treated works to bring them up to exhibition standards.

Also crucial to the study of the artist's work were the librarians and archivists who supplied documents about Dagnan-Bouveret's life and work and about the period in which he lived. First and foremost, the author wishes to recognize the dedication, patience, and good humor of the staff of the Centre de Documentation, or "Doc," at the Musée d'Orsay. Without their passion for acquiring and talent for cataloging and organizing, much documentation about thousands of French nineteenth-century artists would be lost and unavailable to researchers. The author also wishes to recognize the staff at the Bibliothèque Nationale de France, the Ecole Nationale Supérieure des Beaux-Arts, the Archives Nationales, the Institut de France–Académie des Beaux-Arts, the Bibliothèque d'Art et d'Archéologie, all in Paris; the Bibliothèque Municipale, Vesoul; and the staff of the Wilson Library at the University of Minnesota. The author notes particularly an institution that is essential to any study of Dagnan-Bouveret, the Archives Départementales de la Haute-Saône, Vesoul. Under the leadership of Gérard Moyse, Directeur des Archives, and Catherine Boisset, Agent Administratif Qualifié, the artist's archives have been fully classified and cataloged.

The author also wishes to recognize the contribution of Jocelyne Thiriet, who was extremely generous with her help and advice long before the archives were made easily accessible to researchers. Pauline Grisel should also be commended for her work: *P.-A.-J. Dagnan-Bouveret à travers sa correspondance* (D.E.A. d'Histoire de l'Art, Université Lumière, Lyon 2, 1987). She was the first to sort out the artist's correspondence, for her work in writing the first year-by-year history of Dagnan-Bouveret's life. Chang Ming Peng's study, *Pascal Adolphe Jean Dagnan-Bouveret: Recherche sur la formation d'un langage pictural* (Mémoire de maîtrise, Université de Paris IV, 1990), is the first attempt in France to place the artist in the context of nineteenth-century art and to examine the critical reaction to his work.

Also essential in the author's study is the contribution of Jean-David Jumeau-Lafond, Paris, who generously shared documents he obtained from the nephew once removed of Dagnan-Bouveret's wife, Anne-Marie Walter. These documents had been in the possession of the family Legrand-Hubert, longtime friends of the artist. While some of these documents are copies of the originals deposited in the Archives Départmentales de la Haute-Saône, Vesoul, others, such as the *Catalogue chronologique,* by Marie Legrand, greatly helped the author identify many of the

works by the artist. Last, but not least, one should mention Chantal Kiener and Jacques Fischer, who were instrumental in the discovery of an important group of sketches and drawings by the artist and who generously shared their discovery.

My wife, Yvonne, was, as always, active in all aspects of the organization of the exhibition and preparation of the publication. She is an exceptional partner in these projects.

The author is also grateful to Elizabeth Allen, who greatly helped in clarifying his thoughts.

The Dahesh Museum of Art was the organizing institution, and all members of the staff participated in the preparation of the exhibition and catalog. Nancy Pinnella, former Assistant to the Executive Department, and Michelle Montgomery, Intern, were particularly active in maintaining correspondence and organizing material. In addition, the author thanks J. David Farmer, Director, and Michael Fahlund, Associate Director; Stephen Edidin, Curator, Rogier Diederen, Associate Curator, and Lisa Small, Assistant Curator; Lisa Mansfield, Registrar, Richard Feaster, Assistant Registrar, and Sarah Fogel, Contract Registrar; Paula Webster and Pamela Dunn, Public Relations; and Maria Celi, Administrator. The Board of Trustees of the Museum has fully supported this exhibition.

Finally, the author acknowledges a continuing and most agreeable relationship with Rutgers University Press, particularly with Leslie Mitchner, Associate Director and Editor in Chief. This is only the latest in a series of publications with Rutgers, and it has been a pleasure to work with this excellent university press.

<div align="right">

Gabriel P. Weisberg
University of Minnesota

</div>

 # LENDERS TO THE EXHIBITION

The Art Institute of Chicago

Carnegie Museum of Art, Pittsburgh

The Chrysler Museum of Art, Norfolk

Collection Joey and Toby Tanenbaum, Toronto, Canada

Corcoran Gallery of Art, Washington, D.C.

Département des Arts Graphiques du Louvre, Fonds Orsay, Paris

Ecole Nationale Supérieure des Beaux-Arts, Paris

Jacques Fischer, Paris

Frick Art and Historical Center, Pittsburgh

Institut de France, Abbaye Royale de Chaalis

The Metropolitan Museum of Art, New York

Musée d'Art et d'Histoire, Chambéry

Musée des Beaux-Arts, Lyon

Musée des Beaux-Arts, Montreal

Musée des Beaux-Arts, Mulhouse

Musée des Beaux-Arts, Nancy

Musée des Beaux-Arts et d'Archéologie, Besançon

Musée Georges Garret, Vesoul

Musée Municipal, Melun

Museum of Fine Arts, Boston

The Philadelphia Museum of Art

Pyms Gallery, London

Fred and Sherry Ross Collection

M. R. Schweitzer Family Collection

The State Hermitage Museum, St. Petersburg

The State Pushkin Museum of Fine Arts, Moscow

The Walters Art Museum, Baltimore

Edward Wilson, Fund for Fine Arts, Chevy Chase, Maryland

And several lenders who wish to remain anonymous

 AGAINST THE MODERN

Introduction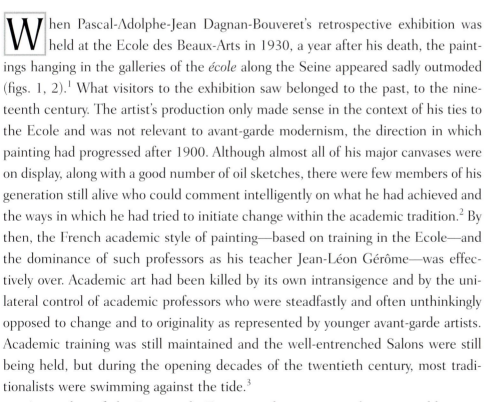

When Pascal-Adolphe-Jean Dagnan-Bouveret's retrospective exhibition was held at the Ecole des Beaux-Arts in 1930, a year after his death, the paintings hanging in the galleries of the *école* along the Seine appeared sadly outmoded (figs. 1, 2).[1] What visitors to the exhibition saw belonged to the past, to the nineteenth century. The artist's production only made sense in the context of his ties to the Ecole and was not relevant to avant-garde modernism, the direction in which painting had progressed after 1900. Although almost all of his major canvases were on display, along with a good number of oil sketches, there were few members of his generation still alive who could comment intelligently on what he had achieved and the ways in which he had tried to initiate change within the academic tradition.[2] By then, the French academic style of painting—based on training in the Ecole—and the dominance of such professors as his teacher Jean-Léon Gérôme—was effectively over. Academic art had been killed by its own intransigence and by the unilateral control of academic professors who were steadfastly and often unthinkingly opposed to change and to originality as represented by younger avant-garde artists. Academic training was still maintained and the well-entrenched Salons were still being held, but during the opening decades of the twentieth century, most traditionalists were swimming against the tide.[3]

A member of the Institut de France, and a painter with innumerable international honors, Dagnan-Bouveret had, in effect, outlived his time beyond the period of his greatest fame and significance.[4] Even though he still maintained an active painting career during the second and third decades of the twentieth century, his approach toward portraiture and his links with the larger art world were

FIGURE 1

Photographer unknown,
*Retrospective
P.-A.-J. Dagnan-Bouveret,*
Ecole des Beaux-Arts,
Paris, 1930. Archives
Départementales de la
Haute-Saône, Vesoul.

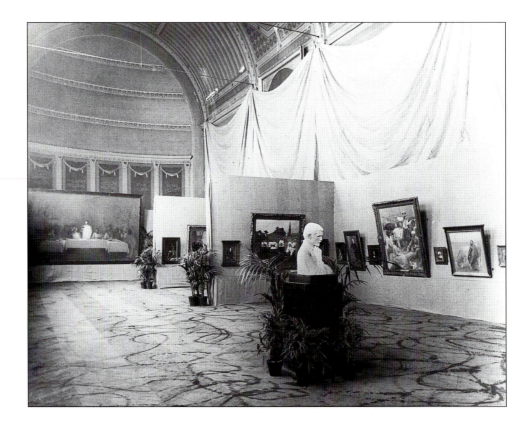

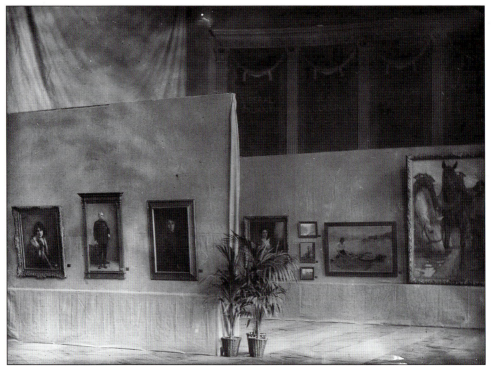

FIGURE 2

Photographer unknown,
*Retrospective
P.-A.-J. Dagnan-Bouveret,*
Ecole des Beaux-Arts,
Paris, 1930. Archives
Départementales de la
Haute-Saône, Vesoul.

based on a tradition that was deemed completely dead by those pushing the parameters of creativity under the banners of fauvism, dadaism, surrealism, and the School of Paris, as initiated by Picasso, Braque, and Modigliani, among many others.[5] Dagnan-Bouveret's naturalist aesthetic, tinged in later years with personal symbolism, appeared so passé that there was apparently little reason—attested to by a general silence, beyond some references in the conservative press—to recognize his passing or assess his contribution.[6] A few critics noted that his career had been virtually over for twenty-five years or more. With almost no one alive who could judge his work vis-à-vis his contemporaries, there were few challenges to the finality of this particular assessment.

I

This was the situation in 1930, one year after the artist's death. He was seen as part of a long line of academic professor-painters whose position in French art was becoming increasingly irrelevant. From this period until the early 1980s, there was almost no attention paid to the artist.[7] Many of his paintings that had found their way into public collections were placed in storage or deaccessioned, having been bequeathed by fervent admirers of another era. Paintings remaining with close friends moldered in obscurity. The story of Dagnan-Bouveret, a major figure who worked to revive the academic tradition in his own lifetime, in some ways echoes that of his teacher Jean-Léon Gérôme, one of the most effective Orientalists of his era, and those of other academic painters of the nineteenth century such as William Bouguereau and Jules Breton. Honored in their own day, they fell into oblivion soon after their deaths. Only in the past few decades have their works been gradually rediscovered, their narratives rebuilt from scratch. Dagnan-Bouveret has not been as fortunate. He is still awaiting rediscovery, as very few of his paintings have appeared in exhibitions or in public sales since the memorial exhibition of 1930.

A steadfast contributor to all kinds of art exhibitions from the 1870s on, the artist played an effective role in the yearly Salons. It was at these exhibitions that all traditionally trained artists wanted to exhibit their best works and where they hoped to receive an enthusiastic response from the press, which would facilitate official commissions from the state or from private individuals desiring portraits. At a time when artists of the impressionist movement had wrested some power from the conservative art establishment by organizing their own exhibitions from 1874 to 1886, Dagnan-Bouveret persevered, along with many other painters of the Third Republic, in demonstrating that the Salon was still alive.[8] By 1890, he assisted in the establishment of a new Salon under the aegis of the Société Nationale des Beaux-Arts, revealing that two or more Salons could exist at the same time, attract a sufficient number of art objects to be put on display, and effectively contribute to reestablishing Paris as the capital of world art. Artist-members of the Société Nationale des Beaux-Arts took a businesslike approach to their work, hanging as

many new pictures as they could and finding considerable support from the wealthy elite of the upper echelon of the Third Republic.[9] In this environment, Dagnan-Bouveret secured a very comfortable position for himself and his family. While still relatively young, at the time of the Paris Exposition Universelle of 1900 he was elected to the Institut. This was a prestigious honor, guaranteeing his standing and reputation.

Yet outside of a small circle of admirers, who actually knew the real Dagnan-Bouveret? His success was based on his art alone, rather than on his efforts at self-promotion. He was not an egocentric like Gustave Courbet, the principal promoter of realism during the early 1850s, and he did little to advance his career, aside from what was normally done by an artist working within the academic tradition. When he used the press, he did so as a way of advertising his work at the Salon; he did not overdo this tendency, as many others did at the time.[10] The relative lack of contemporary comment on the artist has resulted in a corresponding lack of critical response to his work in the standard histories of art. One of the first questions to ask in framing the issues his work addressed is whether his imagery challenged any conceptions of academic art. If his paintings did pose new visual questions, then it makes sense to discuss what direction he intended his art to take.

II

When Dagnan-Bouveret began his career in the opening years of the Third Republic, the supremacy of France was being openly attacked in most areas, including the visual arts. The devastation of the Franco-Prussian War of 1870, the fact that a good part of Paris had been destroyed in the subsequent fighting of the Commune, led many toward the belief that the country was no longer invincible. It was necessary to rebuild from within; it was also essential that a stable government be established that would allow the rebuilding phase to go forward. As the Third Republic evolved, the country began to find its artistic spirit returning both within the circles of the avant-garde and within groups of younger artists who were being trained at the Ecole des Beaux-Arts. By the end of the 1870s there was a very strong increase in the numbers of international students arriving from all European countries and the United States, who came to France because they believed that Paris was where they could receive the best training and where their work would be known if they exhibited in the Salons. These younger artists committed themselves to improving traditional creativity through attendance at the Ecole des Beaux-Arts. By the time of the Exposition Universelle of 1878, Paris, and all of France, had returned to a solid position in the visual arts, making it possible for younger artists to feel secure that an official artistic career was again possible. By the early 1880s, there were thousands of young artists working throughout the city; many of them had contact with the professors at the Ecole or with some of the most vigorous younger students of this tradition, such as Dagnan-Bouveret.

However, at the same time as this was apparent to the artist, he recognized another fact. Training at the Ecole des Beaux-Arts and competing for the fabled Prix de Rome were not the only ways to position oneself in the art world.[11] Rigid adherence to time-honored historical themes and imitation of the old masters were but two approaches that an academic painter could follow. Under the direction of Jean-Léon Gérôme, he, his close friend Jules Bastien-Lepage, and other students at the Ecole discussed ways in which the academic canon could be reinvigorated and improved. Continuous study from plaster casts or dedication to time-honored historical themes were useful in disciplining one's eye, but these were inadequate means to prepare a young student for a creative career in the highly competitive Third Republic. Gérôme's students were to recognize the achievements of painters outside the academy; to be sensitive not only to nuances in theme but also to the handling of light and atmosphere; and to strive to find ways to make the academic method more relevant to contemporary themes. The young artist's natural proclivity for realistic observation, as seen, for example, in his portrait of his grandfather (fig. 3)—a painting that, besides representing a person of great importance in his life, exhibits the precision of an early Netherlandish master—led him away from a pure classical tradition toward a precise rendering of reality. Perhaps stimulated by contact with Gérôme, the younger artist put this tendency to use in expanding the criteria of the category of genre painting from the late 1870s on. This was the first step in Dagnan-Bouveret's transformation from a classically trained academic artist to a painter capable of incorporating new approaches into his artistic vocabulary while still remaining aware of the need to make art that was available to the public.

During the 1880s, after he had won several awards at the Salon and once he had received private and state commissions, he became determined to infuse genre painting, which was quickly becoming the type of artwork demanded and produced by many, with a sense of actuality. While hundreds of painters contributed to the cult status of late nineteenth-century genre painting—satisfying the desire of the middle class to possess sentimental painted stories that would fit on the walls of their homes—the artist elected to create images that would not necessarily have broad appeal but that focused on the highly specific anecdote.[12] Such works were sometimes greeted with derision by critics.[13] By the early 1880s, especially with his canvas of *L'accident* (*The Accident*) (fig. 4), the artist was interpreting mundane themes using strong pictorial terms. *The Accident*'s narrative focus is reinforced by precise detail and compelling analysis, making this scene of an injured farm boy a moving visual drama, in its flavor akin to the naturalistic novels popularized in the press at the time. The canvas provoked considerable discussion and was copied by various artists, including James Ensor, and by the artist himself. By this time, he had gained a broader following and had become one of the most able, if not the best, student of Gérôme, who also made second versions of his best-known works.[14] His personal understanding of the need to infuse genre with naturalist concepts was broadly advocated by critics. But he was not the only artist who was aware that the

academic canon had to shift toward a more contemporary vision; Bastien-Lepage had been his predecessor in this venture.

At the same time that Dagnan-Bouveret, like a number of his contemporaries, was working to rejuvenate genre painting, he began to investigate the uses of photography. Bastien-Lepage, who died in 1884, was also interested in photography and how photography had aided others, including Gérôme. The exact moment of his first use of photography remains unknown; what is certain is that he, along with his friend Jules-Alexis Muenier (also a student of Gérôme's), used photography for the development of their painted compositions, as well as for documentation of people and places they visited.[15] As Dagnan-Bouveret's imagery became more complex at the close of the 1880s, and as he integrated photographic sources with his prelimi-

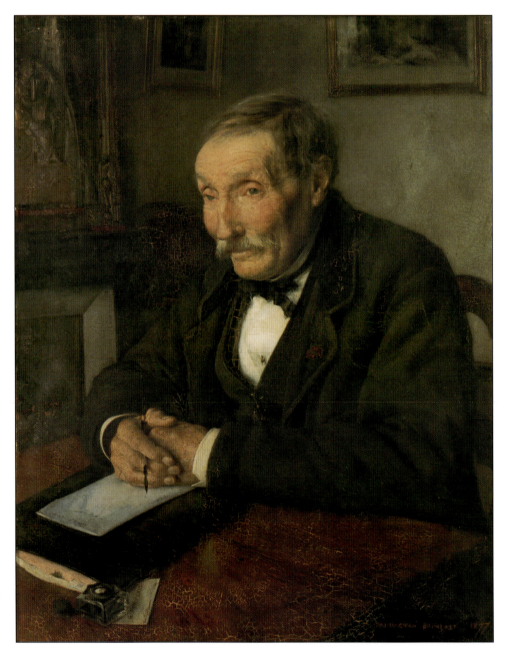

FIGURE 3

Portrait of Gabriel Bouveret,
1877. Oil on canvas.
16 1/8 x 13 in. (41 x 33 cm).
Signed and dated lower right:
P.A.J. DAGNAN-BOUVERET
1877. Mairie de
Bar-sur-Aube, France.

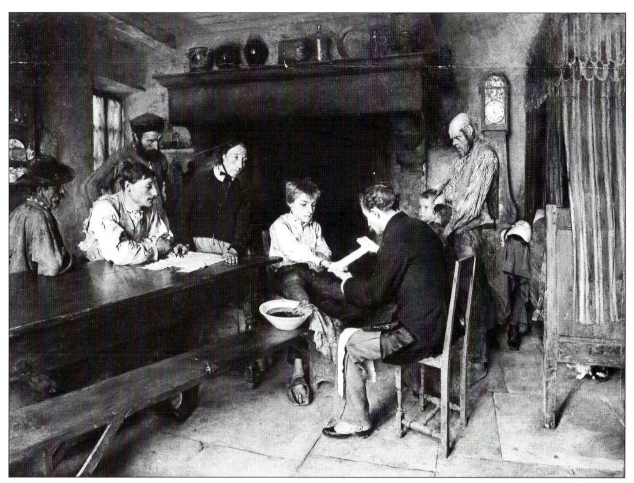

FIGURE 4

The Accident, 1879. Oil on
canvas. 35 5/8 x 58 1/8 in.
(92.5 x 130 cm). Signed
and dated lower right:
P.A.J. DAGNAN-B 1879/
Pasavant-sur-Corre
(Haute-Saône). The Walters
Art Museum, Baltimore.
Photograph courtesy
The Walters Art Museum.

nary studies in the creation of his large-scale compositions (such as *Les conscrits*
[*The Recruits*] [fig. 5]), the artist clearly demonstrated that the traditional academic
method of constructing a composition could be facilitated by this new medium. His
insistence on using photography, under the initial stimulus of Gérôme, reveals that
he was among the most forward-looking members of the academic tradition; he
recognized that the "old" classical system of planning a composition had to respond
to the new technologies that were already being applied and assimilated by painters
of the avant-garde.

The then current fascination among artists with the Near East and Gérôme's
photographically exact images of Near Eastern sites led Dagnan-Bouveret, along
with Muenier, to undertake a brief trip to Algeria in 1887–1888. While there, the
painter took many photographs; he also executed oil sketches of brightly lit city
streets and landscapes, with the hope of completing Orientalist scenes for exhibi-
tion at the Paris Salons. However, aside from heightening his sense of color, the
experience in Algeria did not result in his becoming a true Orientalist painter like
his master. By the 1890s, he had recognized that such naturalist images on Orien-
talist or French regional themes were out-of-date, and he began to create intimate
scenes of mystical contemplation, which were a personal response to the larger

FIGURE 5

The Recruits, 1889. Oil on canvas. 66 1/4 x 57 1/2 in. (168 x 146 cm). Signed and dated lower right: P.A.J. DAGNAN-B Ormoy/1889. Assemblée nationale, Paris.

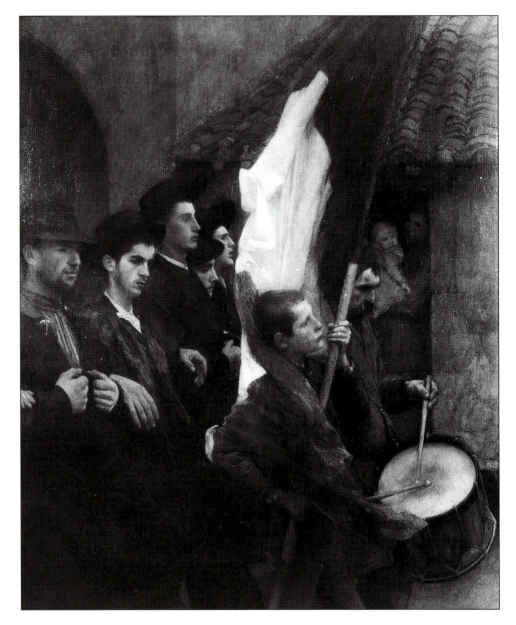

movement in France to reestablish religious spirituality. Motivated by his family, his wife's intense Catholicism, and his own yearning, the artist abandoned his former naturalist inclinations and became a painter of religious compositions. He was particularly inspired by the life of Christ and the role of a consoling Madonna. His masterful series of such paintings had, by 1900, made him one of the most intensely spiritual painters of the Third Republic. His canvases, including *La Cène* (*The Lord's Last Supper*) (fig. 6), were given pride of place in a separate installation on the grounds of that year's Exposition Universelle. Critics noted that these works created a spiritual environment that virtually enveloped the viewer. On the basis of this series, the painter was awarded honors and elected to the Institut de France. In 1900, Dagnan-Bouveret had reached the pinnacle of success.

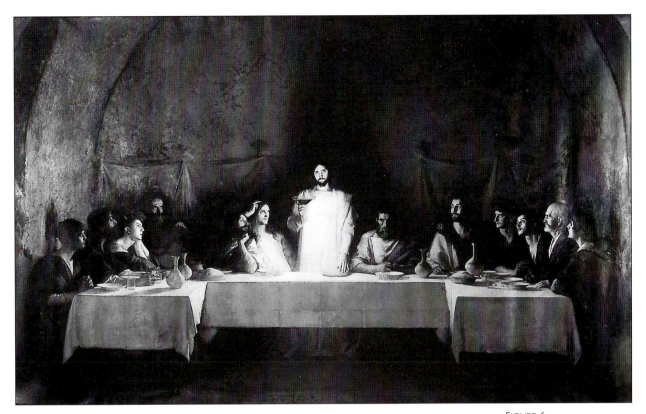

FIGURE 6

The Lord's Last Supper, 1895.
Oil on canvas. 118 x 205 7/8
in. (300 x 500 cm).
Signed and dated lower left:
P.A.J. Dagnan-B 1895.
Musée des Beaux-Arts, Arras.

III

The last three decades of the artist's career can be seen as a descent from Olympian heights. This period also corresponds to the ways in which the academy in France, and specifically academic painting, was trying to maintain itself in the face of ever increasing challenges from younger, progressive artists. The Ecole des Beaux-Arts was no longer seen as the only venue in which an artist could be trained, and it was no longer seen as significant. With the emergence of the principle of continuous change in the visual arts in the early years of the new century, Dagnan-Bouveret's works, mostly religious in theme, seemed increasingly repetitive and passé. His complex scenes were still exceedingly well composed, his portraits were in strong demand among the wealthy elite, and his skill in pastel was unparalleled. But with the disaster of World War I—he lost his only living son, Jean, a doctor, in the war—and infirmities brought on by encroaching old age, the painter seemed to be a relic from an earlier era. His reluctance to either adapt to or openly challenge new developments in the art world left him isolated. His earlier attempts to modify and revivify the academic tradition, while influential for a time, were forgotten as interest in the academic painters of the last half of the nineteenth century waned.

Dagnan-Bouveret poses a dilemma for the art historian. Since he lived well into the twentieth century, long after the heyday of nineteenth-century academic painting had passed, his works have been dismissed as outmoded. In order for the artist and his achievements to be appreciated, the various phases of his career need to be

reconstructed and his paintings have to be reassessed both on their own merits and within the movement that he represented. That the artist was most active precisely when the academic tradition was in rapid decline gives his work a poignancy and a personal expression often missing in that of other mainstream academic painters. In this regard, he stands out. Once we understand that he was selecting various themes or working in a specific way according to his own beliefs, his imagery takes on a deeper resonance. He was certainly one of the most personal of the academic painters, and perhaps the key artist who interiorized academic image-making in a way that reveals the doubts and traumas of an era in which traditional ideology was under severe stress. Of the academic painters, he was among the few to seriously utilize modern developments while maintaining time-honored traditions that he had learned as a young student at the Ecole des Beaux-Arts.

The Early Years I

While many academic painters who rose to fame at the Ecole des Beaux-Arts, the supreme educational institution for those chosen for an official career as a painter, came from a privileged background, this is only partly true of Pascal-Adolphe-Jean Dagnan-Bouveret.[1] Any initial material comfort he experienced must be measured against the loss of his mother, the abandonment by his father in 1867, and the subsequent financial uncertainties that befell his family. With little support from his parents, he learned to develop his native ability within the French art establishment, with the hope of having a successful career. As such, he was different from some of the other young painters enrolled in the Ecole who came from more substantial backgrounds and who easily moved up the ladder of academic success. For the young painter, his progress was more complicated. But, in time, he triumphed over the confusions of his early home life to find his way in the world of art.

A close examination of his youth provides a foundation for understanding the ways in which the older artist was to respond to creative themes. Clearly, the trauma of his childhood led the mature artist to develop an ordered existence free of intense stress. When Pascal-Adolphe-Jean Dagnan was born on January 7, 1852, to Bernard Dagnan and Louise Bouveret, his father seems to have been working as a tailor and as an assistant in his father-in-law's import-export firm, which did business in Rio de Janeiro.[2] Around 1852, troubles within his own business led Gabriel Bouveret, Dagnan's grandfather, to borrow some money from his son-in-law.[3] By 1854, Bernard Dagnan had successfully launched his own business, that of a clothier.[4] Although he apparently did quite well during the Second Empire, the Dagnan

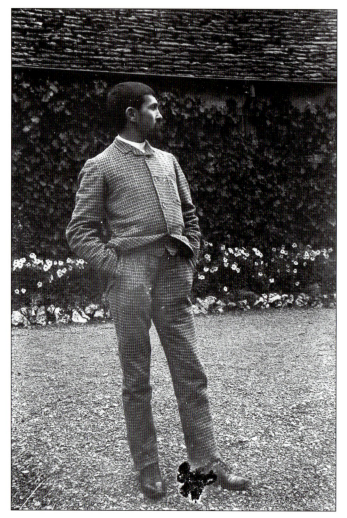

family was somewhat peripatetic; along with selling clothes and materials, they frequently traveled to Brazil, where the garments were made by the local population and then sold to Brazilians and members of the European colony or sent back to France. When Louise moved to Brazil to join her husband in 1857, she brought young Pascal-Adolphe-Jean and a second son, Emile Gabriel, with her to Rio; when she died a year later, Bernard sent his children (then including another son, Victor) back to France to live with their grandfather Bouveret in Melun, not far from Paris.

It is within this comfortable middle-class environment, with its emphasis on material goods, that the young child grew up; from the time he was a boy, he was interested in fine clothes and his comportment in society. As a painter, he later focused on sartorial details and their meaning, and he tried to convey proper breeding through the way he dressed (fig. 7). Yet he was also haunted by the insecurities of a family life that was immersed in sorrow and the death of loved ones and troubled by the uncertainties caused by the possibility of business failure.

The death of Louise Bouveret on March 25, 1858, was a bitter blow to the family. After sending the children to live with their grandparents in France, Bernard Dagnan gave up his clothing business and by 1867 was involved in the import-

export of glass and porcelain.[5] His children gradually lost touch with him. It is not certain how much Bernard Dagnan contributed to the upbringing of his children, but whatever money he might have sent back to France ended with his death in Rio de Janeiro in 1874. Just at the time that young Pascal-Adolphe-Jean was trying to set out on his own, it became clear that there was to be no inheritance. His father's fortune, if there was any, had evaporated or could not be recovered.[6]

Before his death, Bernard Dagnan had tried to involve his eldest son in his business ventures in Brazil. In a letter of 1867, he asked the fifteen-year-old to join him and his business partner; the youth, who had already set his sights on a career in the arts, categorically refused, opting to remain in Melun under the guardianship of Gabriel Bouveret.[7] The latter had become a very strong force in the boy's life. This independent spirit, coupled with a traumatic childhood, affected the ways in which Dagnan-Bouveret viewed his later relationships. Once he matured as a painter and selected his own imagery, there was often a quality of sadness, of fatalism, no doubt a consequence of his lingering sense of loss. Early on, the artist formed strong friendships, especially with the architect André Legrand, whom he met as a young man in Melun and who also studied at the Ecole des Beaux-Arts. Legrand remained his friend throughout his life. Dagnan-Bouveret replaced his familial ties with close associations with other artists, and their families, especially the Legrands.[8]

Exactly who encouraged Pascal-Adolphe-Jean to enter the world of art remains open to conjecture. Was it his grandfather, Gabriel Bouveret, his unofficial guardian? Or was it another member of the extended family, perhaps the engraver Philibert-Louis Deshayes, who suggested a career in art after seeing some of his drawings?[9] In any event, it is apparent that while a student in Melun, he was sharpening his eye by drawing his immediate surroundings, selecting as models members of his own family: his brothers and his grandparents Bouveret. After taking some art classes in Melun, with the support of his family, he decided to enter the Ecole des Beaux-Arts, the preeminent art academy in Paris, where he could be trained for an official career. In all likelihood, he prepared a portfolio, filling it with drawings and paintings that he had done on his own and in art classes. Based on these, he was accepted into the art school with which he was to be identified throughout his career.

He entered the Ecole des Beaux-Arts in April 1869. He does not appear to have been greatly influenced by his first teacher, Alexandre Cabanel.[10] By March 1870, he had shifted to another instructor, Jean-Léon Gérôme, an artist gaining a large following with French and international students as a result of his liberal teaching attitudes. The young student had difficulty following a regularized course of study at this time, for the atmosphere in Paris, as elsewhere in France, was shattered by events surrounding the Franco-Prussian War and the Paris Commune, which left sections of the capital city in a state of ruin.[11] Many artists, and not necessarily those affiliated with the Ecole, left Paris. Some, like Edouard Manet, served in the military, while others, such as François Bonvin, moved to London or Brussels.[12]

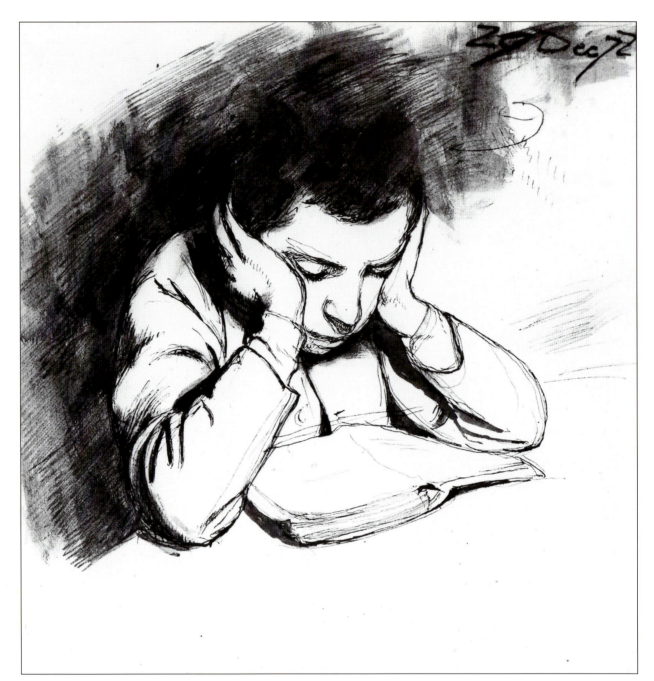

FIGURE 8

Victor Dagnan, 1872. Ink and wash drawing. 5 1/2 x 5 1/2 in. (13.8 x 13.8 cm). Dated upper right: 29 Déc. 72. Private collection.

During the opening months of his studies at the Ecole, he made a series of ink drawings of his brothers and his grandfather in the living room of their home in Melun. As the family sat around the table in the evening, reading or resting, the young artist recorded his impressions (fig. 8). These intimate studies are carefully inscribed with the names of the sitters and the dates. Executed outside the confines of the rigid training of the Ecole, where artificial settings and contrived poses of the nude figure dominated, these early works anticipate the type of art he would frequently create after his formal training was completed. Many are done on independent sheets of paper instead of in a *carnet* (notebook) of drawings, in contrast to the approach that academic painters were trained to take.[13] The informal

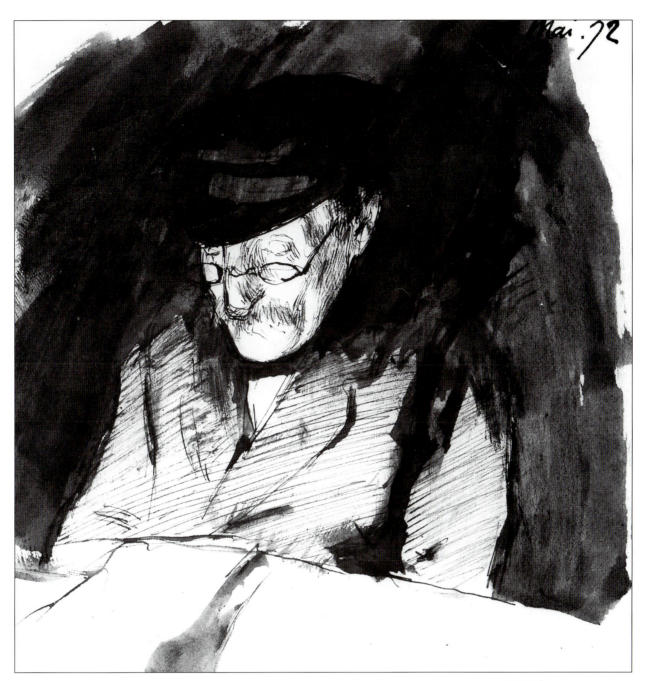

Mai. 72

FIGURE 9

Gabriel Bouveret, 1872.
Ink and wash drawing.
5 1/2 x 5 1/2 in. (13.8 x 13.8
cm). Dated upper right:
9 Mai 72. Private collection.

and unposed studies reveal, early on, a side of Dagnan-Bouveret not always apparent in his more formal presentation pieces made for the Salon. They document the young artist's search for themes and subjects in his immediate world and provide early clues to how he revealed the character of his sitters when he became a professional portraitist.

Some of these early pen-and-wash drawings depict his grandfather Gabriel Bouveret (figs. 9, 10) or his grandmother (fig. 11), who passed away in 1872. These studies convey Gabriel's diligence as he attended to his business, read books, or wrote letters. The sketchier drawing of the grandmother portrays her knitting, probably seated around the same large table where the family congregated.

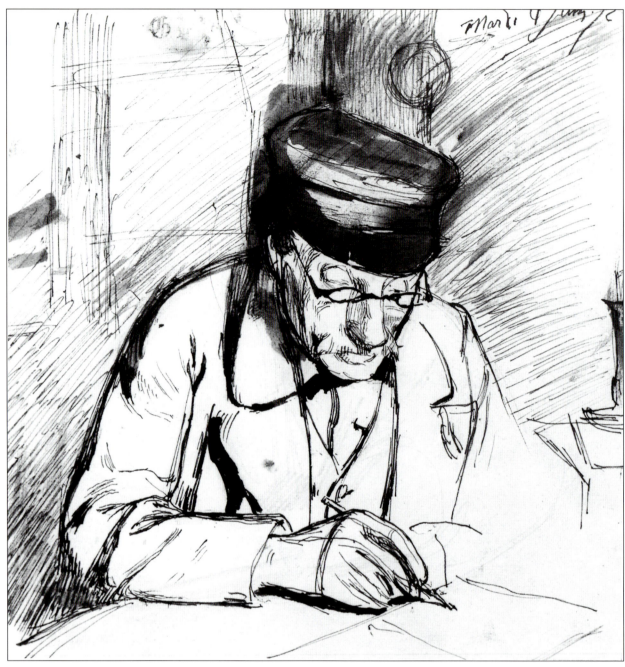

FIGURE 10

Gabriel Bouveret, 1872.
Ink and wash drawing. 5 1/2
x 5 1/2 in. (13.8 x 13.8 cm).
Dated upper right: Mardi
4 Juin 72. Private collection.

These works capture the liveliness of daily activity, while suggesting the quiet atmosphere of a close-knit family. They speak of Dagnan-Bouveret's realist inclinations and attest to his desire to become a "perfect draftsman."[14] The artist ultimately completed thousands of drawings throughout his career, both as a means of sharpening his visual acuity and in preparation for large-scale Salon paintings.[15]

At the same time as he informally studied his family, he began his lifelong habit of making self-portraits, providing a record not only of the aging process, but also of the changes in dress and demeanor of a highly regarded French painter.[16] In a charcoal study of August 1873, the artist drew himself with close-cropped hair, a style

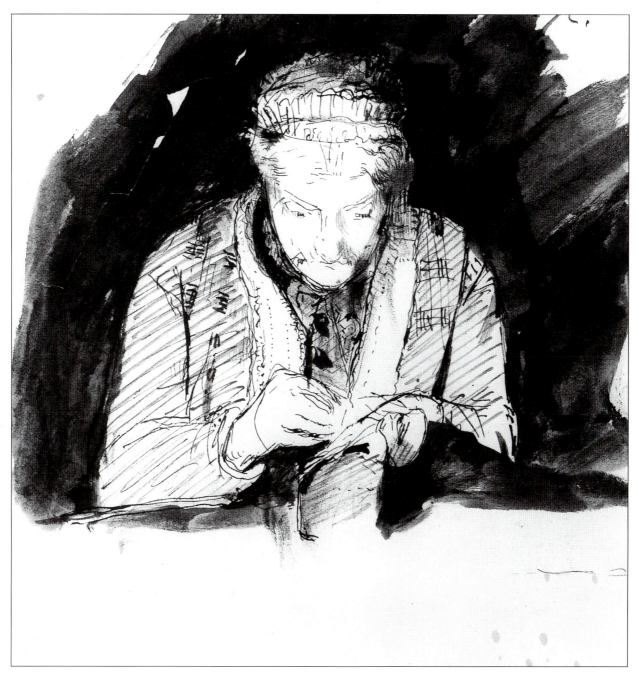

FIGURE 11

Adèle Bouveret, 1872.
Ink and wash drawing.
5 1/2 x 5 1/2 in. (13.8 x
13.8 cm). Dated upper right:
72. Private collection.

that he came to prefer. His carefully trimmed beard and the elegant cut of his jacket convey a fastidiousness in his personal grooming that he would maintain until the end of his life. The slightly monkish attitude, objective gaze, and serious demeanor visually announce his calling as an artist.

Since commuting to Paris from Melun was not feasible, Gabriel Bouveret gave his grandson a small stipend of eighty francs a month for living expenses. He also contacted old friends in Paris who could help. Among these was M. de Ronceroy, who provided the young art student with room and board.[17] Dagnan-Bouveret thanked him with a pencil portrait, which reveals the influence of Ingres—one of the primary prototypes for an academic student working under Gérôme. In 1873,

FIGURE 12

Madonna with Plane, 1885.
Oil on canvas. 33 1/2 x
35 7/8 in. (85 x 91 cm).
Signed and dated lower left:
P.A.J. DAGNAN-B 1885.
Bayerische Staatsgemälde-
sammlungen, Munich.
Photograph courtesy
Bayerische Staatsgemälde-
sammlungen, Munich.

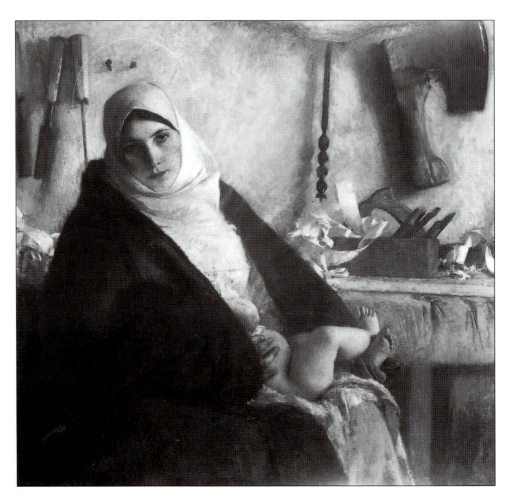

he secured his own studio on the rue des Beaux-Arts with a fellow student at the
Ecole, Gustave Courtois (1852–1923).

Around 1872, Dagnan-Bouveret produced his first oil sketch for Gérôme, *Les
saintes femmes au tombeau* (*Holy Women at Christ's Tomb*).[18] While this study has
not been located, it demonstrates the artist's early involvement with religious sub-
jects, which were a mainstay of training at the Ecole. Such themes appealed to
instincts that would eventually find full expression beginning with his *Madone au
rabot* (*Madonna with Plane*) (fig. 12), of 1885 and culminating with his mystical
religious paintings of the 1890s. In 1873, he painted *Claude élu empereur* (*Claudius
Elected Emperor*), a history painting, also in the academic tradition of the Ecole.[19]
Both exercises fared well in the studio competitions—in 1872 the artist ranked
fourth, and in 1873, first—revealing that he was highly regarded by his teacher and
that he was making considerable progress. However, his attention to his courses and
his work with Gérôme, who was quickly becoming a close friend as well as mentor,
were soon marred by financial difficulties.

In 1874, after his father's death, Dagnan-Bouveret and his grandfather traveled
to Rio de Janeiro to defend the financial interests of the three sons. Although funds
were clearly forthcoming, they had to be negotiated with members of the French

consulate. Unfortunately, the French consul in Rio, who had been looking after the affairs of Bernard Dagnan, reported that the family inheritance had been misused.[20] The artist and his grandfather could have followed matters through the courts, but since they could not stay in Rio de Janeiro indefinitely, the two evidently decided to drop the matter, at least temporarily. Their return to France, in 1874, must have been a solemn journey. It appeared that there was to be no financial cushion for the family after all. The sense of uneasiness that permeated the 1860s returned, and the artist again resolved to shape his own future. The death of his father made it imperative that a legal guardian be found for his two younger brothers, Gabriel and Victor. Gabriel Bouveret, who had already been caring for the boys, became their official guardian.[21] Proof of the close relationship that existed between the grandfather and his grandchildren, and especially Pascal-Adolphe-Jean, is manifested in the fact that, beginning in the late 1870s, the artist started to sign his works Dagnan-Bouveret.[22] Although this name change was not official, and he continued to use the surname Dagnan on legal documents, he honored his grandfather by adding Bouveret, or simply "B," to his signature on works executed from this time on.

During the 1870s, Dagnan-Bouveret's friendship with Gustave Courtois blossomed. They were inseparable at the Ecole, sharing an intense interest in studying past masters. Dagnan-Bouveret was short and Courtois tall, and the two created a comical impression when they stood side by side (fig. 13). Like his friend, Courtois

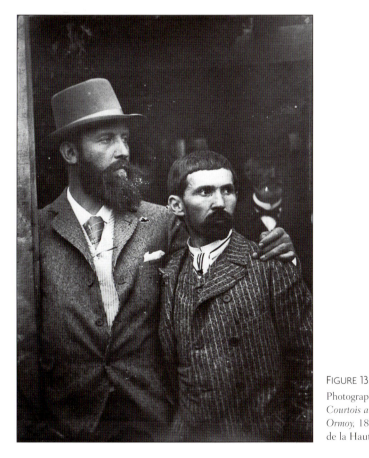

FIGURE 13
Photographer unknown, *Gustave Courtois and P.-A.-J. Dagnan-Bouveret at Ormoy*, 1888. Archives Départementales de la Haute-Saône, Vesoul.

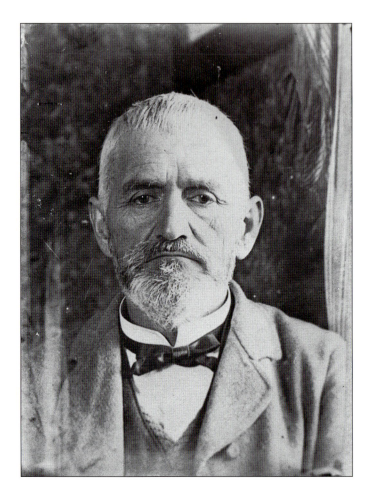

came from a troubled and modest background. The child of an unwed mother, he was similarly dominated by insecurities, although his mother was devoted to her son. Early on Courtois revealed an interest in art, and he entered the Ecole municipale de dessin in Vesoul (a city in the Franche-Comté not far from Besançon). His drawings were shown to Gérôme, who had a summer home in Coulevon, just outside Vesoul. Gérôme encouraged him to enter the Ecole des Beaux-Arts in 1869, the same year that Dagnan-Bouveret enrolled in Cabanel's studio.[23]

Initially Courtois's enrollment fees were paid by a patron from Vesoul, allowing the young man to concentrate on his training free from financial worry. During the Franco-Prussian War and the Commune, he returned to the Franche-Comté; he was only able to reenter Paris in October 1871, when he renewed his contact with Dagnan-Bouveret. (The two had kept in touch through letters.) Beginning in 1872, Courtois, who had numerous ties in the Franche-Comté, including family in the village of Corre, returned for the summer holidays with his friend.[24] It was here that Courtois's congenial great-uncle, Nicolas Walter (fig. 14), a local miller and landowner of considerable means, lived. Walter's daughter, Anne-Marie, was introduced to Dagnan-Bouveret; by 1879 they were married.[25]

Anne-Marie loved the countryside of the Franche-Comté, and she persuaded her husband to establish holiday and summer residences in the region, first in Corre

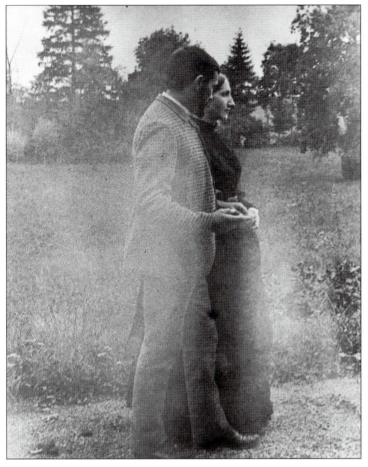

FIGURE 15

Jules-Alexis Muenier,
*P.-A.-J. Dagnan-Bouveret
and His Wife, Anne-Marie,*
Coulevon, August 1887.
Archives Départementales
de la Haute-Saône,
Vesoul.

(1879–1886); then in Ormoy (1886–1894); then in Raze (1894–1897); and, finally, in Quincey, just outside Vesoul (1897–1929).[26] Since his closest colleagues came from the region, first Courtois and later another student of Gérôme's, Jules-Alexis Muenier (1863–1942), Dagnan-Bouveret found a coterie of artists who advocated the academic tradition. But, at least in the case of Muenier, these colleagues were also increasingly interested in blending this tradition with scenes of everyday life. Courtois, curiously, remained a classic academic and, outside of his portraits, continued painting history and religious subjects for the remainder of his career.

Anne-Marie was devoutly religious, and her belief that the teachings of Christ ought to be observed on earth greatly influenced her husband's thoughts. A new spirituality led Dagnan-Bouveret away from the mundane, toward a higher, more mystical realm. The closeness of the couple was captured in photographs of the period, including one by Muenier, an inveterate photographer, who recorded the two walking together on Muenier's property in Coulevon in August 1887 (fig. 15).[27]

Dagnan-Bouveret's new wife fully involved herself in her husband's work. She enjoyed posing as a model, dressing in regional costumes, and playing a role in arranging family members as models in his outdoor studio (fig. 16). As members of the family are often models in his paintings, the artist's imagery takes on a significance beyond the ostensible subject as presented to the public at the Salon.

Dagnan-Bouveret and Courtois maintained a close relationship throughout their lives, although the former was troubled by Courtois's homosexuality.[28] The two remained immersed in their careers and Courtois eventually became a very fine portrait painter, his talent demonstrated in the large-scale, elegant study of his cousin Anne-Marie in 1880 (fig. 17). This presentation piece, in which Anne-Marie wears her most formal clothes and holds an open fan, not only conveys the intelligence of the sitter but also suggests that Courtois wished to commemorate the relationships among the three friends. The sense of the intense personal presence of his subject

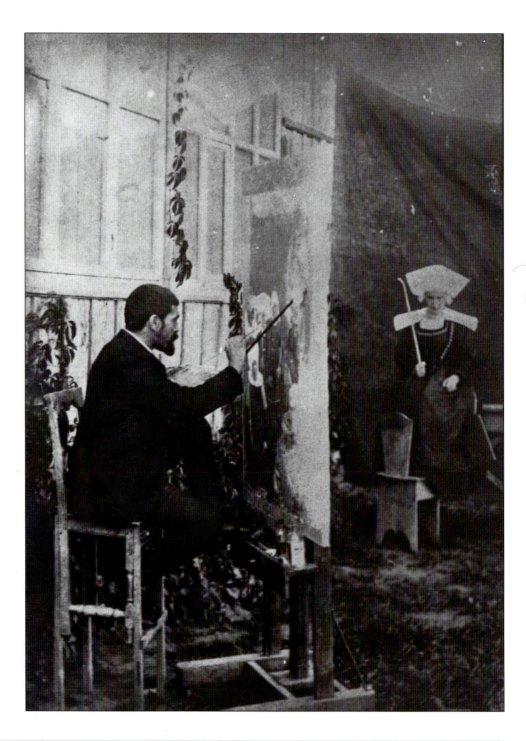

FIGURE 16
Photographer unknown, *Dagnan-Bouveret Painting "The Pardon in Brittany,"* ca. 1887. Archives Départementales de la Haute-Saône, Vesoul.

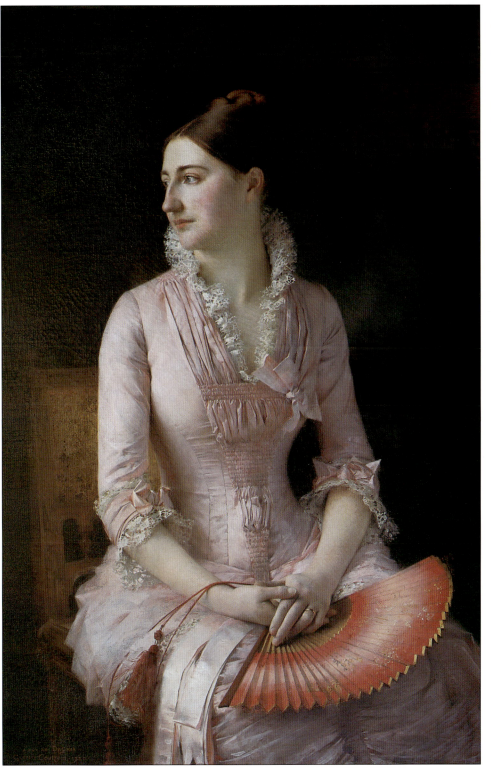

Figure 17
Gustave Courtois,
*Portrait of Anne-Marie
Dagnan,* 1880. Oil on canvas.
47 1/2 x 31 1/2 in. (120.7
x 80 cm). Signed and dated
lower left: A mon ami
Dagnan/Gustave Courtois,
1880. Musée Georges Garret,
Vesoul.

reveals that Courtois, like Dagnan-Bouveret, was on his way to becoming a major portrait painter of the Third Republic.

During the 1880s, as both artists were enjoying considerable public recognition, they pooled their finances to construct a villa in Neuilly, a fashionable suburb of Paris.[29] Dagnan-Bouveret worked and lived on one floor; Courtois on the other.

FIGURE 18

Jules-Alexis Muenier,
*Photograph of a Cemetery
in Blidah,* ca. 1887/1888.
Archives Départementales
de la Haute-Saône, Vesoul.

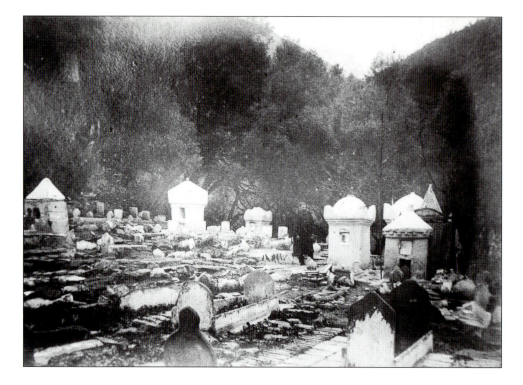

Since his friend was often in the Franche-Comté during the 1880s, Courtois had the run of the building, and he produced many of his best portraits there. However, the choice to remain in Paris and to largely restrict his output to portraiture stunted Courtois's artistic growth; he never strayed far from the orbit of his teacher, Gérôme, whom he idolized.[30] Dagnan-Bouveret, by contrast, enjoyed a greater freedom and sense of independence, reinforced by the guiding spirit of his wife.

By the late 1880s, Muenier, the artist's closest friend, had also become a student of Gérôme's. They had met through mutual contacts in the Franche-Comté, and were now brought together by training in the Ecole. In December 1887, assisted by a grant from the government, both artists traveled to Algeria with their families, their painting equipment, and their cameras.[31] Although the trip was relatively short, it was an opportunity to broaden their visual experiences and possibly to test the idea of becoming Orientalist painters, like their teacher.[32] The trip brought them to unusual locales, including a cemetery in Blidah (fig. 18), where Dagnan-Bouveret wrote in a letter to his friend Henri Amic in France that the melancholy atmosphere of the site was compelling.[33] The intense light, the lonely streets and busy open markets, attracted Dagnan-Bouveret as subjects for painting, but he was bothered by the way in which the Algerians often fled from the presence of the foreigners or shied away from the camera, which was believed by many to be evil.[34] The trip reinforced the artist's awareness that responding to and utilizing photography and new ways of placing a model outside were important if he was to remain a successful painter in the 1880s.[35] It also cemented his friendship with Muenier, whom he continued to visit in Coulevon, where Muenier eventually purchased Gérôme's villa. The ties that Dagnan-Bouveret established with other

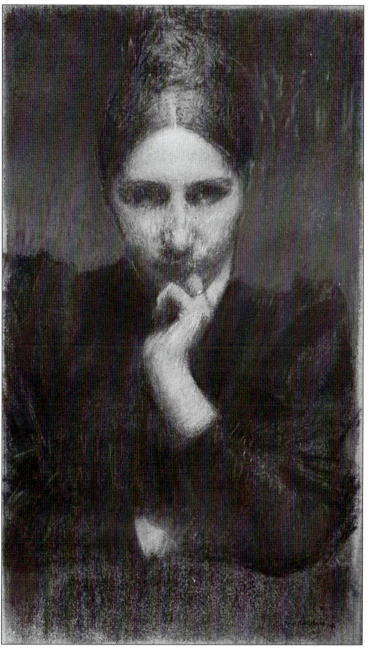

FIGURE 19

Portrait of Anne-Marie Dagnan, 1891. Pastel. 18 1/8 x 12 1/4 in. (46 x 31 cm). Signed lower right: P.A.J. DAGNAN-B/1891. Musée Georges Garret, Vesoul.

artists were to be critical to his working methods and to the development of his imagery.

During the 1890s, commissions came in regularly from private patrons. The artist relied on his family for a quiet oasis away from work. His wife and son Jean were often the subject of his art (figs. 19, 20, 21).[36] His imagery moved from naturalist depictions of rural life toward more introspective, mystical subject matter, which was greatly influenced by Anne-Marie's spirituality. This new religious inspiration led to themes such as *Consolatrix Afflictorum* (*Consoling Madonna*) and *The Lord's Last Supper.* When he exhibited these new paintings at the Paris Exposition Universelle (1900), along with other religious paintings by colleagues

that emphasized the life of Christ, it was his large paintings that often mesmerized the general public.

It was at this time that Dagnan-Bouveret achieved an international reputation. Americans began to collect his paintings; he was an exhibitor at the Carnegie Internationals in Pittsburgh from 1896 on. This brought him to the attention of both Andrew Carnegie and Henry Clay Frick, two active collectors of contemporary French art. Their patronage brought the artist further acclaim and revealed that

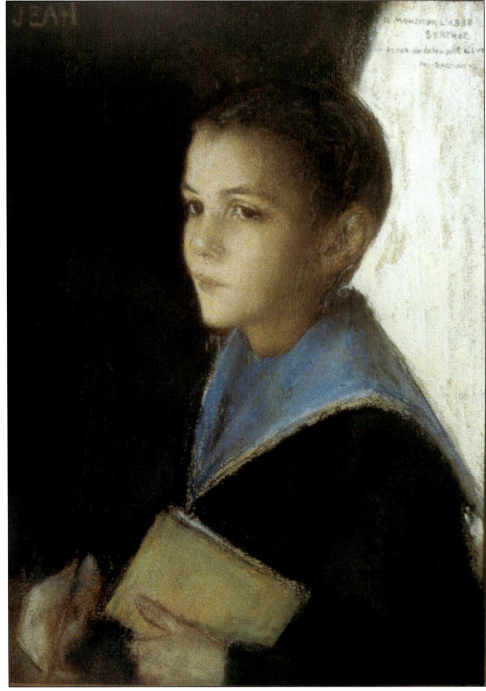

FIGURE 20

Portrait of Jean Dagnan, 1891. Pastel. 8 5/8 x 6 1/4 in. (22 x 16 cm). Dedicated upper left: JEAN. Dedicated upper right: à MONSIEUR L'ABBE BERTHOZ en souvenir de son petit élève P.A.J. DAGNAN. Musée Georges Garret, Vesoul.

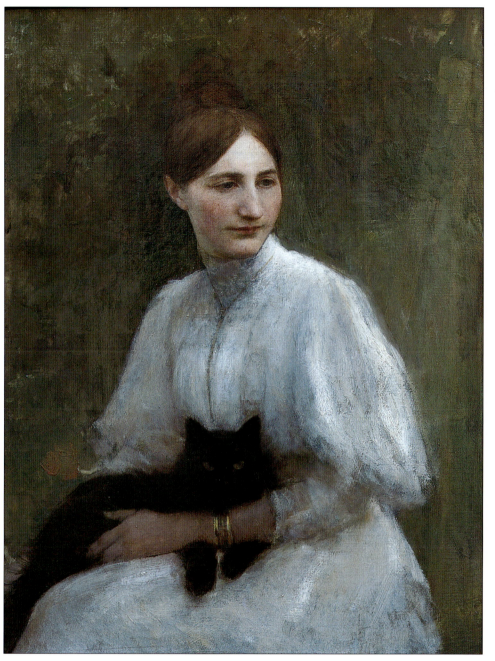

FIGURE 21

Portrait of Anne-Marie Dagnan with Black Cat, not dated. Oil on canvas. 16 1/2 x 13 in. (42 x 33 cm). Musée Georges Garret, Vesoul.

some Americans of position and wealth wanted this type of religious painting to hang on their walls and on those of recently established public museums.[37] While his later works included portraits of leading members of the Third Republic, both before and after World War I, he cared most about his religious paintings—the consoling Madonna, Christ's Passion, the Stations of the Cross, and so forth. This fact suggests that his final direction was inward, to an identification with Christ on a most personal level, especially during periods of tremendous anguish. Above all, it was the painter's reluctance to surrender to the taste of the modern movement that reveals him as a survivor and promoter of the academic tradition.

Knowledge of the artist's past, his personal interests, and his close associations with family and friends is essential to an understanding of Dagnan-Bouveret and his art. Even though he was a traditional academic painter who adhered to the values espoused by Ingres and Gérôme, he relied on his own personal experiences to help him in the creation of his imagery. In the following chapter, we will examine how his works began to evolve during the formative years at the Ecole des Beaux-Arts.

In the Ecole des Beaux-Arts II
1872–1878

F rom the moment of his return to Paris from Melun in October 1872, Dagnan-Bouveret applied himself with exceptional vigor to his course of study at the Ecole des Beaux-Arts. The young artist recognized that the Ecole was the only place where a young creator could be properly trained for an official career. He not only participated in all aspects of the Ecole's curriculum—drawing from plaster casts, the model, or memory; making oil sketches—but also studied the collections of old masters at the Musée du Louvre. Drawing became an integral part of his artistic training and he aspired to become a highly skilled draftsman.[1] Accepting the precepts of the Ecole, he was determined to follow the traditions that the school upheld; he recognized that an emulation of the masters of a past time, primarily the Italian Renaissance, was an ingrained part of the curriculum. The young artist accepted a higher authority and the lessons that could be learned from other artists who had followed along a similar path at an earlier time. In this way, he found that his energies could be channeled; he also recognized, once he had mastered the various approaches in the studio sessions, that a degree of originality was allowed as long as he accepted the dictates of being trained in a time-honored way.

One early drawing represents the visualization of this tradition. With his rendition of the portrait bust of Piero di Lorenzo de Medici that had been executed by the Renaissance workshop of Verrocchio (fig. 22), the young artist was following the principles of an early drawing class, copying a model from a previous era.[2] It is unlikely that he saw the actual example, and he probably drew from a plaster cast after the original. The careful modeling, especially of the crisp, wavy hair and the deep-set eyelids, and the way in which the bust is sharply set off from the

FIGURE 22

*Portrait Bust of Piero di
Lorenzo de Medici*, 1873.
Pencil and charcoal drawing.
16 1/4 x 12 1/8 in. (41.3 x
30.6 cm). Dated middle left:
Juin 1873. Private collection.

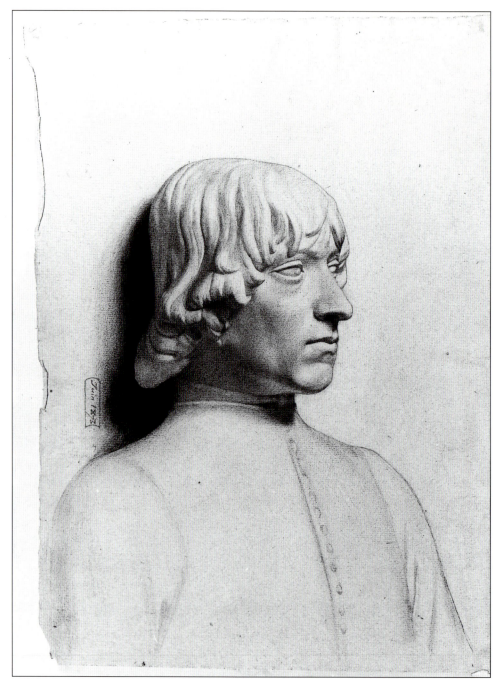

background suggest that the young artist was working from a three-dimensional model and not another drawing. The copy is dated June 1873, and as it is the only one of its kind, it must stand for other such exercises done early in his academic training.[3]

At the same time, he would have been introduced to one of the preeminent painters of the nineteenth century: Jean-Auguste-Dominique Ingres. Gérôme, who quickly became the artist's mentor, encouraged a fundamental acquaintance with and emulation of this artist's work, especially since Ingres maintained the tradition of the Davidian approach to art, in which line was more significant than color and

FIGURE 23

Head of Woman with Hat On,
not dated. Pencil drawing.
5 1/8 x 3 1/2 in. (13 x 9 cm)
Signed upper left: griffonné
d'après Ingres/P.A.J. Dagnan-
B. Abbaye royale de Chaalis,
Institut de France, Bequest
Henri Amic, no. 18.

in which there was a belief that an active interest in portraiture should be combined with the understanding of past masters. That Dagnan-Bouveret produced several drawings after various figures in Ingres's corpus, including a copy of the pencil study of Ingres's wife (fig. 23), demonstrates the importance of this master for any youth studying at the Ecole.[4]

Drawing was at the heart of the academic system, and he would have completed a large number of studies during his first years in the program; unfortunately, most of these are lost or inaccessible.[5] Another essential building block in the art student's preparation for making a finished composition was the oil sketch, or *esquisse*. The practice of making esquisses—which became part of the Ecole's curriculum in 1863—allowed the student's ideas for a composition to develop gradually, after consultation with the professor and exhibition in an open competition with other students. Following the selection of themes generated by the professor, the artist competed in 1872 and in 1873 in the *concours d'esquisse*. Competing for awards at the Ecole was one way that students and their peers and professors could judge their performance and their progress; it also maintained tradition and taught young artists how to compose a painting from a required theme. The program of the Ecole had a dual purpose: to teach what constituted good drawing and painting and, just

FIGURE 24

Atalanta, 1874. Oil on
canvas. 75 x 54 6/8 in.
(190.5 x 139 cm). Signed
and dated lower right:
P.A.J. DAGNAN 1874.
Musée Municipal, Melun.

as important, to acclimate the young artist to the academic system of competition
in the outside world.

In 1874, with the encouragement of Gérôme and his peers, Dagnan-Bouveret
completed a large canvas that he submitted to the Salon jury the following year. The
subject, *Atalante (Atalanta)* (fig. 24), was perfectly attuned to the tastes of the offi-
cial jury, for it depicted a figure from antiquity who triumphs against numerous
competitors.[6] In order to choose among her many suitors, Atalanta, the beautiful,
athletic heroine of Greek legend, devised a contest. If she won, death would be the
reward for her rival, and if she lost, she would become his bride. No one could

match her speed in a footrace, until Melanion (Hippomenes) placed irresistible golden apples in her path, causing Atalanta to lose the race. Dagnan-Bouveret, instead of representing Melanion's victory over Atalanta, chose to portray her triumph over another suitor, who could not run as fast as she. He showed her raising laurel leaves above her head, so that the spectators in the distant field, and the viewers at the Salon, could share in her victory.

The eventual purchase of *Atalanta* by the French government for eighteen hundred francs assured the artist of a very early Salon triumph, one that was based on his mastery of the classical tradition and his subtle allusion to the rebuilding of confidence and the reestablishment of idealism in France after the horrors of the recent war.[7] Nor was the ambitious scale of the canvas lost on the Salon public. When the painting was sent to the Musée municipal in Melun in 1875, Gabriel Bouveret could see with his own eyes that his grandson was succeeding on his own field of battle.[8] With this formative work, Dagnan-Bouveret demonstrated that he had learned his academic lessons well and that he had absorbed the influence of Gérôme, one of the most celebrated academic painters of the day.

The lovely nude figure of Atalanta seen from the back provided the artist with a pretext for demonstrating his mastery of a classical "academic" pose—one that he had studied from the model many times. A more difficult pose was that of the male figure at the left. The radical foreshortening in a very constricted space was necessary so as not to detract from the triumphant Atalanta in the center of the canvas.[9] The flowers in the foreground and the ceramic frieze at the left demonstrate the artist's use of details to add archeological interest to a scene, a device learned from Gérôme, who had become a master at referencing specific architectural details, often from ruins he had studied firsthand. But it is the pose and placement of the ideal nude seen from the back, with its direct reference to Gérôme's painting *Le roi Candaule* (*King Candaules*) (fig. 25), that underscores how carefully the pupil was assimilating the lessons of the teacher.[10]

Atalanta is much more than a pastiche of the academic manner. The eerie lighting, with its metallic tonality, creates a strange mood of apprehension in a scene of glorious triumph. The meticulously painted sword in the foreground, half hidden in the field of flowers and with blood on its tip, alludes to the fact that Atalanta has not merely subdued her competitor but killed him. A fragmentary preliminary drawing reveals that these details, as well as the architectural setting, were added later to the finished work, as the drawing shows only the principal figures (fig. 26). Dagnan-Bouveret moved from an initially tame retelling of the legend to the creation of an allegory of revenge, which would have reflected the mood of the country in the early 1870s. The icy colors and meticulous detail, recalling the work of the Nazarenes, an earlier group of German painters who had based their work on Italian Renaissance models, made the painting accessible to a Salon audience and to leaders of the government. With the acceptance of this work, Dagnan-Bouveret had arrived.[11]

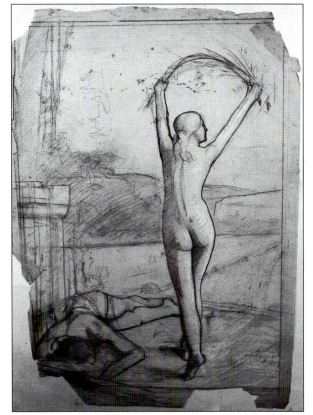

FIGURE 25
Jean-Léon Gérôme, Study for *King Candaules*, not dated.
Oil on canvas. 15 1/2 x 7 7/8 in. (39.5 x 19.7 cm).
Signed lower right: J. L. GEROME. Schweitzer Family Collection.
Photograph courtesy Schweitzer Family.

FIGURE 26
Atalanta, ca. 1874. Preparatory drawing on tracing paper.
15 1/2 x 11 in. (39.5 x 28 cm). Private collection.

Attention to the figure continued as the artist worked on a painted academy (the study of a nude model in the studio) of a male nude in March 1876 (fig. 27). This canvas reveals that the artist was placed in the front row (an honor for a student), where he could study the model *à contre-jour*, with light illuminating one side of the figure. The model assumed a *contrapposto* pose, inspired by classical sculpture, in which the weight is shifted to one leg, creating a subtle curve and forcing the muscles to tighten, thus accentuating the sinews of the legs and upper torso. The model holds a weight in one hand so that the muscles and veins of the slightly out-

stretched arm can be more carefully observed. The sight lines provide evidence of the ways in which students at the Ecole worked from a model. The curtain offers a neutral background, so that attention remains focused on the figure. The floorboards, which Dagnan-Bouveret has chosen to include, suggest that the model is standing on a rotating platform, allowing students to see a different view without changing position. This academy, the crucial means by which students at the Ecole mastered an ability to draw or paint from a posed model, who was often positioned in poses suggestive of past masters or classical sculpture, reveals that the painter's realist proclivities were being put to good advantage; his interest in light and careful observation parallel the concerns of younger avant-garde painters, who were applying similar principles to the study of landscape. Apparently, he received the

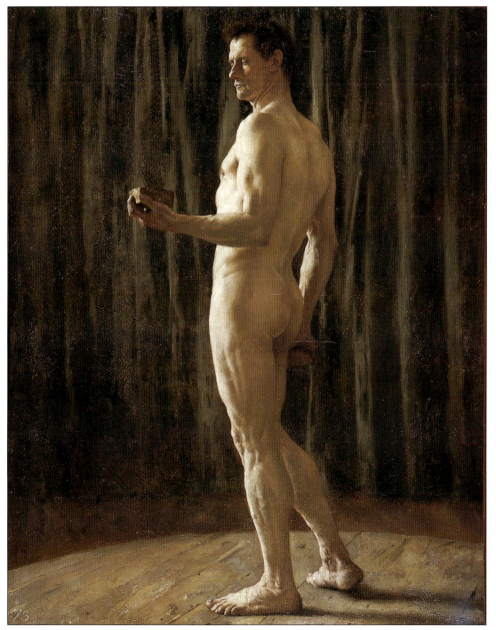

FIGURE 27

Painted Male Academy,
1876. Oil on canvas.
31 7/8 x 25 5/8 in.
(81 x 65 cm). Competition
for the painted figure.
Dated 27 Mars 1876
on the back of the stretcher.
Ecole Nationale Supérieure
des Beaux-Arts, Paris.

first-place medal for a painted figure, as it was obtained by the Ecole and preserved for its permanent collection.[12]

He increasingly participated in the various Ecole contests and earned a second place in the Concours de Rome for a lost work titled *Le reniement de Saint-Pierre* (*The Denial of Saint Peter*).[13] This prize positioned him to win the most prestigious award offered by the school, the Prix de Rome. Even though the Prix de Rome had been criticized for some time by critics and young artists as pandering only to students who were under the control of dominant academicians, it was still highly sought after by students, since it provided recipients with time and means to work from the old masters in Italy and, at the same time, gave them considerable prestige in the academic art world. Each year, a group of the best students were selected for the competition, ranked, and assigned a theme for which they were to draw a preliminary sketch. Students were given twelve hours to complete the study; during this time they could neither leave their cubicles nor communicate with anyone else. At the end of the allotted time, the professor in charge—in 1876, it was William Bouguereau—gathered the sketches, asked the students to sign theirs, and then affixed his own signature.[14] The studies were then kept by a school official, to be compared with the final painted compositions. The paintings were finished by students within seventy-two days, then exhibited so that they could be examined by the public, the press, and the Ecole's jury. Selection criteria were rigorous, and there must have been considerable debate among professors. Works were judged on the basis of originality, adherence to the theme, clarity of composition, and the ability to work out the composition on a larger scale without making severe changes from the original study.[15] Since Dagnan-Bouveret had already proved himself to be an able competitor at the Salon and had received a major award, he was ranked first among his peers who were going to compete *en loge*—placed in actual locations in the Ecole—in the timed sitting for the competition.

He was competing against his closest friends at the Ecole; Courtois (fig. 28) was situated in the eighth loge and Jules Bastien-Lepage (fig. 29) was placed in the ninth, suggesting that the Ecole teachers had already prejudged certain candidates from the loge position they were given.[16] Bastien-Lepage, who was still smarting from what many believed to have been unfair treatment in the 1875 contest, when his work *The Adoration of the Shepherds* had been judged by the press as the best on display, was given another opportunity by the Ecole administration. His position as ninth en loge, however, suggests a reluctance to take him seriously, and his chances of winning would have been no better than those of the lowest-ranked student in the 1876 competition. The fact that Bastien-Lepage was still included in the competition raises another question: his highly naturalistic shepherds had startled the members of the Ecole administration when first exhibited. This painting, and perhaps Bastien-Lepage himself, sounded an alarm that traditional themes could be modified by an interest in highly realistic representations of figures. At the time, in 1876, few in the Ecole were willing to accept this direction as a wave of the future,

FIGURE 28

Gustave Courtois, *Priam Pleading for the Body of His Son Hector from Achilles,* 1876. Preparatory black pencil drawing on tracing paper for the Concours de Rome of 1876. 10 1/4 x 11 3/8 in. (26 x 29 cm). Ecole Nationale Supérieure des Beaux-Arts, Paris.

FIGURE 29

Jules Bastien-Lepage, *Priam Pleading for the Body of His Son Hector from Achilles,* 1876. Preparatory black pencil drawing on tracing paper for the Concours de Rome of 1876. 12 5/8 x 9 7/8 in. (32.2 x 25.2 cm). Ecole Nationale Supérieure des Beaux-Arts, Paris.

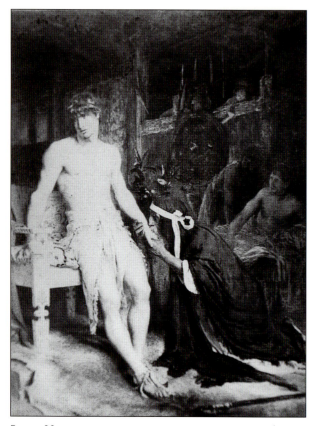

FIGURE 30

Priam Pleading for the Body of His Son Hector from Achilles, 1876.
Oil on canvas. 57 9/16 x 44 3/4 in. (146.5 x 113.7 cm).
Dagnan-Bouveret entry for the Concours de Rome in 1876.
Second prize. Present location unknown.

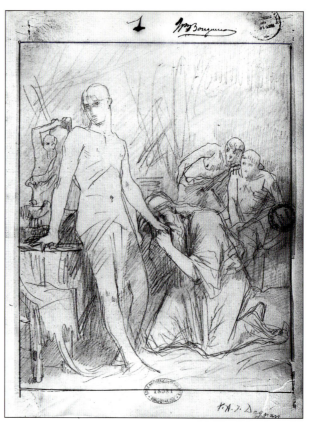

FIGURE 31

Priam Pleading for the Body of His Son Hector from Achilles, 1876.
Preparatory black pencil drawing on tracing paper for the Concours
de Rome of 1876. 13 5/8 x 9 1/4 in. (34.5 x 23.5 cm).
Ecole Nationale Supérieure des Beaux-Arts, Paris.

suggesting that Bastien-Lepage's work was seen as too radical for the period, even though it appealed strongly to the younger students, including Dagnan-Bouveret.

The subject chosen for the Prix de Rome contest in 1876 was *Priam demandant à Achille le corps d'Hector* (*Priam Pleading for the Body of His Son Hector from Achilles*). Unfortunately, only a poor reproduction of Dagnan-Bouveret's actual painting has been located (fig. 30); the preliminary drawing (fig. 31) does, however, provide the placement of the figures in the finished painting. Dagnan-Bouveret's entry was judged highly—he received an award of the second Grand Prix de Rome—and the works by his friends Courtois and Bastien-Lepage were not ranked at all. In the end the Prix de Rome of 1876 was given to Joseph Wencker (fig. 32) another student of Gérôme's, who was already enjoying a degree of success at the Salons in the mid-1870s.[17]

The finished canvas by Wencker shows considerable variation between original conception and final realization (fig. 33). The figure of Achilles in the preliminary drawing seems completely uninvolved with Priam, while in the finished work a lively discussion ensues between the protagonists. Other painters, such as Courtois, showed a closer adherence to the rules, as can be seen from comparing his preliminary esquisse with the final work. Assuming that Dagnan-Bouveret also played by

the rules, the reason that Wencker won might have something to do with the age of the artists—Wencker was eight years older—and the desire on the part of the jury to award him for his longer time in the system.

Artists who finished at a high rank in the Prix de Rome contest, especially those who came in second, were strongly encouraged to continue their careers. Other competitions were based on skill in drawing—the core of academic train-ing—and the rendering of facial expression[18] and Dagnan-Bouveret received a Grande Médaille d'Emulation for one—or perhaps more—of these categories.[19] By the winter of 1876, he, along with Courtois, had become one of Gérôme's favorite students. Even though their work was still evolving and there was stiff competition at the Ecole, both hoped to win the fabled Prix de Rome.

In 1877, Dagnan-Bouveret's ranking in Ecole contests was slightly lower than in the previous year. He placed second in the esquisse contest, whose theme that year was *Alexandre coupant le noeud gordien* (*Alexander Cutting the Gordian Knot*); this historical work also remains unlocated.[20] What has to be recognized is that he remained committed to his training at the Ecole des Beaux-Arts, where students were taught to learn from assigned themes. Thus, even though in the end he did not win the principal award, it was revealed that he wanted to be trained as a history

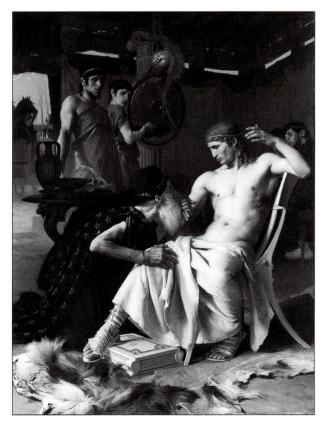

FIGURE 32
Joseph Wencker, *Priam Pleading for the Body of His Son Hector from Achilles*, 1876. Oil on canvas. 57 9/16 x 44 3/4 in. (146.5 x 113.7 cm). First Prix de Rome. Ecole Nationale Supérieure des Beaux-Arts, Paris.

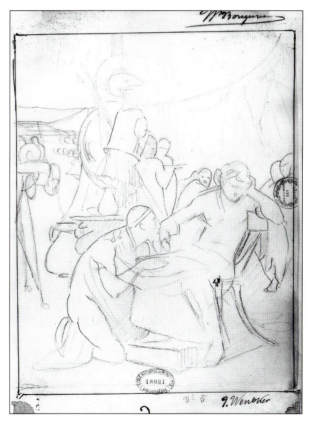

FIGURE 33
Joseph Wencker, *Priam Pleading for the Body of His Son Hector from Achilles*, 1876. Preparatory black pencil drawing on tracing paper for the Concours de Rome of 1876. 13 x 9 5/8 in. (33 x 24.5 cm). Ecole Nationale Supérieure des Beaux-Arts, Paris.

painter—the tradition in which academic artists had been nurtured for more than a century. He made a second attempt at the Prix de Rome, although his placement in the fourth loge rather than the first suggests a slippage in the eyes of some professors.[21] The thematic selection—*Le sac de Rome par les Gaulois* (*The Sack of Rome by the Gauls*)—was more vague than the year before, and lacked the emotive potential of the more personal theme of Priam pleading with Achilles for the body of his dead son. His preliminary sketch (fig. 34) appears stiff and generalized, and the figures show little facial reaction or emotional passion, suggesting that he was less inspired by the subject.

The Prix de Rome that year was awarded to Théobald Chartran, who cleverly personified the city of Rome as an old man vainly trying to defend himself from outside forces (fig. 35). Moreover, he preserved the energy and originality of the study (fig. 36) in the finished painting. In order to focus on old "Rome," Chartran dramatically compressed the scene to focus attention on the central allegorical figure and used theatrical light effects as well. Chartran's powerful image far exceeded the relatively tame painting by Courtois, which earned him second place. The selection of Chartran, a student of Cabanel's, reveals that no one professor's students could dominate the award year after year.

During that same year, Dagnan-Bouveret completed canvases for exhibition at the Salon, including *La douleur d'Orphée* (*Orpheus's Sorrow*) (fig. 37), also known as

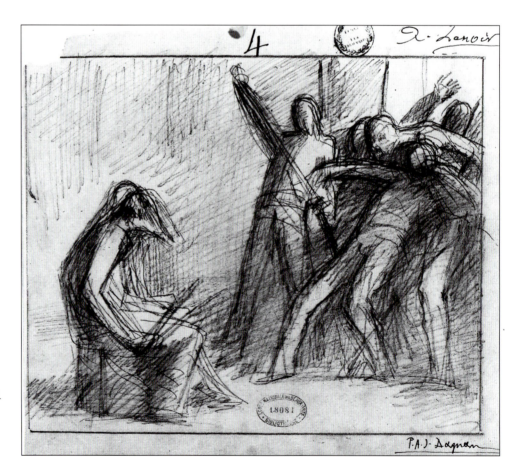

FIGURE 34

The Sack of Rome by the Gauls, 1877. Preparatory black pencil drawing on tracing paper for the Concours de Rome of 1877. 12 1/4 x 10 3/8 in. (31.3 x 26.4 cm). Ecole Nationale Supérieure des Beaux-Arts, Paris.

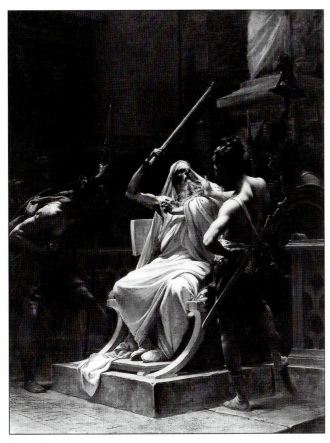

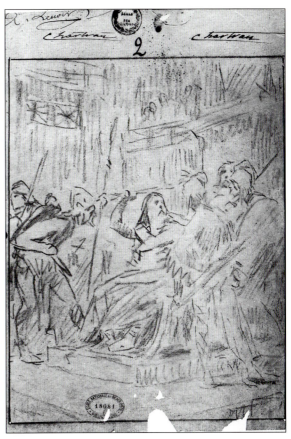

FIGURE 35

Théobald Chartran, *The Sack of Rome by the Gauls,* 1877. Oil on canvas.
57 9/16 x 44 3/4 in. (146.5 x 113.7 cm). First Prix de Rome.
Ecole Nationale Supérieure des Beaux-Arts, Paris.

FIGURE 36

Théobald Chartran, *The Sack of Rome by the Gauls,* 1877.
Preparatory drawing on tracing paper for the Concours de Rome
of 1877. 13 3/8 x 9 1/4 in. (34 x 23.5 cm). Ecole Nationale
Supérieure des Beaux-Arts, Paris.

Orphée et les Bacchantes (*Orpheus and the Bacchantes [Maenads]*). The theme of the grief-stricken Orpheus was extensively used in nineteenth-century literature and operas. The artist showed Orpheus positioned among the trees that he is said to have charmed with the sound of his lyre and expressing his misery at the loss of his wife, Eurydice, to the underworld. A preliminary drawing (fig. 38) and the location of a photograph of the original state of the painting (fig. 39) documents that Dagnan-Bouveret originally included the figures of the Maenads, the frenzied Thracian women who came upon Orpheus during his wanderings and tore him apart limb from limb to satisfy their thirst for blood. These figures were painted out at the request of the first owner of the painting, L. Weiler.[22] The feeling of impending tragedy, resulting from the Maenads' attack of Orpheus, has been replaced by the artist with a concentration on the gentleness of the musician, who seems lost in his own anguish, oblivious to everything but his own sense of misery. The figure of Orpheus in the final canvas, with his skin painted in warm flesh tones, his body emerging seductively from the drapery, and the melodramatic gesture of the arm placed over his head, conveys an aura of sensuality and eroticism that, combined with the tragic theme, recalls the pathos of Michelangelo's sculptures, which the

FIGURE 37

Orpheus's Sorrow, 1876.
Oil on canvas. 59 x 42 1/2 in.
(150 x 108 cm). Signed lower
right: P.A.J. DAGNAN-
BOUVERET. Musée des
Beaux-Arts, Mulhouse.

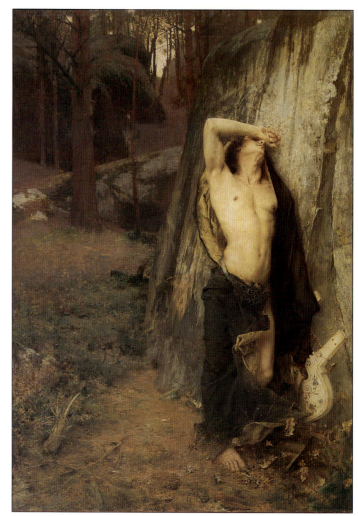

artist would have studied from plaster casts at the Ecole.[23] Completed at a time when Dagnan-Bouveret was exhibiting additional mythological works, this *Orpheus* raises the issue of how far an academic painter could go in treating an erotic theme that had troubling overtones of horrific violence and overt sexuality.[24]

Upon returning to the Ecole in 1878, both Dagnan-Bouveret and Courtois met with their teacher, Gérôme. He encouraged them to compete again in the Prix de Rome competition, assuring them that they were both capable, but adding that if they did not succeed this time, they should leave the Ecole and strike out on their own.[25] For the contest, Dagnan-Bouveret was given the fifth position *en loge*, where he found himself in competition with Courtois and Henri Doucet. His sketch (fig. 40) of the chosen theme, titled *Auguste au tombeau d'Alexandre* (*Augustus at the Tomb of Alexander*) shows Augustus kneeling tenderly alongside the body of Alexander in order to place a laurel crown on his head. As the competition evolved, neither Courtois nor Dagnan-Bouveret won; the prize was awarded to François Schommer, whose painting (fig. 41) carefully followed the initial plan of his sketch. Dagnan-Bouveret's failure to win the Prix de Rome three years in a row was undoubtedly a blow to his sensitive nature. Each year he saw his ranking decline;

he was beaten either by artists who had strong political connections or by those whose careers needed more of a jolt than his. That Courtois also lost that year implies some political maneuvering at the Ecole. It must have been difficult to see the Prix de Rome go year after year to painters with little staying power and even less imagination, as in the case of François Schommer in 1878.[26]

Of some comfort after losing the Prix de Rome was the selection of his *Atalanta* to be exhibited among the works representing France at the Paris Exposition Universelle of 1878. A third-class medal for the painting was public recognition of his considerable talent at exactly the moment he broke from the control and dominance of the Ecole des Beaux-Arts. It is also apparent that at this time the artist was trying to decide how to proceed with his career. The huge display of paintings from France and other countries at the 1878 exhibition would have been a reminder of the various avenues an artist might pursue. He could become a portraitist, a direction already established, especially in his studies of his grandfather; he could integrate the innovations of the younger plein air painters and become a landscapist; or he could become a painter of genre scenes and still lifes (fig. 42) in order to satisfy the growing demand for such pictures. Unwilling to take one path, Dagnan-Bouveret hedged his bets—he set out in all directions simultaneously.

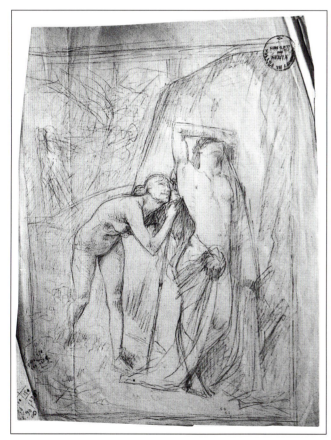

FIGURE 38

Orpheus's Sorrow, 1876. Preparatory pencil drawing on tracing paper for the original version of the painting. 13 x 8 in. (33.2 x 20.4 cm). Private collection.

FIGURE 39

Orpheus's Sorrow, ca. 1876. Photograph of a detail of the original version of the painting. Archives Départementales de la Haute-Saône, Vesoul.

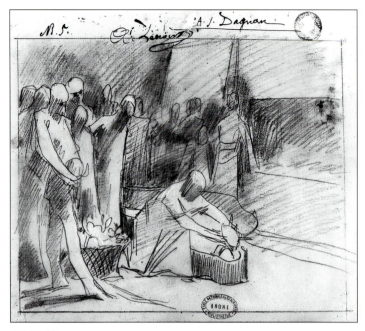

FIGURE 40

Augustus at the Tomb of Alexander, 1878. Preparatory drawing on tracing paper for the Concours de Rome of 1878. 10 1/2 x 13 1/8 in. (26.6 x 33.4 cm). Ecole Nationale Supérieure des Beaux-Arts, Paris.

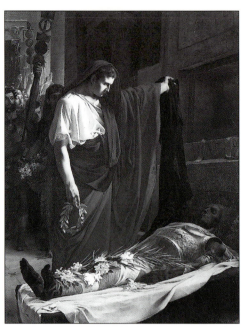

FIGURE 41

François Schommer, *Augustus at the Tomb of Alexander,* 1878. Oil on canvas. 57 9/16 x 44 3/4 in. (146.5 x 113.7 cm). First Prix de Rome in 1878. Ecole Nationale Supérieure des Beaux-Arts, Paris.

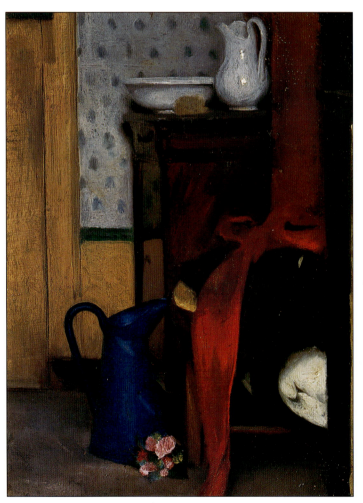

FIGURE 42

Still Life—Interior, not dated. Oil on canvas. 9 7/8 x 6 1/8 in. (25 x 15.6 cm). Private collection.

FIGURE 43

Portrait of M. de Rochetaillée, 1877. Oil on canvas. 43 1/2 x 34 1/4 in. (110.5 x 87 cm). Signed and dated lower left: P.A.J. DAGNAN-BOUVERET Sept. 1877. Collection Joey and Toby Tanenbaum.

A search for private patrons led him to the Rochetaillées, wealthy landowners who lived in Echenoz-la-Méline, not far from Vesoul.[27] They may have first been known to Gérôme, who might have suggested his students Courtois and Dagnan-Bouveret as able portraitists.[28] The latter executed two paintings, one of which survives and was exhibited in the 1878 Salon, *M. de Rochetaillée* (fig. 43). This vibrant likeness, in which Rochetaillée assumes a pose similar to that of Bertin in the portrait by Ingres—with hands on knee and table—conveys an atmosphere of tense expectation. The sitter's gaze moves away from the newspaper he was reading, as if Rochetaillée is expecting the arrival of an unseen visitor.[29] This work, along with a study on wood panel of his fiancée, Anne-Marie Walter (fig. 44), done in 1878, reveals Dagnan-Bouveret's superb abilities as a portraitist. This small

FIGURE 44

*Portrait of His Fiancée,
Anne-Marie Walter,* 1878.
Oil on panel. 6 x 5 1/8 in.
(15.4 x 13 cm). Musée
Georges Garret, Vesoul.

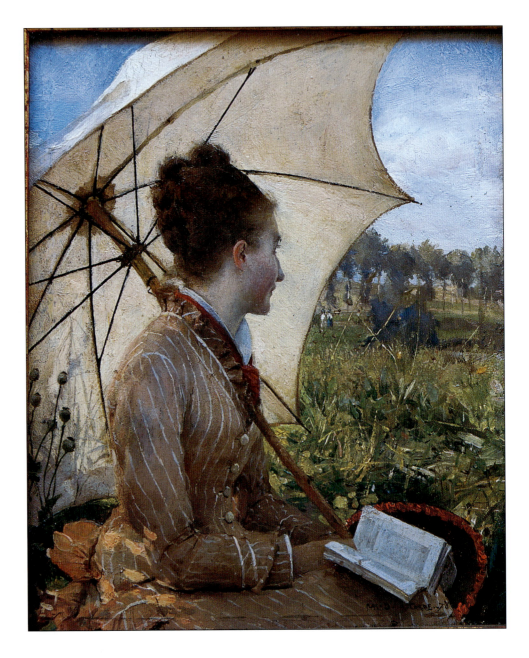

work in particular demonstrates a genuine sensitivity to light and atmosphere, revealing that the artist, even at this early moment in his career, had moved beyond the boundaries of lessons learned at the Ecole des Beaux-Arts. The unusual angle of his fiancée's pose suggests that a photograph was used as a model; and the size of the portrait is close to that of a glass-plate negative. This diminutive painting exemplifies the new course that Dagnan-Bouveret was exploring in his art, one that would make use of contemporary technologies. While his training at the Ecole had been thoroughly conventional, it did not crush his imagination nor inhibit his desire to take academic painting in new directions.

Re-creating Genre III
Making a Popular Reputation, 1879–1881

By the time that Dagnan-Bouveret began producing contemporary genre paintings in the late 1870s, the validity of this category and the question of whether historical reconstructions alone should constitute it was hotly debated.[1] The market was flooded with a wide range of innovative themes, often painted with vibrant energy and a pre-cinematic instinct of how to engage an audience. Hundreds of young artists made such pictures; demand for them was high, since the new middle-class collectors wanted works that were easy to understand and that addressed issues (actual or imagined) pertinent to Third Republic ideology. Buyers of genre pictures were looking for pictorial narratives with a humanitarian emphasis for the walls of their homes or for placement in public buildings. Genre paintings were produced at a rapid rate and in all sizes; the small scale that was once a hallmark of genre painting, in the period of the July Monarchy, for example, became a thing of the past. Now scenes of daily life, which earlier had been considered unworthy of prominent exposure, replaced historical, religious, or mythological compositions. By the middle of the 1880s, this shift in taste prompted Dagnan-Bouveret to work on increasingly larger canvases and to consider themes never before depicted in paint. The popularity of genre paintings paralleled developments in the print media, which began to cater to sentiments of a new readership, with stories often being serialized in newspapers before being published in book form. The entertainment value of genre painting was grasped by some painters, including Dagnan-Bouveret. Many followed Gérôme in the creation of pre-cinematic effects (as, for example, in his historical reconstructions of Rome), and others used a wide-angle view, influenced by images taken with a sequential and continuous frame of reference.[2]

Dagnan-Bouveret's move toward genre painting was undoubtedly encouraged by Gérôme, whose own historical reconstructions had earned him popular acclaim, both in France and internationally.[3] Where the pupil and his mentor differed was in the belief that a genre painter should restrict himself to themes from the ancient past or from recent history. The younger artist preferred themes with a contemporary immediacy, showing various aspects of nineteenth-century French society or rendering episodes from popular literature.

He began his ascendancy as a "modern" genre painter with his version of *Manon Lescaut* (fig. 45), exhibited at the Salon in 1878. The theme inspired many artists of the era in numerous fields—literature, music, and painting—including Maurice Leloir, whose painting of 1892 attests to the continuing interest in the subject (fig. 46). Drawing on the well-known novel by Abbé Prévost published in the eighteenth century, he focused on the Romantic theme of frustrated love and loss, which was manifested in a burial scene that took place on the plains along the Mississippi.[4] Courtois may have helped his friend construct the impressive panorama, since this artist worked on a large scale. For the protagonist Des Grieux, he had his brother Gabriel serve as model, as we know from a preliminary drawing (fig. 47).[5] In the finished version, the youth is idealized, although his expression of grief has been intensified to achieve the desired Romantic emotional impact. The drawing anticipates the naturalist direction the painter would follow later; the finished work intimates that he could not yet break away from using Romantic imagery. The painting brought him considerable public acclaim, a third-class medal at the Salon, and his first contact with the firm of Goupil et Cie, major art dealers who promoted their clients' works through reproduction.[6] *Manon Lescaut* was also widely publicized

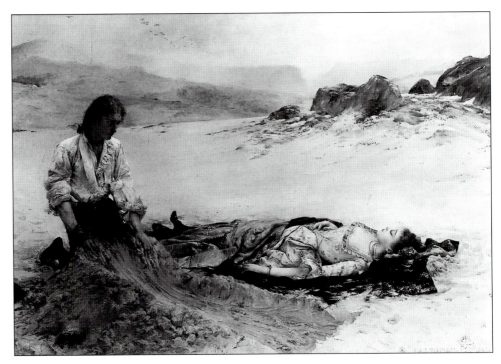

FIGURE 45

Manon Lescaut, 1878.
Oil on canvas. 27 1/2 x 39 in.
(70 x 99.2 cm). Reduction of
the painting exhibited at the
Salon of 1878. Signed and
dated Paris Sept.–Oct. 1878.
Present location unknown.

Against the Modern

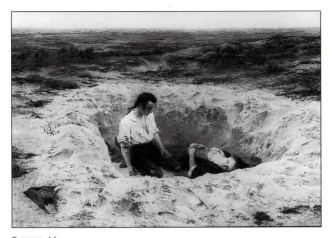

FIGURE 46

Maurice Leloir, *Manon Lescaut,* 1892. Oil on canvas. 41 1/2 x 63 3/8 in.
(105.5 x 161 cm). Signed and dated lower right: Maurice Leloir, 1892.
Dahesh Museum of Art.

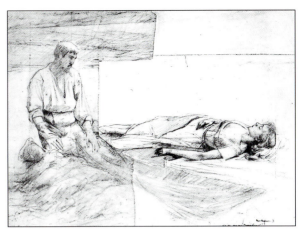

FIGURE 47

Manon Lescaut, not dated. Preparatory squared pencil drawing.
2 1/2 x 3 3/8 in. (6 x 8.6 cm). Signed lower right: P.A.J. Dagnan-B.
Present location unknown.

when it appeared in *L'Illustration* on December 7, 1878. His career as a genre
painter of such popular themes was effectively launched through his personal con-
tacts, initially through Gérôme, combined with his use of the media.

At the end of the 1870s, he was finishing two important canvases in his develop-
ment as a genre painter: *La noce chez le photographe* (*Wedding at the Photographer's*)
(fig. 48) and *L'accident* (*The Accident*) (figs. 49 and 50). The former was exhibited
at the Salon in 1879, the latter in 1880; both were photographed and engraved by
Goupil.[7] *Wedding at the Photographer's* is a valuable commentary on the new craze
for portrait photographs, which promised to document individuals and formal

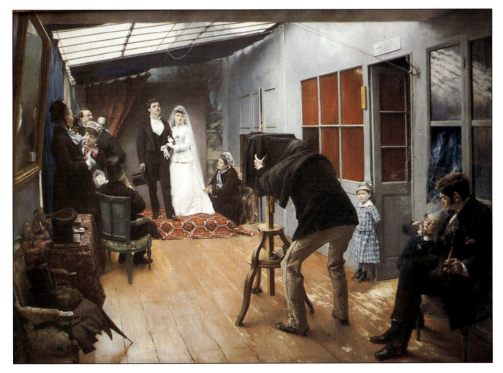

FIGURE 48

Wedding at the Photographer's,
1878–1879. Oil on canvas.
34 x 47 7/8 in. (86.4 x
121.9 cm). Signed and dated
lower left: P.A.J. DAGNAN-
BOUVERET/Paris 1878–79.
Musée des Beaux-Arts, Lyon.

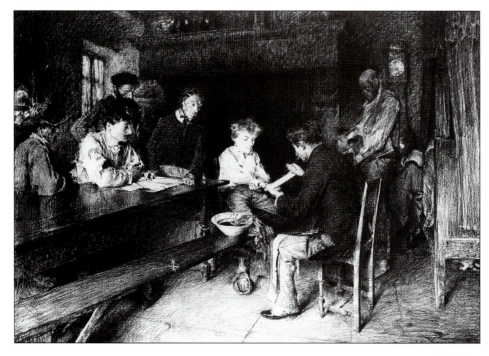

FIGURE 49

The Accident, 1880. Charcoal. Drawing after the painting dated 1879. 12 3/8 x 17 3/8 in. (31.3 x 44 cm). Signed lower right: P.A.J. Dagnan-B. Département des Arts Graphiques du Louvre, Fonds Orsay, RF 23363. Photograph: Réunion des Musées Nationaux/Art Resource, New York.

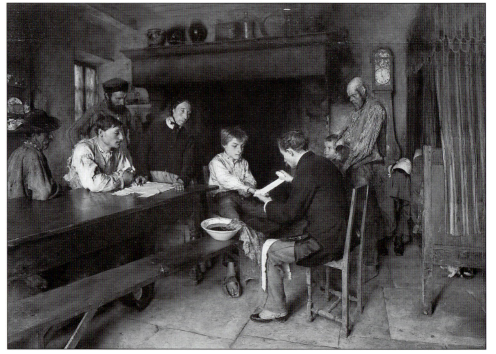

FIGURE 50

The Accident, 1879. Oil on canvas. 35 5/8 x 58 1/8 in. (92.5 x 130 cm). Signed and dated lower right: P.A.J. DAGNAN-B 1879/ Pasavant-sur-Corre (Haute-Saône). The Walters Art Museum, Baltimore. Photograph courtesy the Walters Art Museum.

family occasions for posterity with a degree of verisimilitude hitherto unimaginable. The scene is the inside of a photographer's studio, where a young man and woman are being photographed in their wedding finery. The anecdotal interest of the work shifts from the couple to several humorous vignettes that occupy different sections of the composition. These include a young girl in blue dress watching poutingly what is occurring inside the studio and the photographer going about his work completely oblivious to everything around him. The painting, as was noted by contemporary critics, responded to the public's interest in verisimilitude—as demonstrated

by its fascination with photography itself. The artist recorded objects in microscopic detail, for example, the mirror at the left, in which there is a small calling card advertising the photographer and giving his address in Vesoul. This detail would have gone unnoticed except by those close to the artist. Even though Paris is given in the inscription as the place where the work was completed in 1878–1879, we know from letters that the painter was spending more and more time in the Haute-Saône region near Vesoul, its capital.

Since Dagnan-Bouveret wrote about the painting in a letter to Anne-Marie in early 1879, it is also known that he researched the theme before beginning the composition. He actually visited the studio of a photographer in Paris and made a small study of the rooms (perhaps more than one), in order to explore the way in which the background could be integrated with his figures.[8] He also had the Parisian photographer take his picture, which he eventually sent to his fiancée along with a photograph of his canvas *Manon Lescaut*.[9] When *Wedding at the Photographer's* was exhibited at the Salon, it was extremely well positioned and received many compliments. Yet the artist had a nagging sense of doubt about the picture, thinking it perhaps too clever; he was also troubled that the Salon had become too much of a showplace, where artists tried to outdo their peers.[10]

His success was assured, however, when *Wedding* was published in *L'Illustration*. In a letter to his fiancée of June 1879, he wrote that the painting had been sold for six thousand francs to Jacques Bernard, who was then the mayor of La Guillotière, near the city of Lyon.[11] From family correspondence it is apparent that the painter had hoped to sell the work for a higher price, but as Bernard's offer was the only one, he decided to take it.[12] Bernard intended to form a museum with his painting collection, and this work was among those he eventually gave to the Musée de Lyon.[13] Despite the attention in the press and the sale of the painting, the artist was agitated. The public reaction to *Wedding* was not the type of acclaim he sought. He wished to be recognized as a serious painter and did not want to be accused of pandering to common taste or of creating purely anecdotal scenes. His concern went to the core of what a genre painter *ought* to paint and what the public expected from him. It also reflects the thematic restrictions faced by academically trained painters, given the growing materialism of the Third Republic.

Wedding precipitated a crisis in Dagnan-Bouveret's artistic development. In "La vie," a chronicle by Marie Legrand based on later discussions with him, the painter recounted how he had settled on the composition by visiting a photographer on avenue des Ternes in Paris, and how he had gone to the Salon to witness the crowd's reaction to his painting. Arriving on a busy Sunday, the painter became distressed. The people congregating in front of his work were only commenting on the story, not on the way in which the work had been painted. He recalled that he immediately went to speak with Gérôme, who told him frankly that the composition was unworthy of him and cautioned him to "stop in his tracks . . . as he was made for something else."[14] Although Dagnan-Bouveret did not immediately cease producing

such anecdotal images, he resolved then to produce works with more profound meaning.

With *The Accident,* he shifted his focus. He was newly married at the time the work was in gestation and he had spent about a year with his family in the Franche-Comté, where it has been assumed that he witnessed the scene depicted in the painting.[15] It is the first important example in which the artist focused on the life of peasants or working-class people on a large scale.[16] A family is seated around a rustic table in the crowded kitchen of a farmhouse while a boy is having his arm bandaged by the local doctor. Each of the figures in the composition, from the boy to the older men and woman, are intensely studied from life. His models presumably came from Mélisey, a village near Vesoul, in the Haute-Saône.[17] These authentic peasant types endow the painting with the intensity, sincerity, and extraordinary power that was noted by critics when it was hung in the 1880 Salon.[18] The interior of the farmhouse kitchen, with details such as the pots and pans and the porcelain water basin, is conveyed with the same precision and verisimilitude found in the background of the photographer's studio in *Wedding.* What is different here is the sense of gravity; there is nothing comical about the scene because the artist has focused on the effect that the incident has had on the boy and his family.[19] The range of emotional reactions is more varied and subtler than in *Wedding.* Another difference between the two canvases is the painting technique: in *The Accident* the surface is rougher than it is in *Wedding* or even in the earlier *Petit savoyard déjeunant sous une porte* (*Young Savoyard Eating under a Door*) (1877). *The Accident* can be considered Dagnan-Bouveret's first naturalist painting;[20] it essentially broke new ground in his oeuvre and brought him closer to his goal of being recognized as a serious genre painter.

The artist received considerable press attention in the leading Parisian newspapers and gained a first-class award from the Salon jury. Nevertheless, a few critics believed that too much attention had been given to the bloody bowl on the bench in the foreground.[21] The splattered blood on the edges of the bowl was a bit too graphic for them. However, the general reaction was that Dagnan-Bouveret had achieved a significant place among the leading painters of the day.[22] The positive reception of the theme led the artist to work on several variants of the composition. Among them was a *fusain* (a drawing completed in various tones of dark and light), which closely mirrors the finished Salon painting, and which is signed and dated 1880. It is likely that it was done in order to provide a black-and-white image of the composition for reproductive purposes. A variant of the painting in oil was finished in Corre in 1880 (fig. 51). In the second version, attention has shifted to one side of the composition, leaving only a grieving older man at the right.[23] This painting could have been commissioned by another patron who wanted a version of the Salon success for his own collection. Its existence is evidence of the demand for multiple versions of popular compositions by nineteenth-century academic painters.

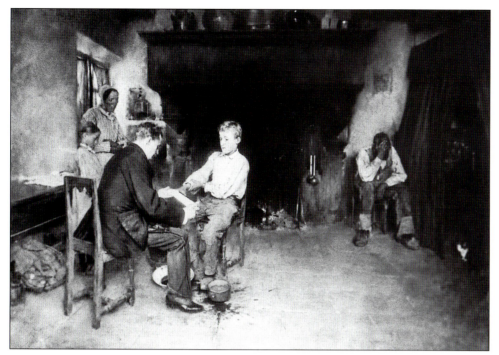

FIGURE 51

The Accident, 1880. Oil on canvas. 32 1/4 x 45 1/2 in. (81.9 x 115.6 cm). Signed and dated lower right: P.A.J. DAGNAN-B/Corre 1880. Different version of the 1879 painting. Present location unknown.

A version of the Salon painting was purchased by George A. Lucas for William Walters, who eventually founded the Walters Art Gallery.[24] It thus became one of the earliest of the artist's works to find a permanent home in a collection or museum in the United States.[25] It was not to be the last, for Dagnan-Bouveret, like Gérôme, soon attracted an international audience for his compositions.

The year 1879 found the artist working on a drawing that was eventually reproduced in *Le Monde Illustré* (1881) (fig. 52).[26] His subject, *Un charmeur d'oiseaux au jardin des Tuileries* (*A Bird Charmer in the Tuileries Gardens*), depicted a typical sight in Parisian parks and gardens. The Tuileries Gardens, restored as a public garden after the destruction of the central part of Paris wrought by the havoc of the Commune, had begun to return to normal; people could now stroll or sit in the gardens, and performers came to entertain them. The drawing re-creates a cross-section of Parisian society: there are *flaneurs* in the background, an old man and his grandchild at the right, a young girl and her grandmother near them, a worker with a basket over his head, and, in the foreground, leaning on an umbrella, an artist. All the figures are heavily bundled against the cold, and the trees are bare, suggesting a winter day. Intended to illustrate a story in the pages of *Le Monde Illustré,* a widely read popular journal of the time, the drawing demonstrates an academically trained painter using his talent for reportorial scenes to satisfy a growing clientele and as a means of expanding his repertoire. Other Salon painters also made drawings for illustration, as it gained them attention and commissions from the owners and readers of the various popular magazines. The drawing was also reproduced as a separate work by Goupil.[27]

At this time, both avant-garde and more traditional painters were recording aspects of urban life, including Dagnan-Bouveret's competitor Jean Béraud, a painter

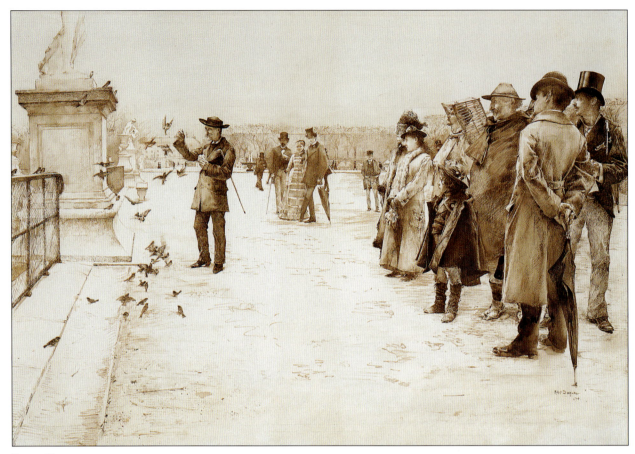

FIGURE 52

A Bird Charmer in the Tuileries Gardens, 1879. Brown ink and ink wash on white paper, mounted on board. 17 x 24 1/3 in. (43.2 x 61.8 cm). Signed and dated lower right: P.A.J. Dagnan, 1879. Chrysler Museum of Art, Norfolk, Virginia, Museum Purchase.

who was trained by Léon Bonnat and who specialized in street scenes that often showed individuals moving through the Place de l'Europe or through rain-swept streets after a funeral.[28] Gustave Caillebotte—an artist closely linked with the impressionists—also painted street scenes featuring, for example, storefront painters, strollers in the rain, or crowds of people moving across the Pont de l'Europe. By the end of the 1870s, Parisian life in its delightful variety provided themes for painters from all parts of the art world.[29] Dagnan-Bouveret's drawing, which is neither overtly sentimental nor satirical, shows the artist to be a preeminent painter of modern subjects. Drawings such as *A Bird Charmer,* a highly finished sheet that is a work of art in its own right, contributed to the enhancement of his reputation, given its contemporaneous theme and its wide circulation in the media.

At the beginning of the new decade, the painter's interest in naturalism remained strong. He completed another highly finished drawing, now lost, which was inspired by Emile Zola's *Nana.* The novel had engendered considerable discussion in the press since Zola's use of settings to suggest character was controversial.[30] The drawing depicted Nana in the Parc Monceau, then and now one of the most fashionable parks in Paris and one surrounded by the homes of wealthy Parisians.[31] A second composition, a painting titled *La blanchisseuse* (*The Laundress*) (figs. 53, 54), was finished in 1880; it could be the work that now goes under the name of *Sur les quais de Paris en automne* (*On the Quays of Paris in the Fall*).[32]

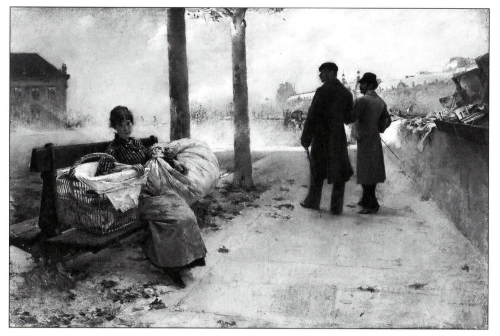

FIGURE 53

The Laundress, 1880. Oil on canvas. 13 1/2 x 20 1/2 in. (34 x 51cm). Signed and dated lower left: P.A.J. Dagnan-B /1880. Pyms Gallery, London. Photograph Courtesy Pyms Gallery.

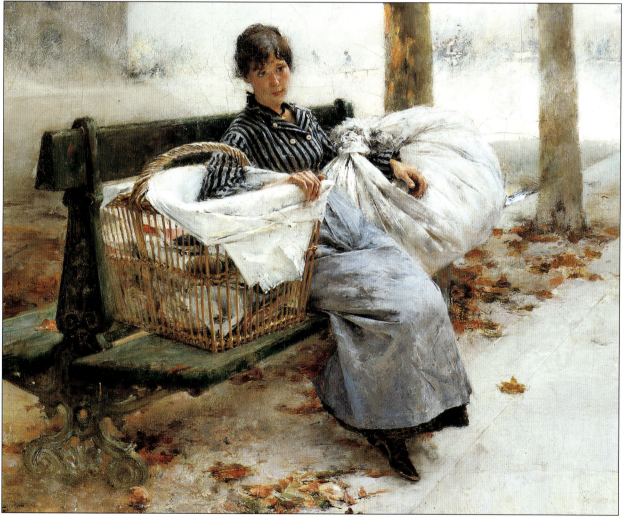

FIGURE 54

The Laundress, 1880 (detail).

In this canvas, Dagnan-Bouveret focused on several themes that are characteristic of this period in his development. The motif of the laundress had been treated by his contemporaries as a symbol of working-class travail, squalor, and prostitution.[33] While Dagnan-Bouveret's laundress is certainly burdened by her chores, weighed down by two huge bundles of clothes, her respectable dress and demeanor undermine any attempt at social criticism. Since the young woman averts her gaze from the gentlemen strollers at the right, and from the viewer of the painting, she conveys a melancholy detachment that romanticizes her within the urban setting. By contrasting the hardworking laundress with the well-dressed men of evident leisure, the artist gives the impression of seeming to be more interested in social satire than in social criticism.

The setting of the Louvre in the distance, and the Institut at the left, indicates that these two fashionable dandies, dressed in long coats and carrying walking sticks, are well-to-do art students, painters trained at the Ecole des Beaux-Arts out for a stroll along the *quais*.[34] This is further suggested by a small portfolio held by one of the men. In fact, the two art students can be identified as friends of the artist, namely, Gustave Courtois, the tall figure at the left, and his close companion Karl von Stetten, the short figure at the right. In the 1880s, as Dagnan-Bouveret was becoming fully committed to the selection of naturalistic themes and to reading and illustrating novels by Zola and Alphonse Daudet, Courtois remained unaffected by these modern trends. While Dagnan-Bouveret would always support Courtois—he painted his portrait in 1883 and 1884 (fig. 55)—Courtois was forging new friendships. Some years earlier he had made the acquaintance of von Stetten, a young, debonair Bavarian painter who had come to Paris for his training.[35] Courtois and von Stetten were close throughout their lives and established a homosexual relationship—a relationship strongly intimated in this work by their common friend, who painted them locked arm in arm. Just as the strolling artists are not tempted by the laundress in the painting, in real life they seldom depicted themes including such figures in their own work, choosing instead to portray a higher stratum of society. Dagnan-Bouveret, however, by prominently featuring the laundress, albeit in an amusing way, refers to his divergent path; indeed, *The Laundress* can be read as an allegory representing the artist's adoption of a new naturalism and symbolism in his art.

The painting, which was not exhibited in the nineteenth century, underscores how the painter was now constructing his genre scenes, using people and incidents from his own life, to create images that resonated with personal symbolism. The work possesses a degree of visual wit that could be appreciated only by the artist's circle of friends, thereby constituting an in-joke that was both amusing and ironic. Here were members of the elite of the Ecole des Beaux-Arts—Courtois and von Stetten—who, in confronting artistic challenges outside their own frame of reference, maintained a haughty reserve. This satiric visualization also reveals Dagnan-Bouveret's increasing awareness of the need to reform the academic tradition.

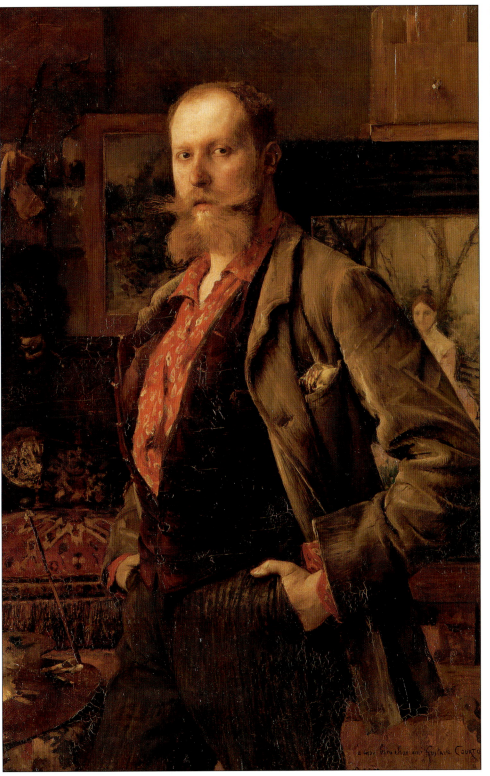

FIGURE 55

Portrait of Gustave Courtois, 1884. Oil on canvas. 48 x 32 1/4 in. (122 x 82 cm). Signed and dated lower right: à mon bien cher ami Gustave Courtois/P.A.J. Dagnan-B Paris 1884 Janvier. Musée des Beaux-Arts et d'Archéologie de Besançon.

The artist's training at the Ecole included copying in the Louvre galleries.[36] Armed with official letters from their teachers, art students gained permission to paint from specific canvases. They were forbidden to work on the same scale as the original canvas and, at any given time, young painters gathered in front of some of the best-known masterpieces, including Antoine Watteau's *Embarkation for*

FIGURE 56

At the Louvre, 1881. Oil
on panel. 14 x 12 in. (35.5
x 30.5 cm). Signed lower left
on back of painted canvas:
P.A.J. DAGNAN. The State
Hermitage Museum,
St. Petersburg.

Cythera. Inspired by this tradition, Dagnan-Bouveret produced his small panel of *Au Louvre* (*At the Louvre*) (fig. 56) in 1881, perhaps as a commentary on the practice of allowing women—who were not admitted to the Ecole—into the museum to pursue their artistic inclinations.[37]

Dressed in a fashionable pink dress, with her hat attached to the back of her easel, a young woman is intently painting a fan-shaped watercolor based on details observed in Watteau's composition. Her open paint box and the fact that there are several small canvases leaning against the back wall under the Watteau suggest that this woman is a member of a class that had been permitted to work inside the galleries. She most likely knew Dagnan-Bouveret—who became a teacher at the Colarossi Academy in the mid-1880s—and could easily have been his private pupil, following the practice of a number of younger Salon painters. While the Ecole des Beaux-Arts was closed to women until the late 1890s, the Académie

FIGURE 57

At the Louvre, 1880. Pen and ink and chalk. 14 1/4 x 10 1/2 in. (36.2 x 26.7 cm). Signed and dated lower right: P.A.J. Dagnan-B 1880. Hazlitt, Gooden and Fox, London. Photograph courtesy Hazlitt, Gooden and Fox.

FIGURE 58

Illustration from *Oeuvres complètes d'Alphonse Daudet—Froment Jeune et Risler Aîné, Moeurs parisiennes*. Alphonse Daudet, *Oeuvres complètes*. Paris, 1881.

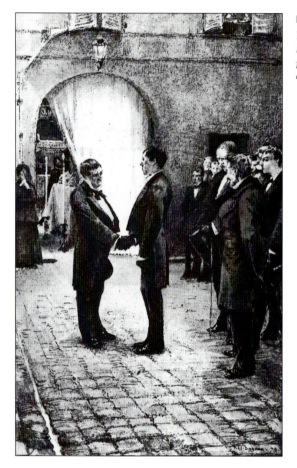

FIGURE 59

Illustration from *Oeuvres complètes d'Alphonse Daudet—Froment Jeune et Risler Aîné. Moeurs parisiennes.* Alphonse Daudet, *Oeuvres complètes.* Paris, 1881.

Julian had been training them from the late 1860s on.[38] In *At the Louvre,* the artist sensitively handles the issue of the influx of these women art students in the final decades of the century, again showing that he was an artist of his time.[39]

At the Louvre served as the basis for an engraving in the July 1883 issue of *L'Illustration.*[40] The composition, developed from a preparatory drawing (fig. 57), was modified to include a matronly companion sitting at the left and, at the right, a male painter watching the female student. In transforming the scene into one that implies a prospective romantic relationship, the artist has shifted away from his earlier focus on the position of women art students within the academic tradition.

A devotee of the writings of Daudet, Dagnan-Bouveret completed two illustrations (figs. 58, 59) that were reproduced in facsimile for the 1881 edition of *Oeuvres complètes d'Alphonse Daudet—Froment Jeune et Risler Aîné, Moeurs parisiennes.*[41] Like his Salon paintings done in the late 1870s, these two drawings include richly observed settings and clearly understandable characters and action. These images also reveal that he was moving into the circle of naturalist writers, critics, and visual artists in Paris. He began to paint fewer small scenes depicting social mores in favor of much larger, more complex compositions that represented actual locales or specific events. In his new large-scale works, dramatic contemporary scenes would be strikingly enhanced through the new medium of photography. Dagnan-Bouveret's genre painting was entering a new phase.

Photographic Verisimilitude
New Dimensions for Genre Painting, 1882–1886

W ith his reputation growing at the Salon and in the popular media, and with people asking to sit for their portraits, the young painter found himself much in demand during the 1880s.[1] At this time, Dagnan-Bouveret entered fully into the orbit of the new naturalist circle of painters, best represented by his friend Jules Bastien-Lepage.

By the end of the 1870s, Bastien-Lepage was truly a phenomenon, a painter whose imagery and working methods were exerting a tremendous impact on the younger generation of academic artists.[2] A critic reviewing the 1882 Paris Salon for the English *Art Journal* noted "the many, and often clever, imitations [in] the style of Bastien-Lepage."[3] The painter was touted in France by such powerful critics as Albert Wolff; indeed the extensive coverage of his career in the press bordered on idolatry. A year after his tragic, early death in 1884, a retrospective exhibition at the Hôtel de Chimay in Paris only enhanced his reputation.[4] Some critics cast the unfortunate painter as a martyr for naturalism, presenting him as an artist who had literally worked himself to death attempting to complete his exceptionally large canvases. This idea was reinforced by such monumental, tour-de-force naturalist compositions as *The Haymakers* (Musée d'Orsay, Paris) and *The Potato Gatherers* (National Gallery of Victoria, Melbourne) (fig. 60).

Neither preparatory drawings nor preliminary oil sketches can account for the impression of immediacy in Bastien-Lepage's Salon scenes. The only plausible explanation is that he used photography to give the illusion that figures were "alive," as was often commented upon by critics.[5] After transferring his life-size figures to the canvas, he re-created the broad, luminous landscape of a rural area and his native locale in northeastern France.

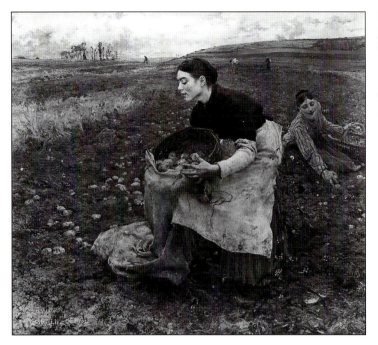

FIGURE 60
Jules Bastien-Lepage,
Potato Gatherers, 1878.
Oil on canvas. 71 x 78 in.
(180.7 x 196 cm).
National Gallery of
Victoria, Melbourne,
Felton Bequest 1927.

Bastien-Lepage was in the vanguard of a group of artists trained at the Ecole des Beaux-Arts who were increasingly working outdoors, sometimes posing models in glass studios, and using photography to assist in organizing their compositions. Paintings became increasingly larger, with figures assuming poses that could only have been captured by a camera, since they showed split-second movement. The incorporation of photography into academic painting created an entirely new "look."

Bastien-Lepage's *Potato Gatherers*, exhibited at the 1879 Salon, where his friend Dagnan-Bouveret was showing *Wedding at the Photographer's,* drew commentary from critics, who were impressed by the sense of light and air. The composition's broad expanse led Emile Zola to deem the artist "nearly the grandson of Courbet and Millet . . . the influence of the Impressionist painters is also obvious."[6] Two critics in particular sensed that Bastien-Lepage was working along highly innovative lines that would engage other Salon painters in the debate about the construction of scenes of rustic naturalism. Paul de Saint-Victor, an art critic since the 1860s, detected a photographic effect in the work.[7] Indeed, the instability of the pose of the primary figure gives the impression that Bastien-Lepage has transferred it from another source to his final canvas. More significantly, Octave Mirbeau, writing in 1885, noted that despite a superficial resemblance to Millet, little actually bound Bastien-Lepage's peasants to the earth they were working; they seemed to have been cut and pasted onto the canvas.[8] The practice of using photographs in the creation of Salon naturalist paintings was soon to be adopted by Dagnan-Bouveret and others, and it is clear that the problem of how to increase verisimilitude while at the same time avoiding overabundant detail was hotly debated by these young painters, most of whom had been close friends since their days at the Ecole des Beaux-Arts.

One work that clearly announces the painter's search for new themes and demonstrates his desire to move beyond anecdotal genre toward naturalism is his *Autoportrait* (*Self-Portrait*) done in the 1880s (fig. 61). Seated on a low camp stool, with an adjustable easel in front of him, the artist is working very close to the ground, near nature, with the option of raising or lowering his large canvas. He is dressed elegantly as always, in a white overcoat similar to a painter's smock, worn over a type of vest donned by Breton men. Surrounded by flowering plants, he subtly declares his adherence to the new tenets of the academic naturalists,

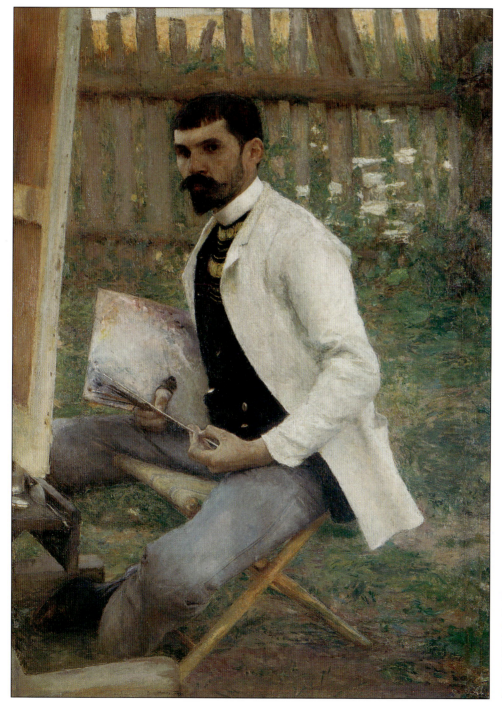

FIGURE 61

Self-Portrait, 1880s. Oil on canvas. 31 7/8 x 23 5/8 in. (81 x 60 cm). Signed and dated lower left: P.A.J. Dagnan-B 18(?) (illegible). Collection Jacques Fischer, Paris.

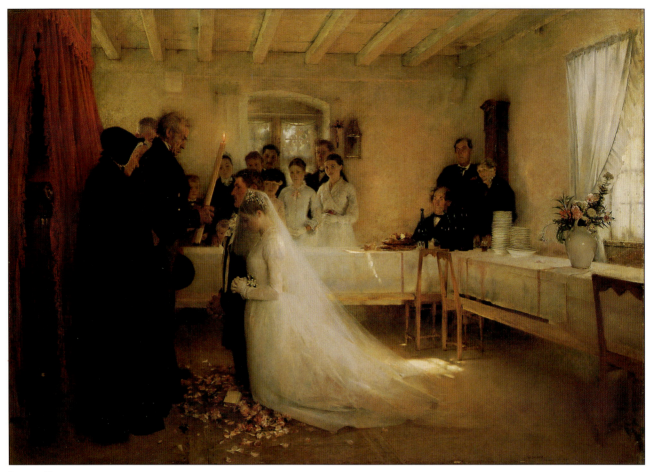

FIGURE 62

Blessing of the Young Couple before Marriage; Custom of the Franche-Comté, 1881. Oil on canvas. 39 x 56 in. (99 x 142.2 cm). Signed and dated lower right: P.A.J. Dagnan-B/Corre 1880–81. The State Pushkin Museum of Fine Arts, Moscow.

visualizing his own desire to paint from nature; from now on, his compositions will reflect ideas of the younger generation. He will continue to attend to detail, as suggested by the tiny brushes held in his hands, but fresh themes from the rural life of the Franche-Comté, his adopted region, will inform his new work. This painting, completed in Corre, the village where he worked during the spring, summer, and fall until 1886, speaks of the peace and solitude that he could not find in Paris. The annual stay in the country provided the painter with a wide range of contemporary rustic scenes that he drew either directly from observation or from his imagination.

In 1881–1882, the artist continued exploring naturalist themes with his *Bénédiction des jeunes époux avant le mariage; coutume de Franche-Comté* (*Blessing of the Young Couple before Marriage; Custom in the Franche-Comté*) (fig. 62) and *La vaccination* (*The Vaccination*) (fig. 63), paintings that he showed at the 1882 Salon and in the Exposition Nationale of 1883.[9] The second has a significant place in his work; the discovery of a photograph revealing models employed in the creation of the composition documents his use of photographic sources by 1882 (fig. 64).[10] In the first painting, inspired by a scene he had witnessed at Corre, he was responding to the current vogue for rustic scenes that recorded the customs of specific regions. The painter was clearly inspired by Bastien-Lepage, who recorded local traditions in his own work. *Blessing of the Young Couple* was a major success at the Salon and was

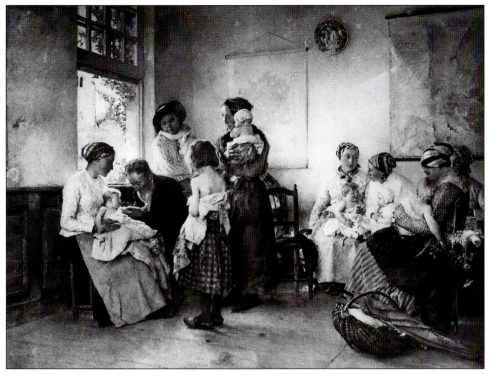

FIGURE 63

The Vaccination, 1882.
Present location unknown.
Archives Départementales
de la Haute-Saône, Vesoul.

photographed and sold to Goupil for about ten thousand francs.[11] Goupil then sold
it to a Moscow collector, Sergei Tretiakoff, who was developing a major collection
of contemporary paintings, thus enhancing the artist's international reputation.[12]

For the setting of this scene, the artist rented an empty space—formerly a gro-
cery store—in Corre to represent the *grande salle* of the Moulin de Corre.[13] He
depicted the specific moment in the traditional French wedding ritual when the

FIGURE 64

Photographer unknown, *Preparatory Photograph
for "The Vaccination,"* ca. 1881. Archives
Départementales de la Haute-Saône, Vesoul.

couple's family members give their blessings before going to church for the ceremony. The model who posed for the bride is the artist's wife, Anne-Marie Walter; and the parents, posed before the kneeling couple, are his parents-in-law.[14] Since Dagnan-Bouveret's marriage took place a few years earlier, in 1879, in Corre, the artist was probably recording his own wedding, albeit in retrospect, which had been based on long-standing regional traditions.[15]

The specificity of the locale, the reliance on an actual episode drawn from the artist's life, and the use of family members for models reveal his evolution toward an intensely personal approach to naturalism. The rural context also places him among a group of painters for whom country life was their primary source of inspiration. The solemn tone of the scene infused it with a deeper sense of purpose. When the painting was hung in Goupil's gallery in Paris, it was studied and admired by painters of the older generation, including Ernest Meissonier.[16]

By 1883, naturalism was the ascendant style, with Bastien-Lepage's canvases being increasingly discussed in the daily press and a large contingent of other naturalist painters, including Dagnan-Bouveret, following his lead. The latter's *Halte de camp volant (Gypsy Camp)* (fig. 65) focused on the preparation of a meal by a Gypsy family. The impression of poverty in the painting is enhanced by the motif of the young child being lifted from the back of an emaciated white horse. The scene appears to be set in the region outside Vesoul and might even show the village of Coulevon, thus referring to the artist's ties with Jules-Alexis Muenier. Such a rustic representation focusing on a family grouping might be encoded with religious references. Could this be an image of the Holy Family in the guise of a poor Gypsy family in rural France? As the naturalist movement grew in importance and strength, such artists as Léon Lhermitte and Jean-Charles Cazin portrayed scenes of everyday life, imbuing them with religious sentiment in an attempt to broaden their themes. Whether Dagnan-Bouveret's painting was meant to be understood in this way, it found its way to the Haseltine Galleries in Philadelphia, where in September 1885, it was purchased by John G. Johnson, a wealthy railroad magnate. Johnson was amassing a collection of contemporary painting and became a primary promoter of French Salon painting in America; he also emerged as one of the earliest collectors of Dagnan-Bouveret's works in the United States.[17]

Another picture painted in 1883 was *Une écurie (A Stable)* (fig. 66), a small, intimate work that documents the artist's growing interest in farming, especially the daily care of animals by the farmhands. Inspired by the stables at Nicolas Walter's mill in Corre, Dagnan-Bouveret observed life in the Haute-Saône much as a naturalist writer would. He recorded his impressions by making drawings of local sites, which were later used as motifs in his paintings. These quick studies served a function similar to that of descriptions written in notebooks by writers such as Zola, who would later use them in a novel. Even for some of his small works, including *A Stable,* he made sketches of details: the hanging lantern or the workman at right

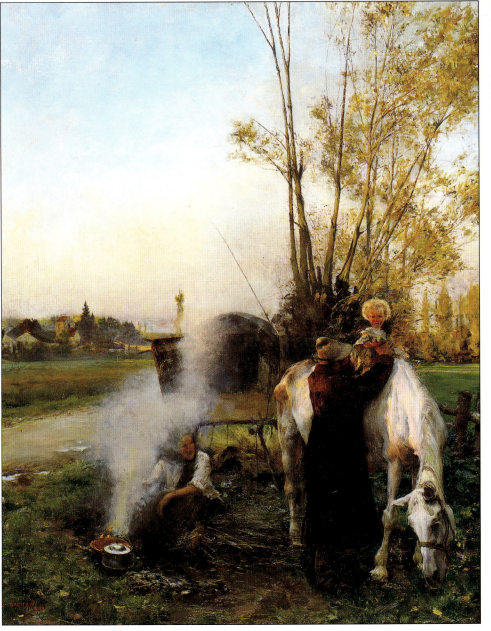

FIGURE 65

Gypsy Camp, 1883. Oil on canvas. 17 3/8 x 14 in. (44.1 x 35.4 cm). Signed and dated lower left: P.A.J. DAGNAN/1883. The John G. Johnson Collection: The Philadelphia Museum of Art.

holding a cigarette (fig. 67). These closely observed details heighten the illusion of reality.

Exactly when he began to regularly use photography in his work remains a topic of some discussion, especially in light of the discovery of a photograph used for *The Vaccination,* but it is apparent that he was aware of its possibilities by the early 1880s.[18] Discussions with Bastien-Lepage and with members of the naturalist contingent from the Ecole des Beaux-Arts undoubtedly strengthened his resolve to assimilate photographic viewpoints into his compositions. Since he was working in Corre, away from the pressures of Paris, it is likely that he experimented with new processes without worrying about the inquisitive eyes of those outside his family. That some of his earliest photographs, at least those that have been located, depict

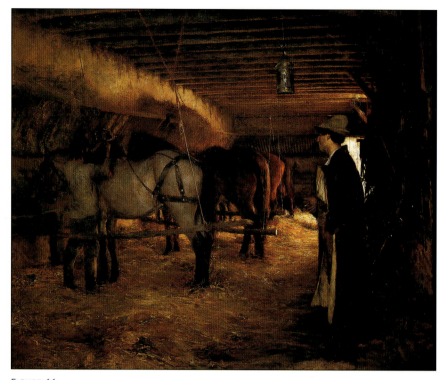

FIGURE 66

A Stable, 1883. Oil on canvas. 18 1/2 x 21 3/4 in. (47 x 55.2 cm). Signed and dated lower left: P.A.J. DAGNAN 1883. Collection Fred and Sherry Ross.

FIGURE 67

Standing Man, not dated.
Pencil on tracing paper. 9 1/2 x 5 in.
(24.2 x 12.7 cm). Study for *A Stable.*
Private collection.

the environment around his father-in-law's mill in Corre provides evidence that he experimented with this medium early on. Could the painter have set up a primitive photographic studio in Corre? Was this how he broadened his naturalist themes? In any event, the additive construction of the composition of *A Stable* makes it more than likely that he began to use photography at this time. Already in this work, he was integrating the academic process that entailed doing sketches for portions of a composition; the pose of one horse, in particular, would have been nearly impossible to capture without a camera to stop the action. Since the death of Bastien-Lepage in 1884, the naturalists had been looking for a new leader. The mantle of responsibility fell to Dagnan-Bouveret, who began producing larger, more imposing naturalist paintings destined for the Salon.

Between 1883 and 1885, the artist was working in three directions simultaneously. Still interested in creating paintings that recalled the Romantic tradition and that demonstrated his knowledge of serious literature, he began work on *Hamlet et les fossoyeurs* (*Hamlet and the Gravediggers*) in 1883 (fig. 68). His commitment to naturalism, revealed in his studies for *A Stable* in Corre, was further manifested in *Chevaux à l'abreuvoir* (*Horses at the Watering Trough*) of 1884 (fig. 69). This is the painting for which related, working photographs do exist. A new approach, one only slightly suggested earlier in the artist's work, was the deliberate attempt to infuse naturalist themes with religious, mystical overtones. This direction is exemplified by

his *Madonna with Plane* of 1885. In each of these paintings, the artist worked in several styles at the same time. The complexity of his vision was such that the Salon audience had difficulty keeping abreast of the changes in his compositions.

Perhaps the least innovative, and the closest to his early genre style, was *Hamlet and the Gravediggers,* for which his friends Gustave Courtois and Karl von Stetten posed for the principal figures. Beginning this painting in 1883, Dagnan-Bouveret quickly tired of his first version and reexamined the composition, in particular, the placement of the figures and their relationship to the background sky and architecture. These modifications he explained in a letter written to Courtois, who posed for the figure of Horatio, in August 1883.[19] Following his earlier *Laundress,* in which he tried to work in a style appropriate for a Salon artist, he settled on the lighthearted and somewhat satiric "troubadour style" for his painting of Hamlet.[20] The sumptuous garments and the noble sentiments of the two principal actors are sharply contrasted with the gnarled peasants in the foreground who have opened the grave.[21] The naturalist rendering of the gravediggers is the most effective section of the composition.

Painted for Jean-Léon Gérôme, the canvas was kept for a time in his collection before it was sold to George Baker, an American collector who patronized academic painters.[22] The painting became popularized through its reproduction in *Le Monde Illustré* and *L'Illustration* in 1884.[23]

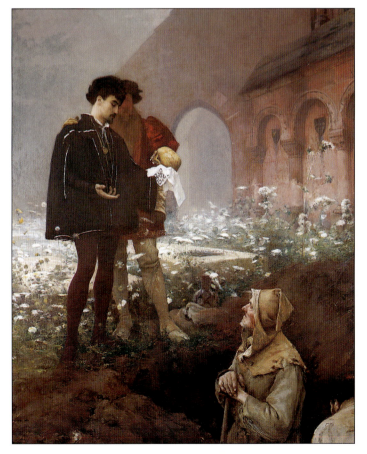

FIGURE 68

Hamlet and the Gravediggers, 1883. Oil on canvas. 40 x 33 5/8 in. (101.8 x 85.5 cm). Signed and dated lower left: P.A.J. Dagnan-B 1883. Edward Wilson Collection/ Fund for Fine Arts, Inc.

FIGURE 69

*Horses at the Watering
Trough,* 1884. Oil on canvas.
88 5/8 x 69 1/8 in.
(222 x 173 cm). Signed
and dated on the trough:
P.A.J. DAGNAN-B/1884.
Musée d'Art et d'Histoire,
Chambéry.

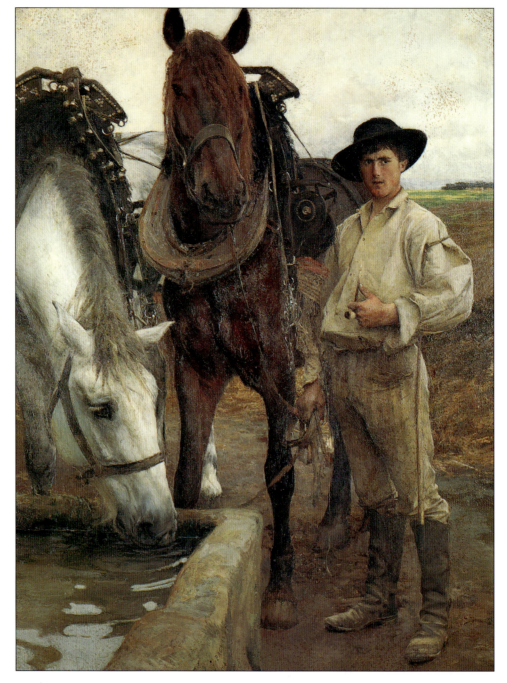

In contrast to his *Hamlet, Horses at the Watering Trough* marks a dramatic change in Dagnan-Bouveret's development as a painter. With this work he entered into a very complex relationship with photography, since it allowed him to distance himself, to objectify what he was painting. Photographs provided him with additional motifs for his compositions, serving as aide-mémoires when studio models or animals could no longer stand still or pose for him. By squaring paper prints made from small glass-plate negatives, he could transfer motifs to a large canvas while still retaining the accuracy of observation so strongly favored at the time.

Preliminary photographs taken in Corre on his father-in-law's property show how the artist's *Horses at the Watering Trough* evolved.[24] His theme, based on a common scene in the Haute-Saône, reflects the regionalism then being advocated by some Salon critics, who believed that French painters ought to immortalize their native regions.[25] One photograph, squared for transfer, shows the black horse from the finished painting, viewed straight on while being held by a farmhand (fig. 70). Other photographs (figs. 71, 72) reveal the horses in the exact poses that the artist used in his final composition. However, the specific setting of the courtyard of Walter's mill and the figure of his father-in-law do not appear in the final work.[26] These black-and-white prints are identified as "photo d'études pour les Chevaux d'Abreuvoir." Although no preliminary drawings have been discovered, it is likely that they once existed, for the new technology did not replace, but rather was integrated into, the painter's overall working procedure.[27]

In the completed painting, Dagnan-Bouveret situated the scene in an expansive landscape, replacing the well-dressed Nicolas Walter (from the photographs) with a farmhand dressed in high leather boots and holding a small pipe. As he casually secures the reins of the horses, one animal drinks from the watering trough in the

FIGURE 70
Photographer unknown, *Squared Preparatory Photograph for "Horses at the Watering Trough,"* ca. 1884. Archives Départementales de la Haute-Saône, Vesoul.

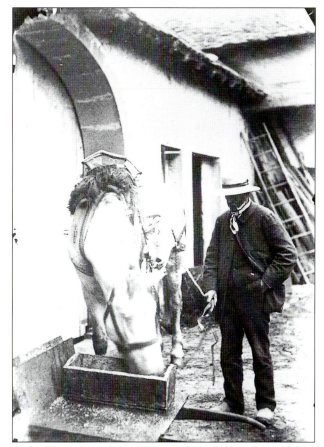

FIGURE 71
Photographer unknown, *Preparatory Photograph for "Horses at the Watering Trough,"* ca. 1884. Archives Départementales de la Haute-Saône, Vesoul.

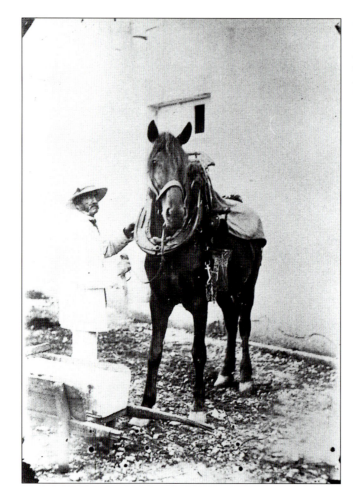

FIGURE 72
Photographer unknown,
*Preparatory Photograph for "Horses
at the Watering Trough,"* ca. 1884.
Archives Départementales de la
Haute-Saône, Vesoul.

foreground. Although the impression is created that the worker has just brought the horses back from the fields at the close of the day, in reality they were used to pull the family carriage. The model for the farmhand might have been employed from among Walter's assistants and asked to dress in the garb of a rustic field-worker. This highly effective illusion of life in a village of the Haute-Saône demonstrates that the artist had become a photorealist of considerable skill who could construct an image from a variety of sources yet maintain a unified impression of verisimilitude.

The *Horses at the Watering Trough* implies the idea of rustic empowerment, a theme identified with Bastien-Lepage. Completed as a memorial for the recently deceased painter, who had been increasingly identified with his region near the village of Damvillers, Dagnan-Bouveret's work commands attention because of its large size and its freer brushwork. The artist abandoned the smooth canvas support of his earlier genre pictures to paint on a coarse, rough canvas, allowing the texture to show through and making some areas appear almost unfinished. In fact, he nearly abandoned the academic tradition in this work to create a painting style that suggests an immediacy of purpose closely connected with the naturalist aesthetic. When these stylistic aspects are combined with the close-up view, the high angle of vision, and the integration of the figures into a suggestive atmospheric space, it is

clear that Dagnan-Bouveret had become the leading artist among the academic naturalists.

The reception of *Horses* when it was exhibited at the Salon of 1885 was enthusiastic; it earned the painter the Legion of Honor and was purchased by the state for the collection of contemporary painting at the Musée du Luxembourg.[28] Critical response in newspapers was somewhat mixed, however. In *La Presse,* the critic commented that the artist had "set free his manner" with a painting of "great style."[29] Albert Wolff, in *Le Figaro,* drew comparisons between Jean-Léon Gérôme and his student, noting that *Horses* was a "well-studied" composition, thereby implying that the artist had worked hard to convey the impression of a specific site and people.[30] However, one critic, in the widely read *Le Siècle,* remarked that the scene, even though it displayed considerable talent, elicited the same kind of reaction that a photograph would. While this writer could scarcely have known how the work had been constructed, the composition precipitated a debate that placed Dagnan-Bouveret squarely in the center of the controversy over how far a painter could go in order to capture reality.[31]

The last factor characterizing the artist's work of the 1880s aligned him with a group of academic painters who presented religious themes in the guise of naturalist compositions depicting peasants. Among these painters were Léon Lhermitte, a major "peasant" painter of the early 1880s, and Jean Charles Cazin, whose figural compositions drew together naturalist and religious iconography to create a new category that can be called religious genre.[32] Dagnan-Bouveret's *Madonna with Plane,* exhibited along with *Horses* at the 1885 Salon, provoked controversy because of the unsettling contrast between the figure of the heavenly Virgin and the setting of the carpenter's shop with its mundane objects depicted in painstaking detail. Albert Wolff remarked on the unusual way in which the artist showed the head of the Christ child through the sheltering cloak of his mother, made transparent because of the light of the halo.[33] Although some critics had difficulty in reconciling it with other works by the artist, the painting drew praise for its evocation of deep religious feeling. Most important, it revealed that he was capable of uniting mysticism with realism; a new direction that artists were explaining as a way to imbue everyday themes with startling emotional effect. The *Madonna with Plane* and a second version known as the *Madone aux roses* (*Madonna of the Rose*) (fig. 73), done in 1885, are striking evidence that the artist had hit upon a new approach for his creative inclinations. His sensitive use of religious symbols, in this case, the figure of Mary to refer to eternal motherhood, was not lost on his audience.[34] In 1888, when the *Madonna with Plane* was shown in Munich at an international exhibition, German curators, critics, and museum officials were impressed by its rich symbolism. The painting was purchased by the Neue Pinakothek and put on display; it was also written about in the German press, attesting to the growing appreciation for his work outside France.[35] By 1889, *A Stable* had attracted an English collector, J. Maddocks of Bradford, who was developing a contemporary collection of British

FIGURE 73

Madonna of the Rose, 1885.
Oil on canvas. 33 3/4 x 27 in.
(85.7 x 68.6 cm). Signed
and dated lower right:
P.A.J. DAGNAN-B/85. The
Metropolitan Museum of Art,
Catharine Lorillard Wolfe
Collection, Wolfe Fund,
1906.

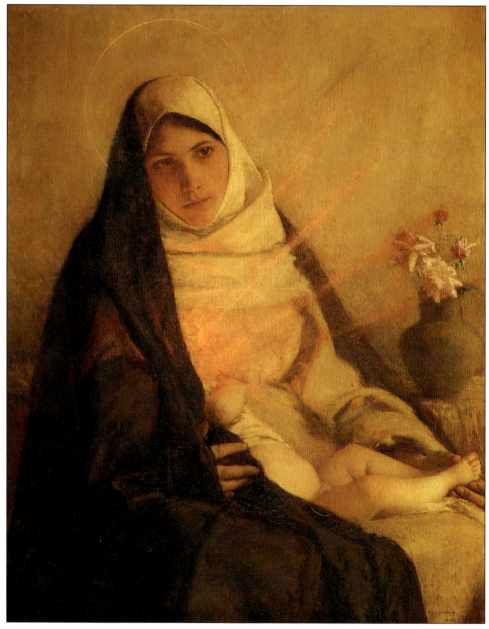

and French paintings. In an article on the formation of his collection published in 1891, *A Stable* was featured in the *Magazine of Art*.[36] The work helped to establish Dagnan-Bouveret's role as a primary figure in the naturalist movement at the moment it was becoming an international phenomenon.

At the end of the 1880s, Dagnan-Bouveret had not only advanced the naturalist cause by using photography to heighten the sense of immediacy in genre paintings; he had also found a way to incorporate his own religious beliefs into his compositions. The infusion of spiritual mysticism into his paintings afforded them deeper meanings, while also providing the artist with a sense of personal connection with his art that he had been seeking throughout his life.

The Internationalization of Dagnan-Bouveret V
1887–1893

At the close of the 1880s, as Dagnan-Bouveret's paintings were attracting increasing attention in several countries, France was striving to regain its position as the leader of Europe. The effects of the Franco-Prussian War (1870–1871) had been difficult to erase; the 1878 Exposition Universelle, while revealing gains that had been made in the few years since the war, also revealed that much had been lost. The international fair of 1889, which commemorated the one hundredth anniversary of the fall of the Bastille, became a lightning rod in the effort to rejuvenate France by showcasing new ideas in numerous fields. In the visual arts, critics were looking for signs of reanimation within the naturalist tradition. Some saw the works of Léon Lhermitte, especially his imposing *Paye des moissonneurs* (*Pay-Day for the Harvesters*) (fig. 74), as evidence that a renaissance was occurring within what was perceived as a complicated moment in French creativity.[1] Dagnan-Bouveret, with his earlier *Blessing of the Young Couple* as well as more recent compositions, was also recognized as contributing to the revitalization of contemporary Salon painting.

The younger generation of French painters—through independent exhibitions and their promotion by aggressive art dealers and critics—had established a strong case for their avant-garde approaches. Recognition that certain artists had broken away from tradition and embraced a more modern aesthetic was heightened by the death of Edouard Manet in 1883 and the subsequent organization of a retrospective exhibition.[2] Similarly, the exhibition held in 1885 after the death of Bastien-Lepage became a touchstone for traditionalist painters.[3] Bastien-Lepage became a martyr, a model to be followed; his paintings revealed that the *juste milieu* concepts

FIGURE 74

Léon Lhermitte, *Pay-Day for the Harvesters*, 1882. Oil on canvas. 84 5/8 x 108 1/4 in. (215 x 275 cm). Signed and dated lower left: L. Lhermitte/1882. Musée d'Orsay, Paris.

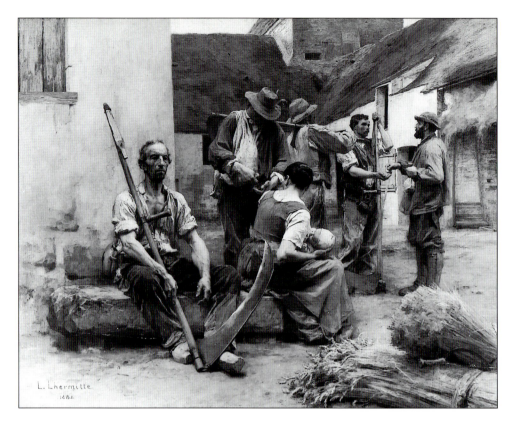

of the Third Republic had found a most capable voice.[4] Other groups had their heroes as well; artists were learning from recently deceased masters at the same time that newer tendencies were advanced with each passing exhibition season.

The exhibition process also came under scrutiny. Traditionalist painters, including Dagnan-Bouveret, became more cognizant of market strategies and began to deal more directly with potential buyers in order to increase sales. They wished to take fuller control of their own careers, marketing their canvases more forcefully through a new type of Salon that appealed to people of means and taste. By 1890, after the strength of the international representations at the Exposition Universelle, a number of painters, including Dagnan-Bouveret, banded together to organize a new Salon under the auspices of the Société Nationale des Beaux-Arts.[5] This all-artist organization was led by some of the leading academic painters of the day; Ernest Meissonier was its first president, and Pierre-Cécile Puvis de Chavannes succeeded him after his death.[6] The Salon of the Société Nationale gradually replaced the other Salon—the Salon of the Société des Artistes Français—as the place where moneyed socialites would go to select either large-scale wall decorations or decorative arts or to see an officially commissioned portrait on display. It also became the site where shifts within the traditional art world were most visible. By the early 1890s, painters were moving away from photographic verisimilitude in genre painting toward a new spiritualism, mysticism, and personal symbolism.

With the internationalization of French art, it was not surprising that Dagnan-Bouveret examined very carefully which themes he should paint for what venues.

Around 1886, he began focusing on scenes from Brittany, which had been the subject of earlier paintings by other artists, for example, Jules Breton.[7] Brittany was an area well known to artists and one with a tradition of strong religious beliefs. Many people, especially artists, made the *pèlerinage* to the region.[8] Dagnan-Bouveret had been urged by Gérôme to expand the parameters of his subject matter, and in seeking a place to do so, settled on Brittany,[9] where he produced scenes that would elicit a variety of contradictory interpretations by both contemporary and modern-day critics.[10]

Even though the artist's correspondence fails to provide an explanation of his personal reasons for going to Brittany, it is likely that he was drawn to the region because of the ethereal light and the traditions of spirituality that he knew existed there, especially surrounding activities associated with pardons—religious ceremonies that involved entire communities.[11] Dagnan-Bouveret probably made his first trip in either 1883 or 1884; he repeatedly returned to the region later in the decade, first from April to June 1886 and later when he actually attended a pardon in 1890, when he met the writer Pierre Loti.[12] During his trips to Brittany, the painter gathered information on regional dress, especially women's headdresses. He even acquired a collection of costumes that he brought back to the Haute-Saône, where he could pose his models in these costumes to recapture scenes he had witnessed in Brittany.

In 1887, Dagnan-Bouveret submitted *Le pardon; Bretagne* (*The Pardon in Brittany*) (fig. 75) to the annual Salon. This canvas shows a fragment of a religious procession as it winds its way outside a church. The figures, in local dress, carry lighted candles that flutter in the air, suggesting a slight breeze. In the back of the procession, the physically disabled hold out their plates to receive alms, a common sight at a ceremonial pilgrimage. In the left foreground, a woman genuflects, possibly before a crucifix outside the picture plane, as the old barefoot "blind" man at her side moves forward, holding his wooden cane securely for support.[13] In this stately, solemn composition, the artist successfully captures the local ritual of the pilgrimage, as the procession leaves or enters the church. On a deeper level, he attempts to convey the inner faith of the participants, who seem oblivious to everything but their own spiritual mission.

In the preparation of the painting, Dagnan-Bouveret used the same techniques that he had in his earlier naturalist canvases. He worked from models dressed in Brittany costumes, took photographs of them in specific poses, and then made a series of drawings and gouache studies to explore color harmonies (fig. 76). Inspired by actual scenes in Brittany in 1886, he reconstructed the procession in Ormoy, the site of his rural home. The models were people he knew, including his wife, who posed for the figure of the young woman directly behind the old man at the left (fig. 77), and Gustave Courtois's mother, who posed for the kneeling older woman in the front row (fig. 78). The artist carefully inscribed the back of this painting and the preliminary drawings with dates, the location, and the names of the models.[14]

FIGURE 75

The Pardon in Brittany, 1886.
Oil on canvas. 45 1/8 x 33
3/8 in. (114.6 x 84.8 cm).
Signed and dated lower right:
P.A.J. DAGNAN-B/1886. The
Metropolitan Museum of Art,
Gift of George F. Baker,
1931.

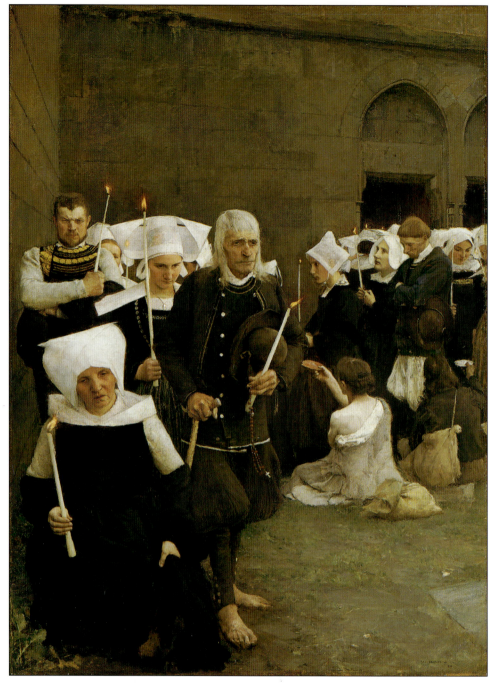

Extant photographs show the painter actually working on the canvas outdoors, in front of his home in Ormoy, as the yard became an extension of his studio (fig. 79). The act of painting is interrupted by conversations with Anne-Marie, his wife, and by the presence of the entire family, including their young son, Jean, who can be seen in the background of a photograph (fig. 80). Two fragmentary photographs show a young woman dressed in a white headdress and holding a large candle; and another depicts Anne-Marie from the side, in an image perhaps used to realize a second figure in the procession (figs. 81, 82). Aside from suggesting that intimacy with his family was essential to the artist's well-being, these photographs

FIGURE 76
Study for *The Pardon in Brittany*, 1886.
Oil on tracing paper. 6 1/4 x 4 3/4 in.
(sight) (16 x 12 cm). Private collection.

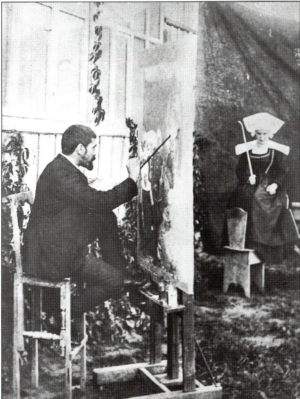

FIGURE 77
Photographer unknown, *Dagnan-Bouveret in His Garden Painting
"The Pardon in Brittany,"* ca. 1886. His wife, Anne-Marie, seated on
the bench in the background, is the model. Archives Départementales
de la Haute-Saône, Vesoul.

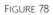

FIGURE 78
Photographer unknown, *Mme Courtois Posing for "The Pardon in
Brittany,"* ca. 1886. Archives Départementales de la Haute-Saône,
Vesoul.

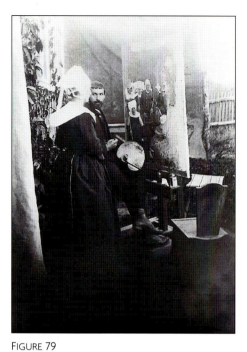

FIGURE 79

Photographer unknown, *Dagnan-Bouveret and His Wife, Anne-Marie, in front of "The Pardon in Brittany" during a Break in a Painting Session,* ca. 1886. Archives Départementales de la Haute-Saône, Vesoul.

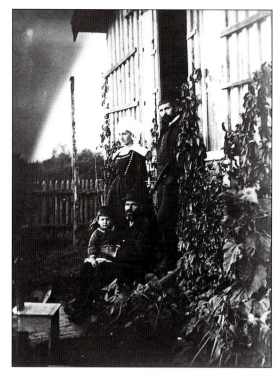

FIGURE 80

Photographer unknown, *Dagnan-Bouveret, His Wife, His Son, Jean, and Nicolas Walter in the Garden,* ca. 1886. Archives Départementales de la Haute-Saône, Vesoul.

FIGURE 81

Photographer unknown, *Model Holding a Large Candle Posing for "The Pardon in Brittany,"* ca. 1876. Archives Départementales de la Haute-Saône, Vesoul.

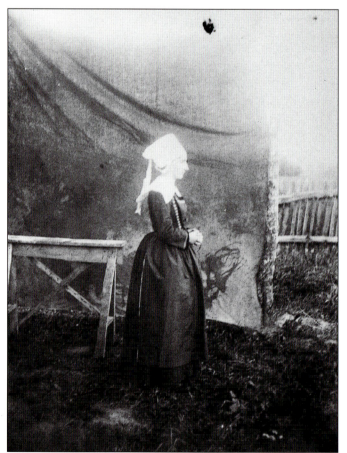

FIGURE 82

Photographer unknown, *Dagnan-Bouveret's Wife, Anne-Marie, in Breton Costume,* ca. 1886. Archives Départementales de la Haute-Saône, Vesoul.

reveal how the new technology had become an integral part of his compositional process.

In developing the final work, Dagnan-Bouveret had some difficulty with the figure of the old blind man in the foreground. A partially destroyed gouache demonstrates the artist struggling to find the right position for the figure, as do several documentary photographs. He later wrote to a friend that he had to complete this figure and the background in Paris.[15] In other drawings, he tried to position the old man among the others in the procession (fig. 83), and an oil sketch shows him from the side, with considerably more weight on the cane, indicating the painter's goal of achieving a precise transcription (fig. 84).[16]

FIGURE 83

Study for *The Pardon in Brittany,* not dated. Charcoal on tracing paper. 7 x 5 1/4 in. (18 x 13.4 cm). Private collection.

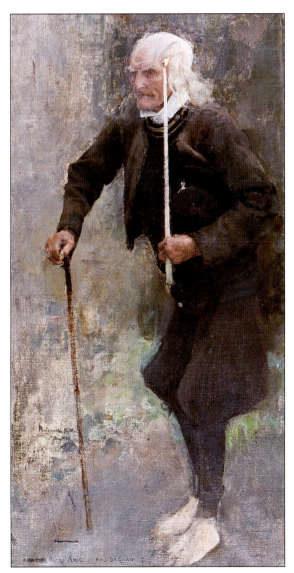

FIGURE 84

Study for *The Pardon in Brittany,* 1886. Oil on canvas. 39 3/8 x 15 3/4 in. (100 x 40 cm). Inscription middle left: Pont-Croix Juillet (illegible). Signed and dedicated lower left: (illegible) Amic P.A.J. DAGNAN-B. Abbaye royale de Chaalis, Institut de France, Bequest Henri Amic, no. 13.

The final figure of the blind man differs from those recorded in the sketches and drawings. Facial features in the preliminary works suggest a slightly younger individual; there is the possibility that the artist used a model named Baptiste Accard, in Paris, to realize the intensity of the gaze.[17] Together, these studies for his first Brittany pilgrimage composition demonstrate that Dagnan-Bouveret's working process was complicated, painstaking, and deeply personal. He invented and modified as he went along; he kept his procedures secret since the success of his paintings at the Salon, as was noted in reviews, hinged on the viewer's full acceptance of an illusion of reality.

The critical reaction to *The Pardon in Brittany* was extensive; reviewers following the political leanings of various newspapers offered divergent interpretations of the painting. Pierre de Soudeille's review in the conservative *Le Monde* noted that the painting "had truthfulness and naturalness in the figures. They are seen in their piety and in the radiance of their faith, just as they are, as they reveal themselves, and their belief in prayer is reflected in their faces."[18] The writer found Breton religiosity in the faces and attitudes of the figures without questioning how the artist had achieved his results.[19] A second critic, writing for the more liberal *Le Radical,* found different qualities in the same painting. Paul Heusy commented that "the white-haired old man, whose piety is tenacious and stubborn, unyielding . . . and the young girl behind him, who walks with her eyes down, faithfully fulfill all the religious practices to the letter; yet her religion is tainted by a sly curiosity."[20] These diverse readings demonstrate how the critics responded according to their own personal biases, developing an interpretation that reinforced their own persuasions.[21]

Other critics commented on the contrasts provided by the figural types: "the heroic and the naive, the fanatical and the charming, the savage and the sweet."[22] The veteran critic Paul Mantz, writing for *Le Temps,* insightfully observed that the artist displayed qualities in the *Pardon* that invited comparison with early Netherlandish painting.[23] Through Dagnan-Bouveret's setting the scene in front of a church and depicting a "slow" procession, each individual could be shown deeply involved in his or her own moment of prayer, allowing the viewer to "see" into their souls. Without resorting to a political rhetoric, Mantz wrote that the artist had left nothing to chance; there was no appearance of studio artifice in the way he had prepared the composition. The various interpretations of this painting are proof of Dagnan-Bouveret's skill at producing an illusion that not only re-created an actual pardon, but also mesmerized his viewers while concealing his reproductive processes.

Other Brittany studies were also completed in 1886. In *Couturière (Bretonne)* (*Seamstress [Breton Woman]*) (fig. 85), the artist again used his wife as a model.[24] Anne-Marie wears regional garb that includes a large white headdress; she is busily cutting material, perhaps the cloth from which such headgear was made. This small interior might have been used as a study for larger Brittany themes, or it might belong to a group of similar paintings done around 1886–1887.[25] Originally part of

FIGURE 85

Seamstress (Breton Woman), 1886. Oil on canvas. 15 1/4 x 11 1/4 in. (38.2 x 28.9 cm). Signed and dated lower right: P.A.J. DAGNAN-B. 1886. The Art Institute of Chicago, Potter Palmer Collection. Photograph © 2001, The Art Institute of Chicago, all rights reserved.

the collection of Jules Roederer (d. 1888), this painting was sold through the Galerie Georges Petit (1891) and eventually entered the Potter Palmer Collection in Chicago, further attesting to the growing interest in Dagnan-Bouveret's art in the United States.[26]

The success of the large *Pardon,* with its models in regional dress, led the painter to capitalize on this interest in costumed figures. Thus, he sent his *Bernoise* (*Woman from Bern*) of 1887 (fig. 86) to the 1888 Salon.[27] In the company of Gustave Courtois and Karl von Stetten, and later his wife, Dagnan-Bouveret often traveled to Switzerland, where he was taken by the traditional clothing worn by the

FIGURE 86

Woman from Bern, 1887. Oil on canvas. 21 7/8 x 16 1/2 in. (55.6 x 42 cm). Signed and dated lower right: P.A.J. DAGNAN-B 1887. The John G. Johnson Collection: The Philadelphia Museum of Art.

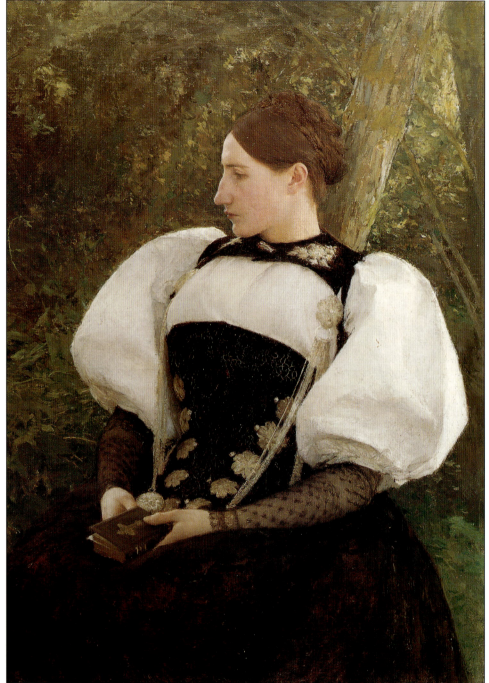

women of Bern (Switzerland's federal city). Returning to Ormoy, the artist dressed his wife in a Bernese costume with swelling shoulders and tight-fitting corset and took her photograph in a pose that would be close to that used for his Salon painting (figs. 87, 88). In the finished painting, the preparatory photograph, and a pastel, Anne-Marie holds a prayer book, conveying an impression of spirituality, pensiveness, and dedication, in keeping with her intense Catholic faith.

The pose allowed the artist to study his wife in profile. Leaning against a tree trunk, surrounded by a mass of foliage that forms a background to her finely mod-

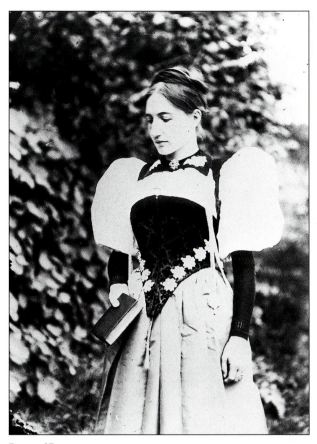

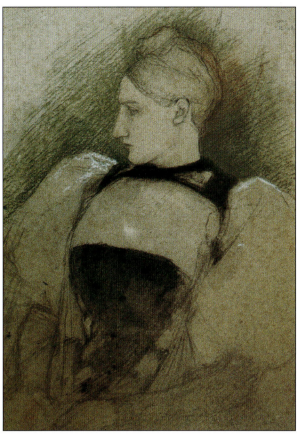

FIGURE 87

Photographer unknown, *Dagnan-Bouveret's Wife, Anne-Marie,*
Dressed in Bernese Costume, ca. 1887. Archives Départementales
de la Haute-Saône, Vesoul.

FIGURE 88

Woman from Bern, 1887. Colored pencil. 16 1/2 x 11 3/8 in.
(42 x 29 cm). Signed and dated upper right: Ormoy/27 Juin 87.
Musée Georges Garret, Vesoul.

eled silhouette, Anne-Marie wears her brown hair drawn tightly back from her fore-
head and braided in a coil at the top of her head. These details, as well as her gar-
ment, which Dagnan-Bouveret had brought back from Switzerland, have been
precisely observed.[28] The black velvet collar, embroidered with white silk and
shaped like a yoke, rests on a white stomacher with large puffed sleeves. Black vel-
vet shoulder straps are connected to a tight bodice in the same material. On either
side is a row of silver filigree rosettes that terminates near the collar in a jeweled
ornament with pendant chains. The arms below the elbow show through black net
sleeves; the hands lie in the black dress and hold a prayer book. Most striking of all
is the silhouette, which has affinities with International Gothic paintings by
Pisanello. The painter expanded the traditional limits of portraiture by depicting his
wife over and over again, in a variety of garments and roles. This painting was pur-
chased by John G. Johnson of Philadelphia.

The artist's fascination with regional garments is also manifest in other small
canvases, these of Breton men. In *Jeune Breton appuyé contre une armoire* (*Breton*
Youth Leaning against a Wardrobe) (fig. 89) of 1887, he seems to have worked from
an actual model in Brittany.[29] The heavy type of wardrobe, the tight space of the
room, and the casual pose of the model, who stands with his hands in his pockets,

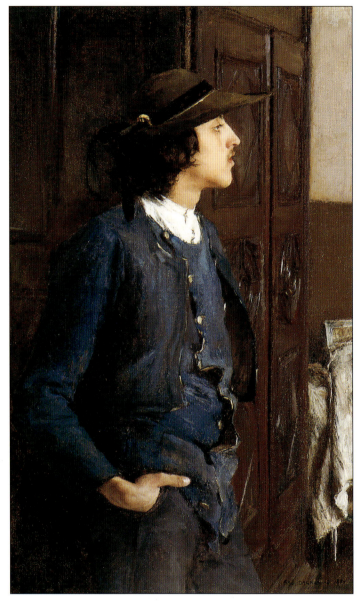

FIGURE 89

Breton Youth Leaning against a Wardrobe, 1887. Oil on canvas. 16 1/2 x 9 3/4 in. (41 x 24.8 cm). Signed and dated lower right: P.A.J. DAGNAN-B 1887. Pyms Gallery, London. Photograph courtesy Pyms Gallery.

suggest that it was painted on the spot. The unkempt hair and rumpled waistcoat further heighten the impression of spontaneity. Other paintings of Breton figure types, recorded as having been done in 1887 but as yet unlocated, suggest that Brittany supplied the artist with a rich and fertile source of imagery. It must have been during a recorded trip to the French region in 1886 that he gathered visual material for *Breton Youth Leaning against a Wardrobe,* as well as for the lost portraits.[30] In addition to drawing or painting sketches, he may also have taken photographs of models for use in his 1887 canvases.[31] This second trip to Brittany likely convinced the artist of the benefits of traveling to other places to enrich his stock of scenes and motifs. Just as he had assembled details for his genre painting *Wedding at the Photographer's,* he was now gathering information for his Brittany series. This documentarian approach was to be used during a brief trip to Algeria, taken at the end of 1887.

In December of that year, Dagnan-Bouveret and his family accompanied Jules-Alexis Muenier, who had received a government grant, and his wife to the Near East. They brought their painting equipment, and Muenier, who had become an enthusiastic photographer in his own right, photographed the group on a number of occasions (fig. 90). By late March 1888, the families had returned to France.

The trip to Algeria allowed Dagnan-Bouveret a much needed respite from his continuous work for the Salon and may also have been prompted by a desire to expand his repertoire of subjects for painting. However, aside from a few studies done of buildings in the Casbah, some landscapes of outlying areas (fig. 91), and the beginning of a detailed figural composition, only two Orientalist paintings were publicly exhibited: one, a study of a cemetery at the Salon of 1890,[32] and another, the *Etude d'Algérie; Ouled Naïl (Algerian Study; Ouled Naïl)* (Musée d'Orsay, Paris), depicting a nomad, shown in the first Paris exhibition of Orientalist painters in 1893.[33] The exoticism of the Near East did not exert a lasting influence on the artist as it did on many painters of his generation; the lure and mystery of Brittany was more fascinating to him.[34] Thus, he returned to painting intensely religious Breton scenes in 1888.

Bretons en prière (Bretons Praying) (fig. 92) is a simplified version of the earlier *Pardon in Brittany*. In this work, Dagnan-Bouveret eliminated the setting to focus

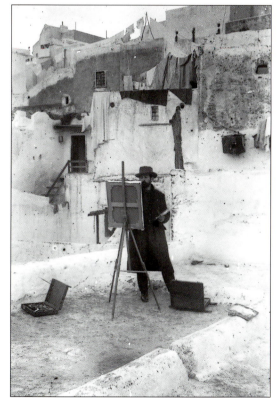

FIGURE 90

Jules-Alexis Muenier, *Photograph of Dagnan-Bouveret at His Easel, Quali-Dada*, 1887/1888. Archives Départementales de la Haute-Saône, Vesoul.

FIGURE 91

El Cantara, 1888. Oil on canvas. 10 1/4 x 9 in. (26 x 23 cm). Inscribed lower right: El Cantara Mars 88. Private collection.

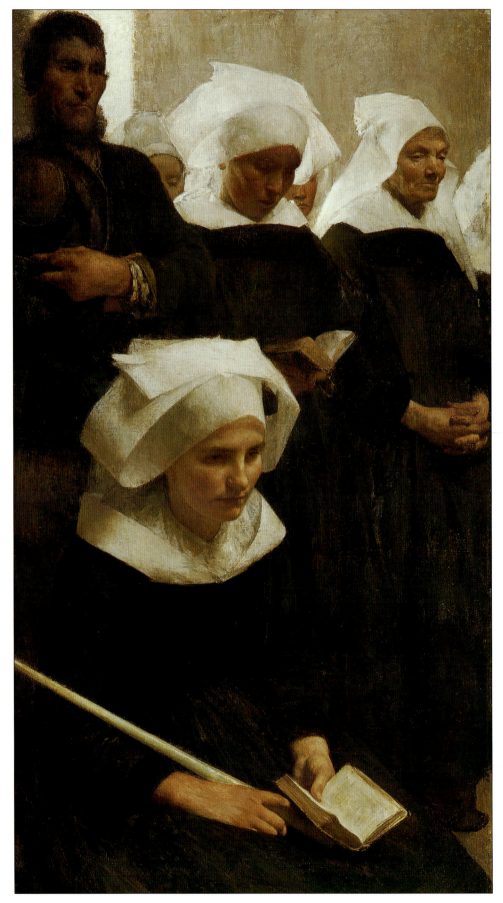

FIGURE 92

Bretons Praying (or *Breton Peasants*), 1888. Oil on canvas. 48 3/4 x 27 1/8 in. (123.5 x 68.9 cm). Signed and dated lower right: P.A.J. DAGNAN-B/1888. The Montreal Museum of Fine Arts, William F. Angus Bequest. Photo: The Montreal Museum of Fine Arts, Marilyn Aitken.

on the piety and spirituality of a few figures, especially the young woman (in the foreground) holding a large candle and open prayer book.[35] Other peasants, of varying ages and also modeled from life, crowd behind this figure in a constricted space, forming a kind of chorus. This close-up view, combined with the minutely observed faces and costumes, heightens the sense of religious spirituality. While some critics responded favorably to the artist's new pared-down vision, Gérôme did not like the work, finding it too fragmentary.[36] In fact, the same working method employed so successfully in *Pardon in Brittany,* in which the artist used preparatory photographs as well as drawn and painted studies,[37] gives this painting the appearance of a snapshot, rather than a classically formulated composition. Moreover, the vertical format and the close proximity of the figures make this an intensely personal work and therefore less a product of descriptive naturalism.[38] Exhibited in 1889, first at the Mirliton and then at the Cercle des Arts, the painting was purchased by Goupil, who was now one of the artist's principal agents.[39] Soon after, it was acquired by a collector in Montreal, further attesting to Dagnan-Bouveret's growing international reputation.

As the 1889 Salon and the Exposition Universelle approached, the painter developed the two directions that had emerged from his production of the mid-1880s. Recognizing that naturalism was still the dominant mode and that he had been cast as the successor to Bastien-Lepage, he also saw clearly that religious sentiment had become a strong undercurrent in academic art. He had already had success in combining trends earlier in his career, including a literary genre painting (*Manon Lescaut*), a naturalist genre scene (*The Accident*), and a naturalist religious picture (*Madonna with Plane*). His work of the late 1880s differed in its pervasive use of photography. In this tendency he joined a large contingent of younger painters, both in France and elsewhere, who might be labeled photorealists.[40] The possibilities of photography were further reinforced by the Exposition Universelle of 1889. A large installation, in which the newest photographic methods and techniques were showcased, demonstrated the widespread interest in the medium.[41] This display no doubt advanced Dagnan-Bouveret's commitment to integrating photographic techniques into his painting.

With the *Bretonnes au pardon* (*Breton Women at a Pardon*) (fig. 93), the artist developed the most complicated procedures yet in order to construct his composition. The scene was based on his trip to Brittany in mid-1886, when he photographed a church in Rumengol and its surroundings (fig. 94). In one of the earliest site photographs, he shot the church in the distance, posing a companion on a small hillock. This embankment, with an added male figure, was incorporated at the left of the finished painting. This early photograph shows another figure seated on the ground, with a white handkerchief over his head, in exactly the spot where the group of Brittany women were to be positioned.

Dagnan-Bouveret began working full-time on this composition during the summer of 1887 in Ormoy.[42] Working in an outdoor tent—where the portrait of the

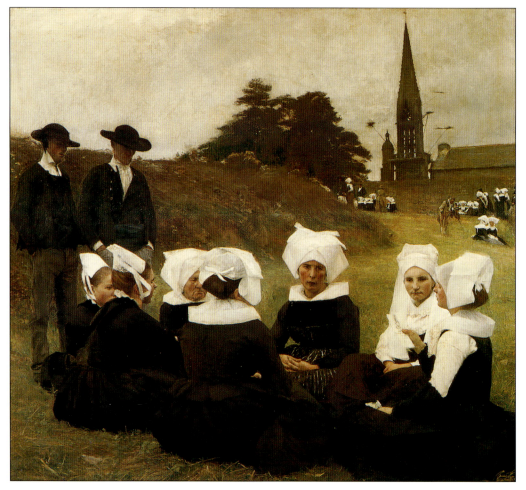

FIGURE 93

*Breton Women
at a Pardon*, 1887.
Oil on canvas.
49 1/4 x 55 1/2 in.
(125.3 x 141.3 cm).
Calouste Gulbenkian
Foundation Museum,
Lisbon.

FIGURE 94

*Preparatory Photograph
of the Church at Rumengol
for "Breton Women at a
Pardon,"* ca. 1887. Archives
Départementales de la
Haute-Saône, Vesoul.

Bernoise can be seen at the back—the artist executed a large number of preliminary drawings, pastels, and studies on tracing paper, so that he could enlarge and modify the poses of his figures for his new *Pardon.* His working procedures are documented in a photograph (fig. 95), which shows him in the midst of his sketches and cut drawings, working out ways to combine pictorial elements. On the table at the right are not only cut tracing-paper drawings, but also small prints of field photographs that the artist referred to as he fit the various sections of his composition together like a collage. The mechanical device that he is shown using allowed him to precisely calibrate the size between figural forms for the final composition.[43] He photographed models outside his tent and in his garden, sometimes posing them independently and sometimes in groups (fig. 96). He must have taken many photographs; however, only a few survive. One, of a single female figure, is squared in pencil, suggesting the way in which the artist transferred the images to canvas. For a group photograph, Dagnan-Bouveret dressed some models in Brittany coifs; he used his wife for the key figure, who is reading to the other women. Although the initial conception was maintained, Anne-Marie did not appear in the final composition. Her place was taken by another model, probably a young woman living in Ormoy or even Corre.

For each of the principal figures, he made independent drawings (figs. 97, 98, 99), sketching in the outlines of the forms. These small studies, mostly completed in July 1887, parallel the photographs. They were, most likely, used interchangeably as the artist struggled to find a satisfying combination of poses.[44] Other, slightly more developed drawings, often completed in charcoal and with the suggestion of

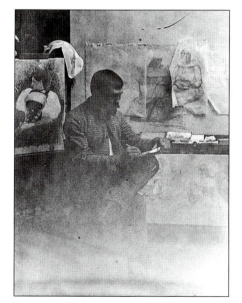

FIGURE 95

Photographer unknown, *Dagnan-Bouveret Working on Tracing Drawings for "Breton Women at a Pardon,"* ca. 1887. Archives Départementales de la Haute-Saône, Vesoul.

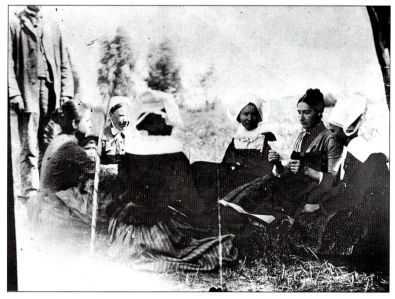

FIGURE 96

Preparatory Photograph for Entire Composition of "Breton Women at a Pardon," ca. 1887. Archives Départementales de la Haute-Saône, Vesoul.

FIGURE 97

Individual figure in *Breton Women at a Pardon,* not dated. Pencil. 8 x 9 3/4 in. (20.4 x 24.8 cm). With indications of position vis-à-vis other figures in the composition. Private collection.

FIGURE 98

Squared drawing of the same figure in *Breton Women at a Pardon,* not dated. Pencil. 8 x 9 3/4 in. (20.4 x 24.8 cm). Private collection.

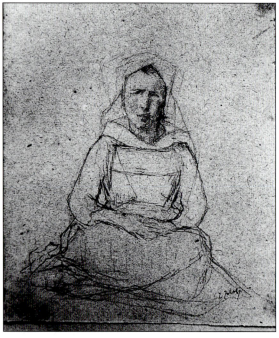

FIGURE 99

Individual figure in *Breton Women at a Pardon,* 1887. Pencil. 7 x 6 in. (17.9 x 15.3 cm). Dated lower right: 2 Juillet 87. Private collection.

FIGURE 100

Seated Breton Woman, not dated. Study for *Breton Women at a Pardon.* Charcoal highlighted with white chalk on tracing paper. 16 1/2 x 11 1/4 in. (42 x 28.5 cm). Private collection.

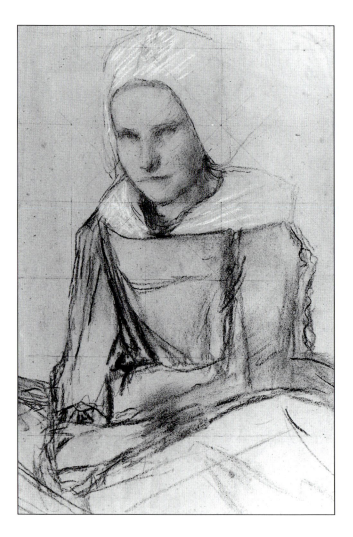

white chalk added for the headpieces or the dresses, were squared for transfer (fig. 100). A charcoal study, most likely for the figure holding a letter, shows a slightly different pose from that used in the painting (fig. 101). An early, unfinished oil sketch (fig. 102) also shows a concern not only with the positioning of his figures, but also with color. There are further studies of his primary models (fig. 103) and a more complete one of the entire composition (fig. 104).[45] All these studies, including a highly finished one of two women (fig. 105), confirm that by the end of October 1887, Dagnan-Bouveret had produced oil sketches or mixed-media studies of all his models in order to preserve their facial features in case one died or left Ormoy before the work was finished.[46]

The artist was concerned about finishing his painting before leaving on his trip to Algeria.[47] He embarked on a series of more complicated oil studies in which the faces of his models were close to those of the final work.[48] In these *ébauches*, each face was meticulously painted, while the garments and the setting were only roughly

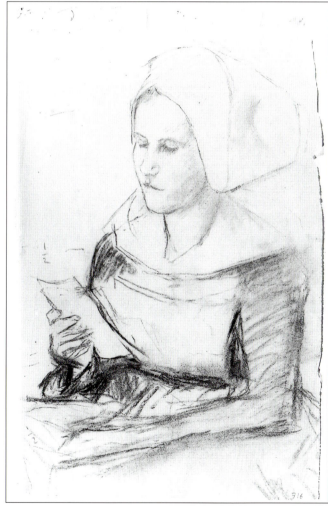

FIGURE 101

Seated Breton Woman Holding a Letter, not dated. Study for *Breton Women at a Pardon.* Charcoal on tracing paper. 16 1/2 x 10 1/2 in. (42 x 26.8 cm). Private collection.

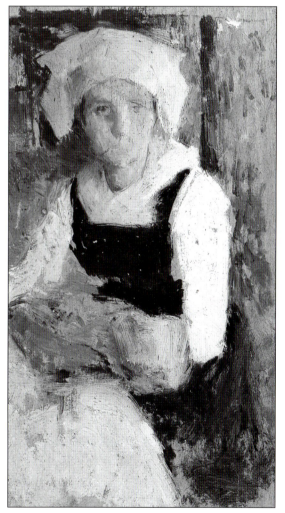

FIGURE 102

Sketch of figure in *Breton Women at a Pardon,* not dated. Oil on paper. 11 x 6 1/8 in. (28 x 15.5 cm). Private collection.

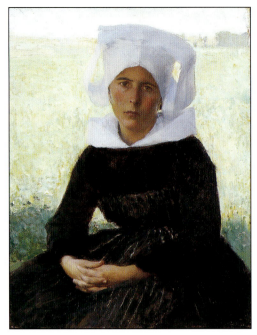

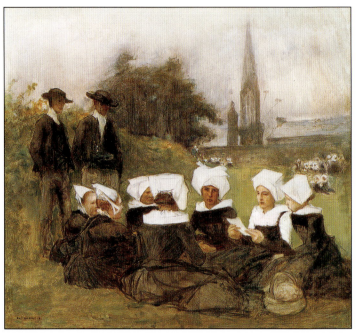

FIGURE 103

Woman in Breton Costume Seated in a Meadow, 1887.
Study for *Breton Women at a Pardon.* Oil on canvas.
16 3/8 x 12 3/4 in. (41.5 x 32.5 cm). Signed and dated
lower right: P.A.J. DAGNAN-B 1887. Bequest of David P.
Kimball in memory of his wife, Clara Bertram Kimball.
Photograph courtesy Museum of Fine Arts, Boston.

FIGURE 104

Study for *Breton Women at a Pardon,* ca. 1887. Oil on panel. 15 9/16 x 17 5/8 in.
(39.6 x 44.8 cm). Signed lower left: P.A.J. DAGNAN-B. In the Collection of the
Corcoran Gallery of Art, William A. Clark Collection.

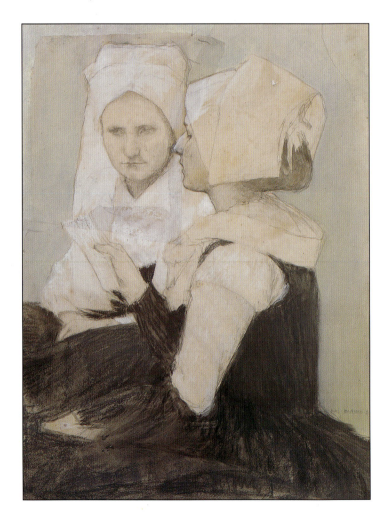

FIGURE 105

Study for *Breton Women at a Pardon,* ca. 1887.
Black ink, pencil, charcoal, and pastel on tracing paper.
21 3/4 x 16 1/8 in. (55 x 41 cm) Signed lower right:
P.A.J. DAGNAN-B. Département des Arts Graphiques du
Louvre, Fonds Orsay, RF 23360. Photograph courtesy
Réunion des Musées nationaux/Art Resource, New York.

sketched in. Such oil studies were often used by academically trained artists in realizing their compositions. The model for the young woman at the center of the painting was later documented in a photograph published in the American magazine *Cosmopolitan*, attesting to the strong interest taken in the identity of the models.[49] The young woman at the right of the painting had been located by Anne-Marie Walter in Corre. She not only was destined to replace the artist's wife here, but also effectively became the painter's principal model in at least eighteen other compositions.[50] It was commonly recognized that the new young woman, Mlle Mougin, closely resembled Anne-Marie, which suggests that Dagnan-Bouveret was still painting his wife in spirit, even if she no longer posed long hours for the artist. Other preliminary studies became more complex. For the same two women at the right of the composition, the artist prepared a mixed-media composition on paper with gouache, pencil, and watercolor. He then glued portions of other studies on tracing paper to areas that he wished to modify or heighten. This form of collage was one of many technical devices used by the artist in the creation of his pictures. Others involved sculpting wax models of a figure or an entire composition. (This process will be explained when we consider the painter's religious compositions.)

With *Women at a Pardon*, Dagnan-Bouveret perfected all the techniques he had used earlier in his career. His highly methodical system recalls the modern term *assemblage;* while other academic painters would have been trained in these methods (or have known about them), rarely had an artist carried them out to such an extent and rarely had they been so carefully documented.

The painting was finally completed either in late 1888 or early 1889, the year it was exhibited at the Salon and the Exposition Universelle. Certainly one of the artist's masterpieces, it represents the culmination of his work done on Brittany themes over a three-year period. By 1889, however, he began to move away from Breton subjects as the number of artists working on similar themes increased.

The public reception of *Breton Women at a Pardon* was overwhelming. Dagnan-Bouveret received the Medal of Honor at the Salon and the Grand Prize at the Exposition Universelle.[51] At the Salon, where it was attracting a huge audience, people stopped in front of the painting to applaud.[52] Gérôme and his students were deeply affected, giving the painter an antique mirror as a reward for his success. The painter's students from the Académie Colarossi, where he taught two or three nights a week, presented him with a large photo of Hans Holbein, with whom he was often compared by critics.[53]

Reviews in the press were unanimous in their praise for the painting. In *Le Courrier Français*, the reviewer noted that the women in the field listen "with an expression of naive faith on their faces. . . . Two Breton men complete this touching scene as they also listen to the prayer. Here is truly the best work at the Salon. The art of painting is the art of expressing what one sees, of expressing what is invisible through the visible. Dagnan's work is certainly imbued with this truth."[54] In *Le Dimanche Illustré*, the critic called it a "poetic and simple scene (in which)

the figures have been observed with such truthfulness, such tenderness, such skillfulness that each one is a poem."[55] Praise from the daily and weekend editions of popular newspapers was aided by a very substantial commentary in the distinguished *Revue des Deux-Mondes.* The artist's draftsmanship was compared to that of earlier Netherlandish and German painters such as Holbein the Elder or Memling.[56] As writers examined his treatment of the background landscape—a genre that he had explored independently in only a few paintings thus far (fig. 106)—they found the luminous light and the grayed tonality reminiscent of the works of Jean-Charles Cazin. The same reviewers noted how the setting helped reinforce the symbolism of the scene. Such accolades came from every section of the artistic community, including critics who hardly knew the reclusive artist. One of these was the very powerful Albert Wolff, who, in *Le Figaro,* championed Dagnan-Bouveret for the Medal of Honor, calling the *Breton Women* a work of "beauty, contemplation and peacefulness. It is great, honest art."[57]

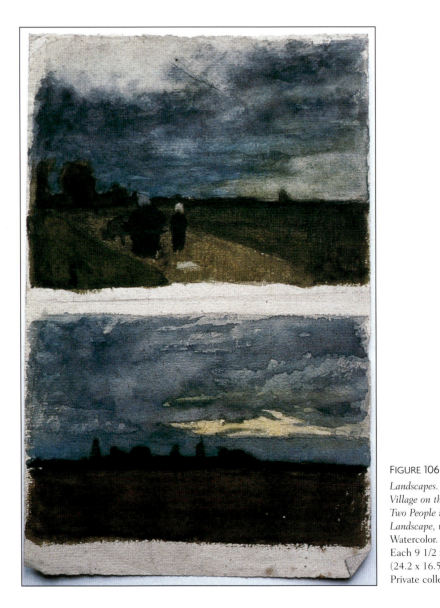

FIGURE 106

Landscapes.
Village on the Horizon.
Two People in a
Landscape, not dated.
Watercolor.
Each 9 1/2 x 6 1/2 in.
(24.2 x 16.5 cm).
Private collection.

Other reviewers—from Louis de Fourcaud, writing for the conservative *Le Gaulois,* to Roger Marx, writing for the Republican *Le Voltaire*—shared a refusal to interpret the picture in strictly religious terms. While they referred in a general way to the mystical quality of figures gathering in the field before evening prayers, they did not attempt a liturgical interpretation.[58] The critic Paul Mantz went only slightly further in his remark that Catholicism was subtly revealed through the evocation of intense "religious feelings."[59] In effect, Dagnan-Bouveret had modernized genre painting by conveying an actual event and evoking the impression of spirituality without becoming doctrinaire. With *Breton Women at a Pardon* the artist had truly arrived.

Dagnan-Bouveret's international impact was in great evidence at the Exposition Universelle, where he exhibited several works in addition to *Breton Women at a Pardon.* In the British *Magazine of Art,* he was seen as a painter who had made considerable progress throughout the 1880s; works at the Salon were discussed along with those at the Exposition Universelle, where "sincerity singles out M. Dagnan so strongly from the majority of his compatriots," attesting to the fact that the artist was being used as a standard against which to measure others.[60]

Of the several paintings submitted to the Exposition in 1889, the one that attracted the most attention after the *Breton Women at a Pardon* was the *Madone à la treille* (*Madonna of the Trellis*) (fig. 107). Commissioned by a private individual,[61] the painting was completed in the fall of 1888. To prepare the scene in Ormoy, a young woman was photographed (fig. 108) under a wild grape arbor. The artist, however, painted his life-size composition directly from the posed model. In a letter to his friend Henri Amic, the painter wrote that he "was trying to express the sweet, happy feeling of motherhood by bathing the picture with a warm, visual sensation."[62] Although the finished painting has not been located, it is apparent that Dagnan-Bouveret was moving away from verisimilitude toward the creation of a symbolic environment in which color and light were used to suggest a special mood. This quality is suggested by an unfinished oil sketch (fig. 109), painted with luminous greens that suffuse both the clothing of the Madonna and Child and the interior of the arbor with a harmonious glow. Georges Lafenestre of *Revue des Deux-Mondes* saw the *Madonna of the Trellis* as a "modern Virgin," given the color symbolism, but he believed that the artist was working on too large a scale, and that his most effective works were of a more intimate size.[63] Another critic remarked on its rare subject matter, since such devotional images were few and far between.[64] The painting was reproduced in the United States, where *Century Magazine* ran a full-page illustration in December 1892, which suggests that the work was then in an American private collection.[65] Louis Comfort Tiffany used the painting as the basis for a stained-glass window, furthering knowledge of this painting in the United States.[66] Dagnan-Bouveret's religious imagery, in which he personalized the archetype of the Madonna and Child, was now recognized as a harbinger of new developments.

FIGURE 107

Madonna of the Trellis, 1888. Oil on canvas. Dimensions unknown. Shown at the Salon of 1889. Present location unknown.

FIGURE 108

Preparatory Photograph for "Madonna of the Trellis," ca. 1888. Archives Départementales de la Haute-Saône, Vesoul.

At the same time that he was developing this personal devotional imagery, he also explored themes of a broader, more contemporary nature. *Les conscrits* (*The Recruits*) (see fig. 5), exhibited at the Salon of the Société Nationale of 1891, is a painting that brought him directly in line with artists who were producing works with strong political overtones.

When it was first shown, *The Recruits* was controversial.[67] Although the painting was set in Ormoy and drew on local inhabitants of the village for models, thus evoking the theme of patriotism for the nation, the image seemed defeatist to some, since the artist didn't depict the protagonists with joyful expressions, but rather somber ones. To others, the painting depicted the loyal commitment of regional brothers, who joined arm in arm to come to the aid of France by literally wrapping themselves in the colors of the flag. An ardent Republican from a family that had always valued the importance of the central government, Dagnan-Bouveret in this work spoke to the patriotism of residents of the Franche-Comté at a moment when democracy was threatened by supporters of those who wanted to challenge the government of the Third Republic. The painting was highly regarded by the critics and purchased by the French government, then sent off to the Chambre des Députés, where today it can only be viewed by special permission. By 1900, despite

the initial controversy, this painting was among Dagnan-Bouveret's most valued works when it was shown at that year's Exposition Universelle. The favorable reaction by the Salon public and the French government was well founded, for in this contemporary scene, still considerably naturalistic in arrangement and startling in the close-up views of individual models, the artist had brought much freshness to his imagery.

Even as he was working on these religious and political pictures, Dagnan-Bouveret did not renounce Breton themes entirely. Late in the summer of 1891, he painted two works of a Breton man, one a full-length view of the figure observed straight on, and another a half-length view. The latter showed the model against a white background, holding his hat and a large candle, while gazing intensely at the viewer.[68] At the same time, the artist began working on two major paintings.[69] The titles would be modified when they were exhibited in the 1893 Salon of the Société Nationale: *Dans la prairie* (*In the Meadow*) (fig. 110) also became known as *La gardeuse de vache* (*Woman Tending a Cow*), and *Dans la forêt* (*In the Forest*) (fig. 111) became known as *Concert dans la forêt* (*Concert in the Forest*). Dagnan-Bouveret continued working on both compositions into late 1892, in part because he was

FIGURE 109
Study for *Madonna of the Trellis*.
Oil on canvas. 13 x 8 1/2 in.
(33 x 21.6 cm). Private collection.

FIGURE 110

In the Meadow, 1892. Oil on canvas. 37 3/4 x 35 7/8 in. (96 x 91 cm). Private collection.

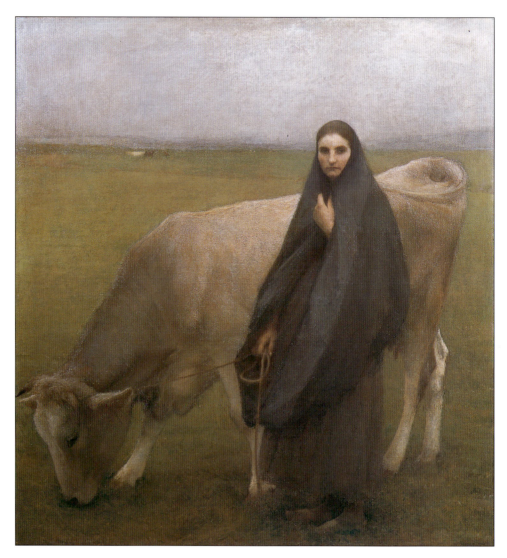

unable to finish the background for *In the Forest* since there had not been enough overcast weather to create a gray, wintry appearance; eventually, he gave up and changed the season to autumn, adjusting his colors accordingly.[70]

In the Meadow, making a return to the artist's interest in animal imagery best exemplified by *Horses at the Watering Trough,* was intended as an homage to Jean-François Millet.[71] It is an extremely stark scene, depicting a young woman, a figure posed for by Mlle Mougin, now Dagnan-Bouveret's favorite model, dressed in wooden clogs and holding a blue blanket over her shoulders to keep warm in the cold, damp weather. The large cow, pushing close to the girl, occupies most of the space of the composition, forcing the woman toward the viewer. A vast, expansive field unfolds behind them, and the gray sky above contributes to the gloomy, damp impression of the setting. Commissioned by Coquelin Aîné, a leading stage actor who was developing a significant collection of naturalist paintings, *In the Meadow* has strong affinities with the rustic scenes of both Millet and Bastien-Lepage. However, it is more than a purely naturalist painting; the young woman, with her mourn-

ful expression and pose, conveys an aura of innocence and sorrow, qualities very typical of symbolist iconography of the 1890s. Her solitude is heightened by her placement in a bleak landscape, a familiar device of symbolist painting.[72]

In the Forest depicts an unusual theme in the artist's oeuvre: the capacity of music to produce a moving, even transcendent moment.[73] For models, Dagnan-Bouveret drew on local types from Ormoy, men who knew the fields and the woods of the region well; he placed them in a forest enclave where, resting after a meal, they listen to a young man play his instrument.[74] Behind the peasants are oxen used for hauling logs from the forest; they, too, seem to be transfixed by the performance. The poses and expressions of some of the figures, especially the young bearded man at the left and the central figure with a moustache, suggest that they

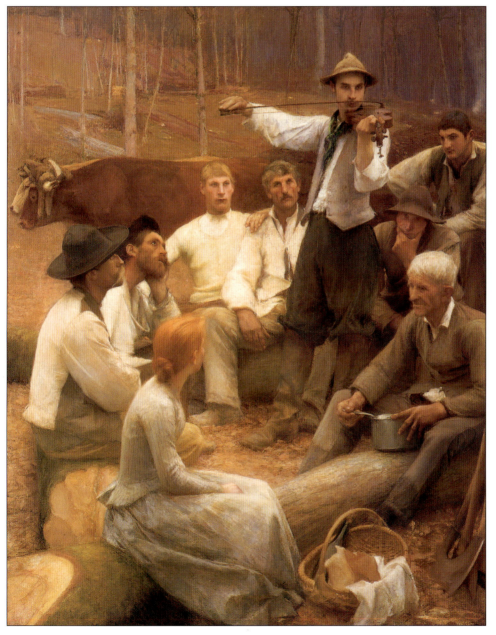

FIGURE 111
In the Forest, 1892. Oil on canvas. 61 x 49 1/8 in. (155 x 125 cm). Signed and dated lower left: P.A.J. DAGNAN-B Ormoy 1892. Nancy, Musée des Beaux-Arts, Dépôt du Musée d'Orsay. Photo C. Philippot, 1998.

FIGURE 112
Photographer unknown, *Photograph of Dagnan-Bouveret Used in the Preparation of "In the Forest,"* not dated. Archives Départementales de la Haute-Saône, Vesoul.

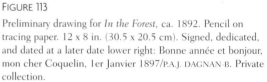

FIGURE 113
Preliminary drawing for *In the Forest*, ca. 1892. Pencil on tracing paper. 12 x 8 in. (30.5 x 20.5 cm). Signed, dedicated, and dated at a later date lower right: Bonne année et bonjour, mon cher Coquelin, 1er Janvier 1897/P.A.J. DAGNAN-B. Private collection.

have been mystically transported to another realm. The existence of a photograph showing Dagnan-Bouveret in the midst of the forest that he had selected for the work reinforces how carefully the artist tried to find a location that would suggest the mystical effects both for himself and for his models (fig. 112).

Each of the figures was developed—following the artist's typical method—from a large number of preparatory drawings: some are in pencil on tracing paper (fig. 113) and others are in red chalk or pastel on heavier paper. These sketches capture the intense expressions of the sitters, whose moods are in harmony with the russet tones of the countryside and the evocative notes struck by the violinist. In the final work, sound merges with feeling in a symbolist vision that reveals how far the painter has moved from his naturalist beginnings.

This painting entered the London collection of George McCulloch, where it remained until it was displayed at the Royal Academy winter exhibition of 1909.[75] After the McCulloch collection was sold, this work was purchased anonymously for the Luxembourg Museum, with the stipulation that the painting would eventually go to the Louvre.[76] In 1915, it was sent to the United States to the Panama Pacific International Exhibition in San Francisco.[77]

In the Forest and *In the Meadow* were among several works that Dagnan-Bouveret showed at the 1893 Salon. Indeed, the 1893 Salon can be regarded as a watershed moment for the artist. He not only had a large number of works on view, but also he was a respected member of the Société Nationale, and one of his paintings—*The Recruits*—had been selected for the Chicago World's Columbian Exposition. Collectors flocked to his Paris studio to acquire a Salon composition or to commission a portrait.[78] Critics were repeatedly drawn to his 1893 works. Ary Renan, a leader of the symbolist camp and a highly evocative painter and writer, found Dagnan-Bouveret to be "a sorcerer" who cast beneficial spells on an audience. His *In the Forest* was compared to the writings of George Sand, who created an atmosphere full of "velvety, warm color."[79] Renan was equally moved by the "suffering figure" of *In the Meadow*. Both works struck a chord with the younger generation of artists, committed to a symbolist imagery in poetry, novels, and painting. Another critic, listing Dagnan-Bouveret among Les Poètes, wrote that "he manages to bring poetry out of a reality that is strictly observed and captured."[80] In addition to being admired by the symbolists, the painter found favor with a broader audience, and his works were illustrated and discussed in such prestigious publications as *La Revue Encyclopédique*. The critic of *La Revue* noted that in his painting *In the Forest*, the artist not only represented a real event in the forest but also strove to engage the viewer's imagination.[81] The English press, especially the *Magazine of Art*, also praised Dagnan-Bouveret's contributions to the 1893 Salon; he was now a well-recognized artist whose career was being avidly followed in countries outside of France.

A final work begun at this time was *La Ronde* (fig. 114), a private commission depicting young peasant women dancing in the forest.[82] This pastoral scene, in which the landscape dominates, was never completed. It was developed from several small preparatory drawings of dancing women to the state of a partially finished, mixed-media composition.[83] To the left, the women glide across the landscape; behind them a forest glen opens gently near the horizon. The suggestion of the close rapport between human beings and nature was a theme that other artists were interested in at the time and one that anticipates the work of Henri Matisse with his famous ronde of dancers in *The Joy of Life*. Dagnan-Bouveret's *Ronde* shows that he remained open to new themes; its unresolved state only emphasizes that his painting approach was undergoing a significant transformation and demonstrates, once again, the artist's openness to experimentation.

It is interesting and rather unusual to find an academic artist solidifying his international reputation at the same time that he was subtly modifying his painting. But this is exactly the case of Dagnan-Bouveret in the period from 1887 to 1893. His highly flexible approach is manifest in his ability to switch back and forth between his exacting paintings of Breton peasants and those of a religious (*Madonna of the Trellis*) or political (*The Recruits*) nature. Moreover, he was responding to new symbolist ideas that heightened the impact of his paintings. Compositions

FIGURE 114

Three Women Dancing in the Forest, not dated. Pastel and oil on canvas. 38 3/4 x 33 1/4 in. (97.2 x 84.5 cm). Private collection.

could be unified through color, which precipitated a particular mood in the onlooker. By engaging the viewer through abstract means rather than through narrative details, the artist moved toward the evocation of ideas that cannot be precisely identified. In this attempt to express the mystical, or even subconscious, Dagnan-Bouveret aligned himself with such artists as Léon Lhermitte or Jean-Charles Cazin. Contemporary critics recognized his inclination toward symbolist ideas within a naturalist framework and welcomed him into their ranks when his paintings were exhibited at the Salons. The painter's involvement in mysticism, which began with his religious works of the early 1880s, would grow ever more intense in the waning years of the nineteenth century, making it a complex task for an audience always to grasp his new intentions.

Transcendent Spirituality VI
1894–1900

A renewed interest in religious themes among French painters was the outcome of the revitalization of the Catholic church in the nineteenth century.[1] With materialism regarded by many as one of the most prevalent evils of the Third Republic, leaders of the church took the opportunity of recasting religious ideology in a way that was more relevant to the modern man or woman. It fell to architects—especially those responsible for the construction of the Sacré-Coeur in Montmartre—and to painters to reveal through their images the ongoing battle for ideas in the contest between church and state.[2] The last twenty years of the century saw a steady increase in the number of artists, both among the avant-garde (Paul Gauguin or Maurice Denis) and among traditional Salon painters, who used religious iconography in their works. The latter, a group including such figures as Léon Lhermitte or Jean Béraud, represented religious ideals using a naturalist or symbolist mode of expression. Murals inspired by religious sentiment, such as those by Puvis de Chavannes, were created to decorate huge public spaces. During the 1890s, especially at the end of the decade, the number of painters contributing to the religious renaissance had multiplied; one of the staunchest proponents of this type of imagery was Dagnan-Bouveret.

By 1891, writers for popular periodicals such as *L'Art* were commenting on the increasing number of religious scenes that were being produced; they noted a "renaissance of religious art" and observed that this genre had been dormant in the middle decades of the century.[3] More than following a new trend, the artists who painted these scenes truly believed in the messages they intended to communicate. "Sincerity" became a catchword in the press. Religious paintings seemed

increasingly suggestive, abstract, and otherworldly as their creators were animated by a "new spirit," hoping to convert viewers on an intellectual and intuitive level.[4] The new religious painters did not simply depict allegories based on formulations or readings from traditional texts; they incorporated "modern symbolism" to suggest the character of the period, and they personalized religious experience so that the viewers would become engrossed in the imagery. These artists also moved away from the "brutalities" of representation that had become central to both realism and naturalism toward the creation of an "ideal" state. The new commitment to religious transcendence was, in effect, a repudiation of Zola's naturalism.[5]

Dagnan-Bouveret's religious conversion was a gradual process, and his artistic production reflected his growing personal spiritualism. Aware of the importance of religious art from his years at the Ecole des Beaux-Arts, the painter had been treating Christian subjects since the mid-1880s. His *Madonna of the Trellis,* shown at the 1889 Salon, emerged as his most modern interpretation of a traditional theme.[6] By the 1894 Salon, with his *Christ à Gethsémani (Christ at Gethsemane)* (fig. 115), he had shifted from religious themes couched in the guise of everyday scenes to the direct depiction of the life of Christ.[7]

FIGURE 115
Head of Christ from
Christ at Gethsemane,
ca. 1894. Archives
Départementales de la
Haute-Saône, Vesoul.

Dagnan-Bouveret's conception of Christ as a tormented man was unusual and suggests that he was equating his own place in society with Christ's in his day. For an eminently successful painter to focus on Christ as a dispirited soul was rare.[8] Critics responded to this visualization in different ways, some recognizing that his treatment broke from the representation of the Savior as the "True Christ." His vision emphasized Christ as a sufferer, with few aspirations and few ideas, thus deemphasizing his divinity; and these qualities were deeply troubling to religious purists.[9] This introspective view of Christ was undoubtedly a reflection of the artist's state of mind. It came at a moment in his career when he was having doubts about his own artistic direction, when naturalism no longer seemed a creative option for him. Since his wife's fervent religious beliefs reinforced his thinking about his role as a creator, it is not hard to imagine that the artist entered a period of personal anguish. His Catholic faith and, in particular, the mystical presence of Christ and the Virgin seemed to bring him comfort, and this is reflected in his painting.

For his *Lord's Last Supper,* the next significant large-scale religious painting, the painter developed an unusual method to convey the idea of spiritual transcendence (see fig. 6).[10] He prepared clay models for his figures[11] so that he could manipulate the lighting of the scene more easily, creating the desired dramatic effect. As he worked on the project, he substituted the clay figures with actual models from Ormoy, whom he posed in a church. There a kerosene lamp was used to illuminate the models, recapturing the effects he had obtained with the clay figures.[12] The artist had, in essence, become a theatrical director, positioning his actors on a stage and modifying the lighting in order to heighten the mystical atmosphere and express Christ's divinity.

In preparation for this work, Dagnan-Bouveret traveled to Berlin and Dresden to study Northern European and Italian Renaissance old master paintings.[13] In Germany, as in France, he may have seen Passion plays and other dramatic presentations reenacting various episodes from the life of Christ.[14] In any event, *The Last Supper* appears to have been conceived and constructed as if it were an actual stage performance.[15] Moreover, his choice to represent this time-honored scene in Christian art demonstrates that the artist saw himself in relation to painters of the past who had worked on the same theme.

In the nineteenth century, as today, the most famous painting depicting Christ's last meal was, of course, Leonardo da Vinci's fresco in Milan.[16] Dagnan-Bouveret made the trip there, and although he found it a pitiful wreck, he was inspired by Leonardo's arrangement of the figures. With this model in mind, he incorporated Leonardo's long white table in the foreground, although, instead of there being a seated Christ, his own hovers over the disciples, his body emitting an intense light. In sharp contrast to his earthbound figure in the earlier *Christ at Gethsemane,* the Lord is portrayed as a disembodied, divine spirit. Using models from Ormoy for the disciples, the artist focuses on their faces, especially the eyes, as they react to the presence of their beloved Savior.

To highlight the presence of Judas, the artist, rather than separating this figure from the other disciples, accentuated his facial features to reveal his betrayal of Christ (fig. 116). Shown at the right, Judas has a dark, dour expression. The painter sketched this face in a charcoal drawing that was at one time a wall decoration in Jules-Alexis Muenier's house in Coulevon.[17] Several other preliminary drawings for *The Last Supper* ended up in the possession of Dagnan-Bouveret's friend Henri Amic. One, drawn in pencil, charcoal, and colored chalk, sensitively captures the expression of the disciple at the left, who is transfixed by Christ's presence at the table (fig. 117). Dated November 1895, the drawing documents that the artist worked on the composition over a two-year period. A second preliminary study for Saint John also entered Amic's collection (fig. 118). Dagnan-Bouveret's resounding success at the Salon with *The Last Supper* in 1896 prompted admirers to send him congratulatory letters and even poems dedicated to the painting. It was also exclusively reproduced by Boussod (the successor to Goupil).[18] The same year, he completed a replica of the work, which was sold to George McCulloch.[19] The British collector wanted his own version of this composition, which eventually became one of the artist's most controversial images.

The reaction in the press was mixed, both at the time the painting was originally shown and later on when it was exhibited at the 1900 World's Fair. Gustave Geffroy, commenting on the 1896 Salon, found that the artist had tried to show the "sub-

FIGURE 116

Bust of Judas from *The Lord's Last Supper*, ca. 1895. Charcoal on canvas. Dimensions unknown. Signed lower right: P.A.J. Dagnan-B. Location unknown.

FIGURE 117

Study for *The Lord's Last Supper* (head of Disciple), 1895. Charcoal
with colored pencil (red and blue) on squared paper. 20 7/8 x 17 3/4 in.
(53 x 45 cm). Signed and dated lower right: 7 Nov. 95/P.A.J. Dagnan-B.
Abbaye royale de Chaalis, Institut de France, Bequest Henri Amic, no. 15.

FIGURE 118

Study for *The Lord's Last Supper* (head of Saint John), 1895.
Black chalk, colored pencil (red, orange, and mauve),
watercolor on the black garment and touches of yellow in the
eyes. 16 7/8 x 11 in. (43 x 28 cm). Signed lower right:
P.A.J. Dagnan-B. Abbaye royale de Chaalis, Institut de France,
Bequest Henri Amic, no. 16.

lime" and "to paint the miracle [of Christ's appearance]" by flooding the scene with
a "supernatural divine light."[20] The writer for the *Revue Encyclopédique* was also
supportive of the work, noting that the figure of Christ had to be understood liter-
ally and symbolically, for it was through his presence that "light" entered the dis-
ciples' souls and also those of the viewers of the painting.[21] Lafenestre, the reviewer
for the *Revue des Deux-Mondes,* examined the work in great detail, drawing analo-
gies with Italian Renaissance masterpieces. He noted what pains had been taken to
render each disciple's features, especially those of Judas, his eyes transfixed and
unfeeling.[22] Other writers were equally impressed by the painting, although some
found it poorly lit, filled with false theatricality, and not equal to Leonardo's achieve-
ment. In the end, the most devastating criticism was that the figures recalled actors
in a staged performance.[23] In 1900, when the painting was shown in a special instal-
lation of the artist's major religious canvases at the Exposition Universelle, it was
further lambasted in the *Revue Bleue.* Time had not been kind to the work. The
critic wrote: "I don't know any work that is more pretentious, more exasperating in
its ambitious pretensions, and more in disagreement with the feeling of the
theme."[24] Dagnan-Bouveret was clearly at the center of a religious firestorm that

had as many detractors as it had supporters. This debate deserves to be examined in some detail, for it resonated within the larger community of academic painters and their critics in France.

Dagnan-Bouveret's *Last Supper* was based on an awareness of past masters who represented the theme; he deliberately studied their works in preparation for his own composition. In the spirit of his renewed faith, the artist attempted to invoke the divine in two ways: through the light that seems to emanate from the figure of Christ and through the expressions of awe on the seated disciples' faces. His intention was to modernize the tradition of religious painting, as he later told his colleagues and close friends. His experimentation with dramatic light effects (derived in part from artists as varied as Rembrandt or even Caravaggio), which was at the heart of his attempt to revitalize the ancient tradition, was, unhappily, just the kind of artifice most critics objected to, finding it false or even fake. Moreover, the emotionalism of the disciples, an element that derived not only from his studies of actual models (evidence of his maintaining the tradition of the Ecole des Beaux-Arts) but also from his memory of religious Passion plays, alienated many reviewers. It is to the artist's credit that he tried to find a more modern approach for conveying Christ's Passion to a nineteenth-century audience. That he was attacked specifically for being too theatrical suggests that at least a few critics were aware of his sources. Whether or not they were, they disapproved of these effects in a devotional painting. While the theatrical presentation appealed to some, his complicated approach to religious themes made the evaluation of his work complicated as well.

When he read the reviews of *The Last Supper,* he was hurt, especially when other painters, among them Edgar Degas, attacked it.[25] Yet the painting found a receptive collector in Paris, Martine de Béhague, countess of Béarn, who hung the painting in her townhouse as part of a theatrical installation that attracted considerable attention from other symbolist painters and avant-garde playwrights.[26]

Dagnan-Bouveret's next religious painting, *Le Christ et les pèlerins à Emmaüs* (*Christ and the Disciples at Emmaus*) (fig. 119), was purchased, soon after its completion, by Henry Clay Frick of Pittsburgh, demonstrating the worldwide interest in the artist's spiritual themes, as well as in his earlier works on Breton subjects. Completed in 1897, when controversy was swirling around *The Last Supper,* the new painting was exhibited in London (at the gallery of Arthur Tooth) before being shown at the Paris Salon of the Société Nationale in 1898.[27] He selected the moment when the disciples recognize Christ, as described by Saint Luke: "And it came to pass, as He sat at the meal with them, He took bread and blessed it, and broke, and gave to them, And their eyes were opened and they knew Him: and He vanished out of their sight." The painting follows in the tradition of Netherlandish painting, in which artists regularly included themselves or their donors in the composition, an unusual device for the nineteenth century; the representation of the painter and his family at the right further ignited controversy among the critics.[28] When the work was displayed in December 1897 in London, the *Times* examined

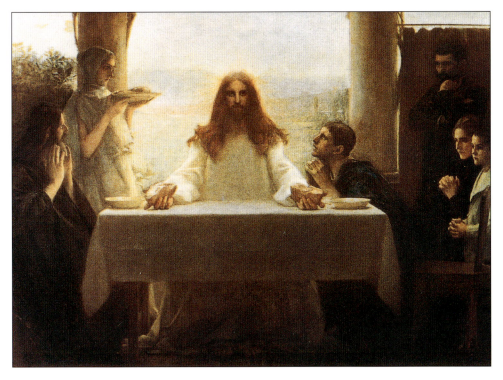

FIGURE 119

Christ and the Disciples at Emmaus, 1896–1897. Oil on canvas. 78 x 110 1/2 in. (198.1 x 280.7 cm). Signed and dated lower left: P.A.J. Dagnan-B 96–97. Carnegie Museum of Art, Pittsburgh. Gift of Henry Clay Frick.

its significance in an article titled "Dagnan-Bouveret's New Picture."[29] The author noted that the painter was following a course between traditional artists (such as Raphael and other masters of the Italian Renaissance) and modern religious genre painters, including Fritz von Uhde in Germany and James Tissot in France. The addition of the portraits of the artist and his family gave the painting a personal and quite controversial dimension, since their identities were known. Not only an oil sketch for this group portrait but also preparatory photographs have come down to us (fig. 120). According to the *Times,* the painter explained the three figures as "representatives of the modern world face to face with the Divine mystery. The woman and child are kneeling; the man stands perplexed. . . . [The] man, after all his troubles, after all his doubts and denials, can no longer kneel as he once did. His brow is careworn, anxiety has desolated his heart."[30] This deeply personal interpretation was published in an effort to dispel any attacks against the work, and it helps to explain why Henry Clay Frick was so moved by the composition that he bought it for Pittsburgh.[31]

By the time the exhibition closed in London, *Disciples at Emmaus* had attracted considerable international notice.[32] The newspapers in Pittsburgh began to publish articles on the painting and what Frick had paid for it.[33] One article in particular examined the controversy raging in London over the artist's inclusion of himself and his family in the composition. Its author asserted that the painter had portrayed himself as a skeptical theologian, one whose dress as a *boulevardier* was antagonistic and sacrilegious.[34] Talk of the painting spread to Chicago, where the *Tribune* accused Frick of buying a "freak." The reviewer railed that such religious skepticism

FIGURE 120

Sketch of donors in *Christ and the Disciples at Emmaus*, ca. 1896. Oil on canvas. 7 7/8 x 7 7/8 in. (20 x 20 cm). Private collection.

was inappropriate and claimed that Frick, even more than the painter, was insensitive to needy members of society.[35]

When *Disciples at Emmaus* was unveiled in Paris at the Salon of the Société Nationale des Beaux-Arts in April 1898, the press devoted considerable attention to it. The painting came with considerable art-critical baggage. Louis de Fourcaud, who had written earlier on Dagnan-Bouveret's paintings, tried to blunt attacks against the painting, proclaiming the figures at the right to be "beautiful," perhaps more "saintly religious than the principal subject [the Christ]."[36] The critic for *La Liberté* championed the work more strongly: he placed the work within the context of both past and contemporary religious painters, calling Dagnan-Bouveret "an excellent painter and a fervent Christian."[37] In his view, the artist had constructed a "poetic landscape" with Christ "seated in front of a very humble table." While he approved of the light emanating from Christ's body as an effective "emblematic device suggesting divinity," the writer felt that the artist had portrayed Christ as an "unmoving" and "cold" figure, repeating some of the criticisms that had been made about *The Last Supper*. The critic writing for the widely read *L'Evénement* praised the composition's beauty and the facial expressions of those witnessing the miracle,

as well as the spiritual quality achieved through the mystical play of light.[38] *Disciples at Emmaus* was widely discussed on both sides of the Atlantic, contributing to Dagnan-Bouveret's fame and notoriety as a contemporary painter.

Henry Clay Frick, who had bought the painting on the spot when he had seen the work in Europe, was prevented from traveling abroad to the Salon in Paris. Before having it shipped home to Pittsburgh, he arranged a showing in New York.[39] Since the canvas was to be one of the principal works displayed at the Carnegie International and was also the first work donated to the Carnegie Institute, the contemporary-painting museum established in Pittsburgh, its arrival in the city was eagerly anticipated.[40] At the opening of the Carnegie International, the *Pittsburgh Post* gushed, "the one great picture which dominates everything is 'The Christ' by Dagnan-Bouveret. Any exhibition would be great which held this masterpiece by the great master."[41]

The painting had evolved slowly. The artist executed preliminary charcoal studies for each major figure, focusing on the facial features in each figural drawing to convey intense religious devotion.[42] Following his usual practice, he took photographs of his family for the group portrait at the right (figs. 121, 122), again using

FIGURE 121

Photograph of Anne-Marie Dagnan Used in the Preparation of "Christ and the Disciples at Emmaus," ca. 1896. Archives Départementales de la Haute-Saône, Vesoul.

FIGURE 122

Photograph of Jean Dagnan Used in the Preparation of "Christ and the Disciples at Emmaus," ca. 1896. Archives Départementales de la Haute-Saône, Vesoul.

FIGURE 123

Christ and the Disciples at Emmaus (reduced version), 1897. Oil on panel. 26 1/2 x 37 7/8 in. (67.5 x 96.2 cm). Signed upper right: P.A.J. Dagnan-B. Frick Art and Historical Center, Pittsburgh. Photograph courtesy Frick Art and Historical Center.

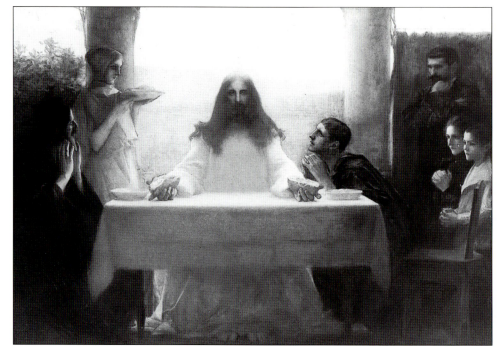

his wife as a model after her not posing for him since his *Brittany Women at a Pardon*. We can only speculate about how Dagnan-Bouveret intended *Disciples at Emmaus* to be exhibited. Placing the work in a completely darkened room, for example, would have intensified the ethereal mood of the "miracle" that he had painted. At Frick's request, the artist produced the identical composition on a smaller scale for the collector's private residence (fig. 123), where it created a similar effect.[43]

By 1899, Dagnan-Bouveret had completed another major religious composition, the *Consolatrix Afflictorum* (*The Consoling Madonna*) (fig. 124). Frick, upon learning of the new work, immediately expressed an interest in purchasing it, although he did not actually pay for the canvas until April 1901.[44] The artist had begun thinking about this painting as early as December 1897, when he wrote to his wife that "I have a theme that would involve me, a type of Madonna of the Afflicted, which I think I have already discussed with you."[45] His new picture would show a woodland scene with a Madonna and Child, enveloped in a great cloak, similar in color to the "greenest moss." The Madonna was to be surrounded by "a small deer, a small rabbit, and birds." These animals, he explained, would enhance the impression of calm, peace, and innocence, contrasting with the sorrow of the suffering man crouching at the Madonna's feet. In the summer of 1898, when he was living at Quincey, near Vesoul, he paid particular attention to the woods near his home for the painting's setting.[46] The idea for the theme most likely came to him because his wife was suffering from severe arthritis, among other ailments; in addition to reflecting his concern for her, he also wanted to emphasize the care that Anne-Marie had always shown for others, including himself.

FIGURE 124

Consolatrix Afflictorum, 1899. Oil on canvas. 86 1/4 x 74 3/4 in.
(219 x 190 cm). Signed and dated lower left: P.A.J Dagnan-B
1899. Frick Art and Historical Center, Pittsburgh. Photograph
courtesy Frick Art and Historical Center.

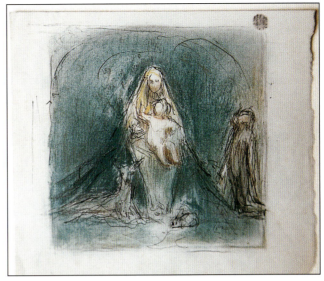

FIGURE 125

Study for *Consolatrix Afflictorum,* ca. 1899. Pastel, pen and ink,
and gouache on paper. 5 x 5 1/2 in. (12.8 x 14 cm). Private collection.

 To prepare the final painting, the artist made several compositional studies. In
one version, the green woodland setting is particularly vivid, and the male figure
imploring the Madonna kneels with arms at his sides slightly outstretched in a pose
of supplication (fig. 125). In the finished work, he hides his head in his hands as he
lies prostrate before the enthroned Madonna. The final pose emphasizes even more
strongly that the figure is a symbol of the most distressed elements of society. The
artist also made a painted study of the bust of the Madonna dated July 1898 (fig.
126).[47] This pensive "portrait," inspired by Leonardo, reveals Dagnan-Bouveret's
continuing association with the Renaissance master. The delicate, pastel tones cre-
ate an otherworldly effect. The work is dedicated to Mme Julia Bartet, an actress at
the Comédie-Française and a collector of his art; the dedication may also suggest
that something he had seen in the theater helped him realize this composition.

 In a letter to Mme Bartet, the painter explained that his Madonna "emerges
from the earth, she is part of it."[48] Seated on a low throne, surrounded by angels and
animals, this Madonna of mercy holds a pomegranate, signifying the unity of the
church and the earth's continuous rejuvenation each spring. This symbolic group
also provides the primary message of the painting: that belief in the Madonna and
Christ heals human suffering while offering hope for immortality and resurrection.
The painter intended this message of hope for his wife, whom he saw as his earth
mother and as the salvation of his life; it was also evidently relevant to Frick, who
hung it in his mansion's dining room in Pittsburgh.[49]

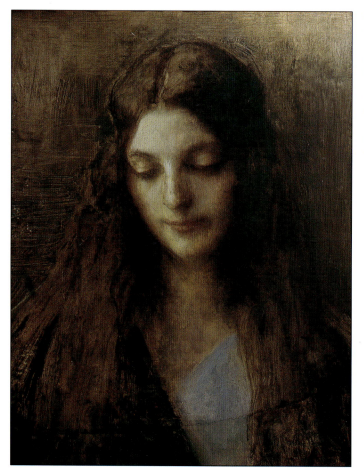

FIGURE 126

Study for *Consolatrix Afflictorum,* 1898. Dated on the back: 1898. Oil on paper laid down on cardboard. 16 7/8 x 13 in. (43 x 33 cm). Signed and dedicated lower left: à Madame Bartet bien affectueusement P.A.J. Dagnan-B. Musée Georges Garret, Vesoul, France.

The *Consoling Madonna* was among the group of works by the artist shown at the Décennale exhibition held in conjunction with the Exposition Universelle of 1900.[50] At this exhibition, Dagnan-Bouveret, who had been one of the most productive French painters of the past decade, was given his own special area where many of his best paintings could be studied and admired.[51] In effect, this was a small retrospective exhibition, a singular honor for a painter at the World's Fair.

Critics christened the space the "sanctuary of Dagnan-Bouveret," since *The Last Supper,* as well as the *Consoling Madonna,* dominated the works shown. While some still found his religious imagery overdone or lacking in what they defined as true "compassion," others drew positive parallels between his work and the compositions of Jan van Eyck or the English Pre-Raphaelites.[52] The Pre-Raphaelite movement, and Edward Burne-Jones in particular, were very popular in France, and Dagnan-Bouveret's newest painting seemed allied with the intense religious spirit of this style. One critic, unable to grasp the *Consoling Madonna*'s complexity, simply deemed the painting "étrange."[53] However, another, writing for the *English and American Gazette,* called the the work "a very beautiful picture," a true "peinture sacrée."[54]

The reviewer for *Le Figaro Illustré* took a larger view of Dagnan-Bouveret's efforts, writing that the installation should have included earlier works showing his

relationships with the old masters, such as Jean Clouet or Hans Holbein, especially in his handling of facial features as revealed in the numerous Brittany scenes. This was the "definitive Dagnan," whose simpler compositions were also purer. The same critic found *The Last Supper* and the *Consoling Madonna* "too complicated and laborious" in comparison with the artist's earlier works.[55] Another, writing for *La République Française*, praised the "exquisite sentiment" of the *Consoling Madonna, The Recruits, Breton Women at a Pardon,* and other compositions in the Décennale. In the eyes of this writer, Dagnan-Bouveret was at the peak of his powers and his works "among the best produced in France over the past ten years."[56] Despite some scathing reviews in Pittsburgh concerning the *Consoling Madonna*, the general consensus in France regarding the level of Dagnan-Bouveret's creativity in 1900 was positive, and he was awarded the Grand Prix at the Exposition Universelle.[57]

Dagnan-Bouveret's latest paintings clearly aligned him with the conservative arm of French art. In recalling the old masters, whether Dutch, Netherlandish, or Italian, the artist revealed, once again, that his influences were rooted in the tradition of the Ecole des Beaux-Arts. With his innovative use of photography, he had helped modernize genre painting earlier in this decade; however his supernatural compositions, his expressive color harmonies, and his desire to be equated with the masters of former times drove him further away from the progressive symbolists and younger avant-garde painters. At the same time, his imagery became increasingly attractive, even sought after, by members of the French academy.

The year 1900 saw another critical moment in Dagnan-Bouveret's career, one that would have a lasting effect, enduring for the remainder of his life. A position in the Académie des Beaux-Arts, a section of the Institut de France, became vacant with the death of the still life painter Antoine Vollon. It was the dream of every traditionally trained painter to become an academician, since it proffered power and prestige with its fixed membership and lifetime recognition. Membership proved, however, elusive, as the Académie des Beaux-Arts remained a small, exclusive body.[58] The average age of members was fifty-three; electors favored seasoned candidates, since election to the post entailed that the academician would participate in molding teaching instruction at the Ecole des Beaux-Arts, thereby helping to carefully monitor the creative approaches that would gain public exposure.[59] For several reasons, the 1900 election was a critical one. At that time, the academy viewed its position as insecure. Artistic influences from other countries, combined with pressure from younger French artists who opposed traditional painting techniques and themes, demonstrated that the academy must either adapt or relinquish its role as an effective body whose teachings could be perpetuated for future generations. If its traditions were to be upheld, the academy had to show a degree of openness by electing a member whose work had revealed diversity and creativity.

The debate over who would succeed to Vollon's seat was covered in the daily press. Some writers favored Henri Harpignies, others Jean-Charles Cazin, Théobald

Chartran, or Léon Lhermitte. At the top of the list, however, was Dagnan-Bouveret.[60] At age forty-eight, he was among the younger candidates being considered for this honor.[61]

The seat was hotly contested, with three votes being taken before a winner was finally declared. On the first ballot, Dagnan-Bouveret received twelve out of the nineteen votes needed for confirmation; eleven votes were for Léopold Flameng.[62] Dagnan-Bouveret saw his votes increase on the second ballot; and on the third he received twenty-two, or three more votes than were necessary to win.[63] On November 6, the official tally was filed with the Ministère de l'Instruction Publique et des Beaux-Arts.[64] The daily press welcomed the news; a special edition of *Le Gaulois* was published celebrating Dagnan-Bouveret's election to the Institut.[65] The artist was at the height of his public recognition. Now a member of the academy, he was on a par with his mentor, Gérôme. It was expected that he, as a younger man, would both maintain the traditions of the past and energize the academic system, which at this moment was in a state of considerable confusion. He was poised to become one of the most influential academic painters of the nineteenth and early twentieth centuries. That he did not, and that this election in fact sealed his fate, is one of the ironies of art history. From that time forward the painter began a gradual decline into obscurity.

On the Inside Looking Out VII
1901–1929

D agnan-Bouveret's election to the Académie des Beaux-Arts solidified his position in the art establishment, assured him a lucrative teaching position at the Ecole des Beaux-Arts (if he wanted it), and brought him a steady stream of public and private commissions. However, external circumstances in the art world, as well as his own sense of insecurity, conspired against the artist's desire to join the pantheon of great French painters, in which his mentor, Gérôme, was situated. His late letters are concerned with his artistic achievement; he was obsessed with the thought that his legacy was not to be as strong as he had hoped.[1] Although he did receive commissions for major murals at the Hôtel de Ville and the Sorbonne, as well as for numerous portraits of the wealthy elite of the Third Republic, he watched helplessly as the academy lost its former luster and fell increasingly out of step with younger painters and a good part of the art-going public.[2] The contributions of the academicians to the yearly Salons—whether the Société des Artistes Français or the Société Nationale des Beaux-Arts—were conservative in style and repetitive and often failed to generate the excitement of the Salon exhibitions of the 1890s. From his post at the Académie des Beaux-Arts, Dagnan-Bouveret witnessed the decline of tradition and, with it, the decay of his own creative powers. After 1900, he virtually abandoned genre painting, which had been at the core of his most innovative approaches. Over the remainder of his career, he produced mostly religious scenes, portraiture, and a few public murals. The critical reception of these later works was often lukewarm, in contrast to his earlier successes. The one area in which he had continually maintained his creative drive was as a pastellist (fig. 127). This diverse range of creativity was borne out by an extraordinary showing of

FIGURE 127

Portrait of Mme Théodore Reinach, 1896. Pastel. 26 1/8 x 18 1/2 in. (66.5 x 47 cm). Signed, dated, and dedicated lower right: à Madame Théodore Reinach bien affectueusement/P.A.J. Dagnan-B/mai 96. Gallery Chantal Kiener, Paris.

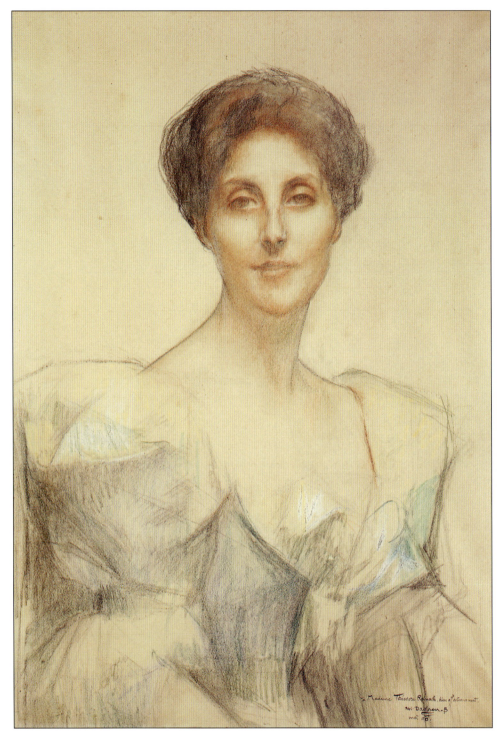

pastels, along with some preliminary drawings, at the 1909 Salon of the Société Nationale des Beaux-Arts. Despite his reception at this exhibition, which was greeted with acclaim,[3] the artist seemed trapped by the official apparatus. His was an unusual case, since he was still relatively young when he began to experience a failure of motivation and imagination.

Intimations of the artist's decline came almost immediately after his election to the academy. As American collectors returned from the Exposition Universelle of

1900, they recognized that this was an opportune moment to show Dagnan-Bouveret's work in the United States.[4] Accordingly, a small exhibition of twelve paintings and one drawing was held at the Art Institute of Chicago in March 1901.[5] One major loan was the *Christ and the Disciples at Emmaus*, which Henry Clay Frick had donated to the Carnegie Museum in Pittsburgh. Other works came from collectors in Montreal (*Bretons Praying*); Hartford; Washington, D.C.; Philadelphia (*Gypsy Camp*); St. Louis; New York (*The Brittany Pilgrimage*, then owned by George Baker); and Chicago (*The Seamstress* [*Breton Woman*], then owned by Potter Palmer). Works that could not be borrowed from France or elsewhere were reproduced as autotypes; this was one of the first instances in which photographs were used in a retrospective exhibition when the actual work of art they reproduced could not be obtained.[6] The show received broad coverage in newspapers in Chicago, Pittsburgh, and other U.S. cities, although not in France. Several Chicago reviewers commented that once they saw the range of Dagnan-Bouveret's work, it became apparent that he was not such a versatile artist after all, an unfortunate conclusion based on a very small sampling of his paintings.[7]

Others attacked his religious imagery, noting that the *Disciples at Emmaus* was "driven by artificiality . . . full of cheap theatricals" and that it was saved only by the portraits of "Dagnan himself, with his wife and child, placed in the obscurity to one side."[8] In short, the first and only American exhibition of the artist's work in his lifetime did not generate much enthusiasm.[9] The painter's elevation to the heights of the French academic system did little to enlarge his international reputation. Moreover, with the ascendancy of such artistic movements as postimpressionism, fauvism, and cubism, his former international renown vanished almost completely.

The American failure was not the only reason Dagnan-Bouveret's star began to dim in the latter years of his life. In 1904, Jean-Léon Gérôme died.[10] The younger man was distraught; he had lost the one person with whom he could discuss the selection of themes he hoped to paint, the organization of a composition, and the public reception of a work. Gérôme had always spoken freely with his student and, even if the latter did not always heed his advice, the influence of this mentor had been profound and long-lasting. Without Gérôme's guidance, he was somewhat lost. His melancholic nature and a sense of his own mortality was heightened by the death of his revered teacher. He never found another friend who would challenge him to create new images.

As a member of the Académie, Dagnan-Bouveret believed in the institution and carried out his duties faithfully. He could finally enjoy the success that came with his new status. With money he received from portraits, and from royalties for the reproduction of his religious paintings, he began to amass a sizeable fortune.[11] By the age of fifty—roughly Dagnan-Bouveret's age when Gérôme died—Dagnan-Bouveret owned several properties, including buildings in Paris and a home in Quincey (near Vesoul) (fig. 128). To this must be added the substance of his wife's

FIGURE 128

Photographer unknown,
*Dagnan-Bouveret's House
at Quincey* (near Vesoul),
between 1897 and 1920.
Archives Départementales
de la Haute-Saône, Vesoul.

inheritance and other family properties in the Haute-Saône, which placed him, in terms of wealth, in the upper echelon of French society. With such material comforts, he was no longer compelled to be as productive as he had been earlier. His position in the Académie assured him of recognition within the social elite, and he had little incentive to respond to new ideas from the outside world of the visual arts. In particular, as a portraitist he maintained essentially the same approach from 1880 to 1920, presumably because his sitters wished to be idealized, and the artist could paint such recognizable works easily and quickly.[12] Sheltered on one side by his social and political connections and on the other by his professional associations with members of Gérôme's entourage or the Ecole des Beaux-Arts, he was increasingly isolated from newer creative artistic trends.

The painter's personal life in the early years of the twentieth century needs further examination. He had always received great comfort from his small family. His constant companion, Anne-Marie, who had always worked closely with him early in his career, entered a period of declining health and died in 1926.[13] Even more tragic was the early death of Dagnan-Bouveret's son, Jean. As a child, he was the subject of innumerable studies (fig. 129) in pencil, chalk, and pastel, and was often posed with his mother (fig. 130). The parents were proud of their intelligent, lively son; having lost a first son in infancy, they were especially devoted to Jean. Photographs record his early years; reaching maturity, he earned degrees in philosophy and medicine.[14] Jean became a specialist in nervous disorders and he published articles in this field, becoming an authority while still a young man.[15] He remained very close to his parents, especially his father, with whom he corresponded regularly once he left home.[16] During World War I, Jean enlisted as a medical specialist, serving with distinction at the front; sadly, he contracted pneumonia from

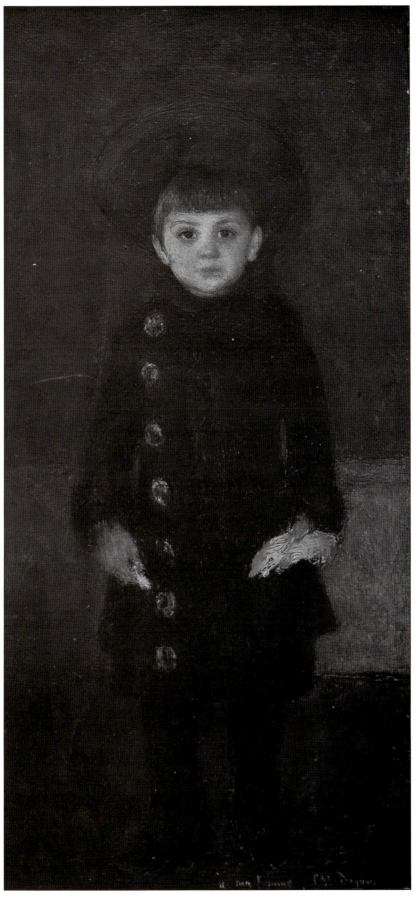

FIGURE 129

Portrait of Jean Dagnan, 1886.
Oil on panel. 6 1/4 x 3 in.
(15.7 x 7.7 cm). Signed and
dedicated lower right: à ma
femme; upper right: JEAN
P.A.J. Dagnan. Musée
Georges Garret, Vesoul.

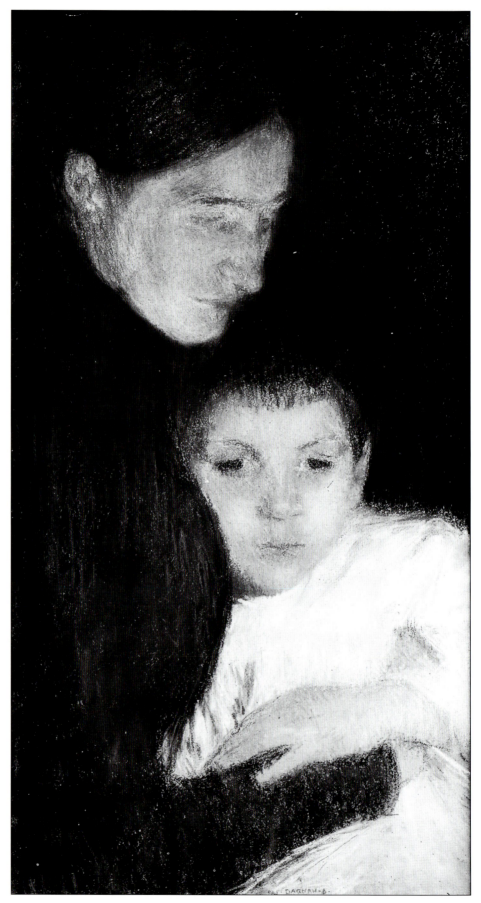

FIGURE 130

*Portrait of Anne-Marie
Dagnan and Son Jean,* not
dated. Pastel on paper. 21 3/4
x 12 1/8 in. (55 x 30.8 cm).
Signed bottom middle: P.A.J.
Dagnan-B. Palais des Beaux-
Arts de la Ville de Paris.

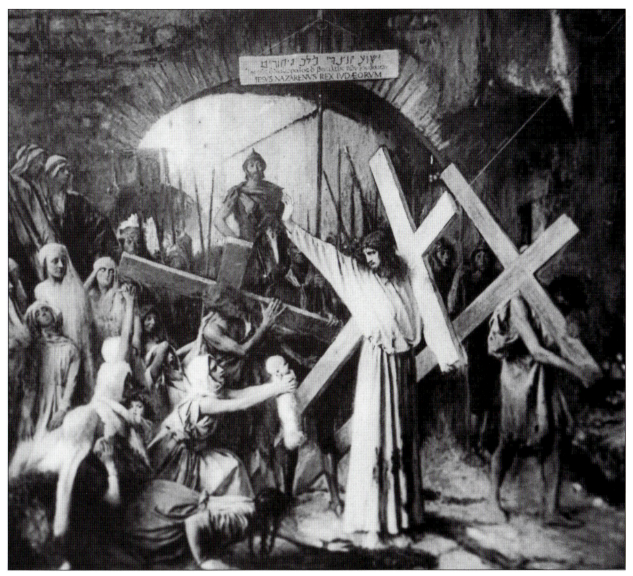

FIGURE 131

Via Dolorosa (from
Catalogue des oeuvres),
1927. Photo author.

overwork and exhaustion, and died in 1918. The news crushed his parents, and
Anne-Marie's poor health deteriorated even further.[17] The ill health and sub-
sequent loss of his wife and son made it difficult for Dagnan-Bouveret to focus on
his art during these later years.

After 1900, the artist developed an ever stronger interest in religious themes.
The combination of his wife's influence as a devout Catholic and his own mystical
inclinations, especially his dedication to the cult of the Virgin, guided several
late works, including *In Excelcis* (*Madonna of the Stars*) (1907), *Vendredi Saint*
(*Good Friday*) (1917), *Mater Dolorosa* (*The Sorrowful Mother*) (1920), *Stabat Mater*
(*Stood the Mother*) (1926), and the monumental *Via Dolorosa* (1927). A number of
these were painted during World War I or shortly thereafter, and beyond their reli-
gious content, they reflect the overwhelming loss experienced by the French
people. In the *Mater Dolorosa,* in which the cross is seen from the back, he con-
centrated on the grief and anguish expressed in the faces and gestures of those at

the base of the crucifix. An independent study of the head of the Virgin captures the artist's own loss of Jean. Hung in the late 1920s in the Eglise du Sacré-Coeur in Vesoul, the canvas became a fitting symbol of Dagnan-Bouveret's continuing faith despite the country's agonizing trials of the recent past, as well as a memorial to his beloved son.[18]

Toward the end of his life, the artist decided to create a major religious master-piece on a grand scale. He considered a Pietà or a Descent from the Cross, and while these were never completed, there are studies for them.[19] He settled on the theme of the *Via Dolorosa* (fig. 131), with imagery linked to that of leading artists of the past. Despite his advanced age, Dagnan-Bouveret began to prepare his magnum opus using the extensive procedures that he had employed throughout his career.

Models were posed for photographs, including the painter himself (fig. 132), who stood near the model for the Roman centurion. The soldier, wearing a helmet, is seen seated on a wooden horse. In the finished painting, the centurion is found in the background, dutifully following Christ along the Stations of the Cross.[20] A second photograph of a mother and a young child was taken inside Dagnan-Bouveret's studio in Quincey (fig. 133); a working sketch for the gigantic composi-tion was placed behind the models, providing the correct scale. In the finished

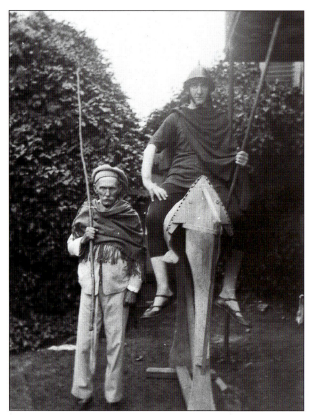

FIGURE 132

Photographer unknown, *Dagnan-Bouveret and Model Posing for "Via Dolorosa,"* ca. 1926. Archives Départementales de la Haute-Saône, Vesoul.

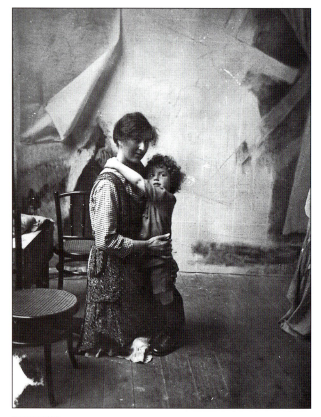

FIGURE 133

Photographer unknown, *Two Models Posing for "Via Dolorosa,"* ca. 1926. Archives Départementales de la Haute-Saône, Vesoul.

FIGURE 134
Study for *Via Dolorosa*, ca. 1926. Oil on canvas. Sight: 19 3/4 x 17 3/4 in. (50 x 45 cm). Private collection.

work, both figures are at the left; the young child looking imploringly toward the viewer is captured exactly as he appears in the photograph. The artist executed detailed preparatory drawings and oil studies for each figure (fig. 134), including one of the young woman at the lower left who is praying to Christ (fig 135). For the elongated and expressive figure of Christ, whose gesture soothes the grieving witnesses, Dagnan-Bouveret expended considerable energy. A number of preparatory studies (fig. 136) demonstrate that, close to the end of his life, he was still capable of creating highly evocative imagery in beautiful drawings. Interestingly, biblical epics were again in vogue, especially in silent films, suggesting that the artist's panoramic composition, which incorporated photographic studies, was an intuitive response to a cinematic visualization of Christ's life. As such, his *Via Dolorosa* was both antimodern and modern at the same time.

When Dagnan-Bouveret died in 1929, the unfinished canvas was placed on view in his studio in Quincey. After Sunday mass, the villagers, many of whom had posed for the artist, were allowed to see the work and were able to recognize themselves in the painting. One visitor even drew a parallel between the painting and *Ben Hur,* a silent film that had been released in 1925.[21] This was an astute observation, as both painting and film created the effect of a seething crowd of troubled souls, effectively reconstructing the ancient world in the time of Christ.[22]

His religious works aside, Dagnan-Bouveret revisited themes that had been most popular at the Salons. He returned to his early obsession with Brittany types

FIGURE 135

Woman Praying (Study for *Via Dolorosa*), 1927. Chalk drawing on paper squared for transfer. 11 7/8 x 8 5/8 in. (30 x 22 cm). Musée Georges Garret, Vesoul.

FIGURE 136

Head of Christ (Study for *Via Dolorosa*), 1925. Chalk, sanguine, and pencil. 8 5/8 x 7 in. (22 x 18 cm). Dated upper right: 29 Juillet XXV. Musée Georges Garret, Vesoul.

in a series of studies, often in pastel, of half-length seated figures. Other pastels, such as *L'Arlésienne* (*The Woman from Arles*) (1907; Musée des Beaux-Arts, Dijon), demonstrate the artist's mastery of this medium. This and other works were shown in the 1909 exhibition at the Salon of the Société Nationale. The large group of pastels from this period reveals that he never lost the ability to work intensely on a small scale, even if his energy sometimes flagged in the process of executing more demanding large-scale projects.

The artist was frequently called on to paint members of prominent families in France and the United States. Portraits from later in his career include the *Portrait of Childs Frick* of 1899 (fig. 137) and the pencil study of *Jacqueline Esquier* of 1914 (fig. 138).[23] He either worked directly from the model or from photographs if necessary. While the faces in these paintings or drawings are often idealized, he excelled at conveying an attitude of distinction and wealth, which was extremely important to his sitters. The demand for painted portraits remained high even in the age of photography: wealthy families could distinguish themselves from members of the middle class by commissioning portraits that they could hang on the walls of their homes, underscoring their sense of power and class. As was the case with other fashionable portraitists, such as Théobald Chartran, Dagnan-Bouveret made

good use of his talent in this artistic category, although he seldom varied his formula. The rare exceptions are portraits of family members or friends, or of regional types such as the *Bernoise* or *The Seamstress* (*Breton Woman*). For an artist with the ability to judge character and to reflect the emotions of a subject in a genre or religious scene, Dagnan-Bouveret's portraits express a curious impassivity. In general, these commissions were accepted by him simply as a way to make money.

Occasionally, in an oil painting, the aging artist moved in another creative direction. His 1908 Salon painting titled *Spanish Dancer* conveys the exotic beauty of his

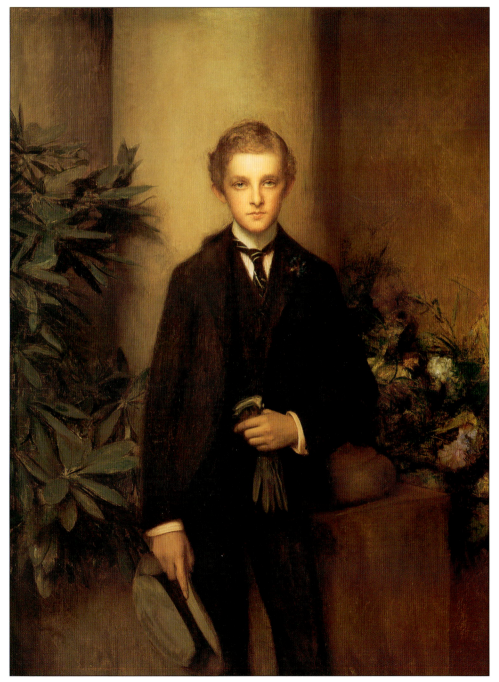

FIGURE 137

Portrait of Childs Frick, 1899. Oil on canvas. 56 1/4 x 42 1/2 in. (143.2 x 108.1 cm). Frick Art and Historical Center, Pittsburgh, Gift of Dr. and Mrs. Henry Clay Frick II.

FIGURE 138

Portrait of Jacqueline Esquier, 1914. Black lead pencil and chalk. 9 x 6 5/8 in. (23 x 17 cm). Signed and dated lower right: P.A.J. Dagnan-B/1914. Abbaye royale de Chaalis, Institut de France, Bequest Henri Amic no. 17.

model, whom he may have seen on stage in Paris (fig. 139).[24] In this close-up half-length view of a young woman, the stage lights seem to illuminate her figure from below, suggesting an inner animation. This work may have been intended as part of a larger composition; in any case, it shows that, late in his career, he could still find models to excite his imagination.

One other genre intrigued the artist later in his career: landscape. Although he had produced independent landscapes in watercolor and oil at various moments earlier in his career—including studies done in the 1870s of the mill at Corre (fig. 140) and some views of Algeria and the Franche-Comté—most were done in preparation for the background of his Salon compositions.[25]

During his summers in Quincey, and in close association with his friend Jules-Alexis Muenier, Dagnan-Bouveret undoubtedly drew inspiration from the landscape near Coulevon and the entire Franche-Comté region. Neither artist painted totally from direct observation, but instead created an academic version of impressionism by relying on their memories of what they had actually seen.[26] One late composition, *Willows by a Stream,* of 1908, evokes a dreamy atmosphere with fading early fall light enveloping the yellow trees at the left (fig. 141).[27] Muenier executed many

compositions similar to this one.[28] Dagnan-Bouveret may have painted landscapes as a way of relaxing from the demands of large figural paintings or portraits, and also as an exercise in color and tonal combinations. They almost certainly were done for his own pleasure.

The painter's post-1900 works reveal not so much a gradual lessening of creative drive as a misdirection of talent. His great desire to create the religious masterpiece that would assure him immortality shows his failure to realize that his real talents lay elsewhere and that painting in the style of the Renaissance was completely passé. Perhaps, if he had followed in the footsteps of religious and symbolist painters such as the German Fritz von Uhde, or the Americans George Hitchcock and Gari Melchers, or if he had simply picked up on his own early symbolist works, he might have avoided a critical decline. Instead, he lost interest in other types of

FIGURE 139

Spanish Dancer, 1908. Oil on canvas. 24 5/8 x 20 1/2 in. (62.5 x 52 cm). Signed and dated upper left: P.A.J. Dagnan-B. Private collection.

FIGURE 140

The Mill at Corre, 1878. Oil on panel. 6 1/4 x 8 5/8 in. (16 x 22 cm). Signed and dated lower left: P.A.J. Dagnan/Corre-Sept. 78. Musée Georges Garret, Vesoul.

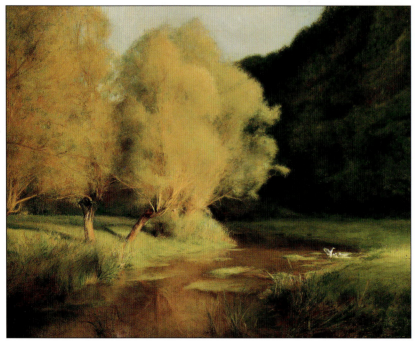

FIGURE 141

Willows by a Stream, 1908. Oil on canvas. 25 3/4 x 32 in. (65.4 x 81.3 cm). Signed lower right: P.A.J. Dagnan-B. Museum of Fine Arts, Boston. Gift of Robert Jordan from the Collection of Eben D. Jordan. Photograph courtesy Museum of Fine Arts, Boston.

imagery and his work—aside from his preparatory studies and pastels—stagnated. His late paintings, while showing no diminishment of the artist's skill, are stale examples of the academic tradition. By virtue of his obsessive commitment to religious iconography painted with an exacting verisimilitude at a time when creative abstraction was the newest tendency in the art world, Dagnan-Bouveret had become a staunch defender of the antimodernist position.

Conclusion

Even as his international reputation waned and he was no longer the innovative artist that he had been in his youth, Dagnan-Bouveret continued to sell his works into the twentieth century. Exclusive dealers such as Arthur Tooth or Boussod-Valadon had no difficulty placing his works with wealthy private clients at high prices.[1] His was still a name that was recognized; if someone wanted a composition by an artist of standing, it was possible to secure one by this well-established painter. His works were selected for touring exhibitions in England and for a show dedicated to the theme of women (Devambez Gallery, Paris), and some connoisseurs of art, especially museum directors, still praised the artist's achievements.[2] However, critics in modernist circles—including Gustave Geffroy, Roger Marx, Octave Mirbeau, L. Descaves, and Georges Lecomte, among many others— showed only disdain for the painter. They did their utmost, through their reviews and connections with dealers and younger collectors, to promote artists of the avant-garde while openly attacking established artists.[3]

As time passed, Dagnan-Bouveret's supporters found themselves, like the artist himself, more and more isolated from the center of the art world. His contacts dwindled and his paintings were increasingly ignored; canvases that had once graced the walls of the Luxembourg Museum were sent to regional museums where they often languished in basement storerooms. As training at the Ecole des Beaux-Arts came to be seen as a means of stifling artistic creativity, and with the leaders of the Ecole ateliers increasingly looked upon as roadblocks to progress, artists who espoused these leaders' principles lost influence. Dagnan-Bouveret was a casualty of this trend and could have done little to counteract it. What makes his story so

poignant and unusual is his severe and rapid descent from the heights of artistic prominence.

His reputation was at first greatly enhanced through his connections with Jean-Léon Gérôme and energetic dealers who not only sold his works, but also reproduced them in photographs and prints. Thanks to a solid promotional network, also available to other academically trained artists, he could keep his name before the public. In 1893, Prince Bojidar Karageorgevitch wrote in the *Magazine of Art* that Dagnan-Bouveret was "a poet and a great artist."[4] In 1894, shortly after the World Columbian Exposition in Chicago, the painter was featured in the American *Century Magazine*. A favorable commentary by the talented writer William A. Coffin was accompanied by a number of illustrations of paintings that were either in American collections or soon to enter them.[5] The good press in the United States continued in 1896 when John C. Van Dyke, a respected connoisseur and art historian, edited a series of essays on contemporary modern French masters.[6] Coffin contributed the piece on Dagnan-Bouveret, which was both complimentary and insightful. He wrote that the artist worked in solitude "more like an artist of the early Renaissance than a Parisian of today."[7] Coffin, who was himself a painter, recognized that Dagnan-Bouveret's slow, careful methods were major attributes of his creative endeavor.

In 1899, the artist was interviewed in his studio in Neuilly by Rowland Strong for the *New York Times Saturday Review.*[8] Strong captured the simplicity of Dagnan-Bouveret's life and his dedication to his work, noting that "his studio is that of an earnest worker, constantly absorbed in his task, and is adorned with none of the more-or-less picturesque frippery that many painters are so fond of. The walls are of bare gray stucco; a narrow gallery of white wood runs around them. The great picture of the Last Supper, which established M. Dagnan's reputation as the first painter of religious subjects living, leans frameless against the wall at the back of the studio behind a white cloth."[9] The image of a hardworking artist painting in an austere setting—suggesting sincerity and frugality—would have appealed to American readers, who were already familiar with Dagnan-Bouveret as the creator of several religious paintings commissioned or purchased by Henry Clay Frick.

Twelve years later, he granted an interview to Louis Gillet for *Lectures pour Tous,* which would have reminded the French people of his contribution to their artistic patrimony.[10] The painter spoke of how he had been trained, his search beyond the confines of the Ecole des Beaux-Arts for themes, and the inspiration for his religious compositions. When asked how he saw his own work, he replied that he viewed it as a combination of poetic effect united with reality. This article ended with a reproduction of *In the Meadow*, a painting that clearly evidenced the two poles of Dagnan-Bouveret's artistic sensibility. This interview most effectively reveals how his work was seen at the time in the context of French art. Contemporary critics interpreted it as uniting two basic strains: symbolism and naturalism.

When the artist died in 1929, less than two decades after the appearance of the article, however, obituary writers had a difficult time placing him in the context of nineteenth-century art, and nearly all failed to understand his unique contribution. Over time his best works had gone into storage or were removed to more remote locations so that the younger generation had little familiarity with them. How he was remembered and how his works were viewed had a lot to do with where the obituary appeared. In one published in the Franche-Comté, Robert Fernier, an astute critic who also wrote about Gustave Courtois and was the author of the first catalogue raisonné of the work of Gustave Courbet (1977), noted that while the artist was not a native, he had quickly embraced the beauty of the region. His teacher, Gérôme; his best friend, Courtois; and his wife's family were all from the Franche-Comté. In Fernier's view, "Dagnan understood the landscape, the look of our people, their roughness and frankness," and he incorporated these qualities into his compositions.[11] Classifying the painter in this way assured him a place of honor among other regionalists and sidestepped the problem of situating him in a broader historical context.

Writers of obituaries for the Parisian papers *Le Figaro* and *La Croix* had more difficulty trying to assess the painter's contribution.[12] Without any disciples to follow in his path, and without works readily accessible, these writers fell back on platitudes. They remarked on his longevity, his diligence, and his skill as a portraitist. Parallels were drawn with masters of former times, especially with Clouet, yet by 1929 it was apparent that his legacy was unclear. In *Le Figaro*, the critic singled out *The Lord's Last Supper*, painted more than three decades earlier, as Dagnan-Bouveret's most famous work, even though it was not regularly displayed.

At the time of the 1930 retrospective at the Ecole des Beaux-Arts, some writers tried to provide a historical perspective for the painter.[13] Albert Flament, in *La Revue de Paris*, placed him alongside Emile-René Ménard and Ernest Laurent—artists classified as symbolists—noting that time had to pass before his work could be fully appreciated.[14] Flament wrote that the painter had not moved far enough away from the traditions of the Ecole. What he failed to appreciate was the artist's unusual practice of painting figures out of doors instead of in the closed interior space of a studio. For Dagnan-Bouveret and a few others, especially Muenier, the "studio" was without walls. Such a plein air approach was common among the impressionists but not among those artists who had remained within the academic tradition.

Other newspaper articles appeared in Neuilly, just outside Paris, where the painter had his private atelier.[15] After reviewing the 1930 retrospective and providing a standard overview of his career, the writers referred to paintings that the artist had executed in Neuilly for the Eglise Saint-Pierre and the Hôtel de Ville.[16] Aside from linking his imagery to the city, however, they failed to situate him in the larger context of nineteenth-century French art. One other reviewer commented on how the artist's reputation had declined since 1900, noting that many of his later works

seemed labored; in his view the 1930 exhibition was an attempt to rehabilitate the artist through the display of earlier examples.[17] The retrospective, however, did not achieve such a goal: the artist remained an anomaly, for his works defied exact interpretation and his position could not be firmly linked with any one style or school of painting. While works such as *Breton Women at a Pardon* were characterized as representative of a type of "modernisme permanent," in 1930, the jury was still out on the artist and his place in history.

In the more than seventy years that have passed, one doctoral dissertation, a master's thesis, and a handful of articles have treated Dagnan-Bouveret's career, and not one exhibition has been devoted to his work.[18]

Yet the artist's story and his involvement with the Ecole des Beaux-Arts and the French Academy, have much to teach us about how the French art establishment of the late nineteenth century tried to right itself at a moment of severe outside attack. Leaders of the Ecole struggled valiantly to equip young academic painters with methods and concepts that they thought would serve them well into the twentieth century. No one, least of all Dagnan-Bouveret, could have predicted the overwhelming tide of modernism that would deluge the academics after 1900.

The artist's contribution can be more clearly elucidated through the evolving theory that there existed in his day an active movement in opposition to modernism. Antimodernism was essentially an elitist, conservative view that placed emphasis on the spiritual cultivation of the individual through the preservation of social privilege and the political status quo.[19] For the adherents of this movement, including Dagnan-Bouveret, the only way to escape from the crass materialism of the age was through spiritual recommitment. While this implied strong religious associations, it also meant a return to the past for inspiration, and an interest in rescuing the culture of earlier times, as Jacob Burckhardt had done in 1860 with his important book on the society and arts of the Italian Renaissance.[20]

An ardent student of the old masters, Dagnan-Bouveret reflected this intellectual approach to the making of art, allowing the modern art historian to interpret his career as a deliberate confrontation with elements of modernism that ran counter to his spiritual beliefs and aesthetic principles. At the same time, the artist did not dismiss every modern tendency, neither in his imagery nor in the manner in which he constructed them. He recognized that the invention of photography was invaluable in the preparation of his paintings, which, like the old master pictures he admired, were wedded to the notion of verisimilitude. He carefully selected modern elements that aided his development and discarded the rest. That he closely guarded the secret of his working procedures until near the end of his life reveals that he wanted to preserve the illusion that he had been following traditional studio practice. Yet his complex preparatory methods were actually remarkably innovative and mark him as a pioneer in this regard.

As an antimodernist who understood and even borrowed from modernism, Dagnan-Bouveret is a fascinating and unusual figure in French nineteenth-century

art history. In coming up against the avant-garde, he worked as an artist and as a member of the art establishment to preserve tradition. At the same time, he was aware of the complexities of the present, and in his search for the "truth," he created compelling images, especially during his naturalist phase, that now strike us as major works of the period. With this understanding of his motivations, even his late religious imagery may withstand closer scrutiny. What is certain is that this complex and private painter should no longer remain hidden within the ranks of French academic painters; rather, his unique contribution deserves the proper recognition that eluded him at the very end of his life, and then for decades to come.[21]

THE SALONS OF P.-A.-J. DAGNAN-BOUVERET

COMPILED BY MICHELLE MONTGOMERY

THE FRENCH SALONS were the most important venues in which artists were able to gain recognition and fame throughout the nineteenth century and into the twentieth. Each year, thousands of artists submitted works to the Salon, where this art could be seen by attendees from throughout the world, reviewed by critics, and judged by the artists' peers.

P.-A.-J. Dagnan-Bouveret had a long and successful Salon career. His first work was accepted into the Salon in 1875, and over the following forty-three years he would show more than 112 paintings, drawings, and pastels at thirty-six different Salons. He won a third-class medal at the Salon of 1878 for his painting *Manon Lescaut* and a first-class medal in 1880 for *An Accident*. By the mid-1880s, he was recognized as a leading modern painter and his work was mentioned and illustrated in magazines such as *Le Monde Illustré, L'Illustration,* the *Magazine of Art,* and the *Gazette des Beaux-Arts.* He won a medal of honor·at the Salon of 1885 for *Horses at the Watering Trough* and was inducted into the Legion of Honor. At the Salon of 1889, he won the Grand Prize for *Breton Women at a Pardon.*

In 1890, after fifteen years of showing at the Salon of the Société des Artistes Français, Dagnan-Bouveret, along with Meissonier and seven other members of the Société, founded the Société Nationale des Beaux-Arts. His success and official recognition continued. He was made an Officer of the Legion of Honor in 1891 and a member of the Institut de France in 1900.

The following is a list of the works that Dagnan-Bouveret showed at the annual Salons, as well as two other important official exhibitions: the Décennale Exposition that accompanied the World's Fair of 1900 and the War Benefit Exposition of 1918.

SALONS OF THE SOCIÉTÉ DES ARTISTES FRANÇAIS

■ Salon of 1875

Dagnan-Bouveret (Pascal-Adolphe-Jean) né à Paris, élève de M. Gérôme, –Rue Notre-Dame-des-Champs, 53.

peinture
> #554 Atalante.

Fille d'un roi de Cyros, Atalante avait appris de l'oracle que peu de temps après son mariage, elle serait changée en monstre. Elle s'avisa de mettre à sa main un prix qui semblait lui assurer qu'elle n'aurait jamais époux: ce fut de ne recevoir que celui qui l'aurait dépassée à la course, se réservant de poignarder les autres. Sa grande légèreté lui faisait espérer qu'elle ne serait jamais vaincue.

[Daughter of a King of Cyros, Atalanta learned from the oracle that shortly after her wedding she would be transformed into a monster. She had the idea to devise a contest that guaranteed that she would never find a husband. Her plan was to accept only the one who was able to overtake her in a race, while she reserved the right to kill the others. Her great speed made her hope that she would never be vanquished.]

dessins, cartons, etc.

#2202 Portrait de M. G. B. . .

#2203 Portrait de jeune ***.

■ Salon of 1877

Dagnan-Bouveret (Pascal-Adolphe-Jean) né à Paris, élève de M. Gérôme, –Rue Notre-Dame-des-Champs, 53.

peinture

#595 Orphée et les Bacchantes.

Les Bacchantes en joie obsèdent le poëte,
Railleuses, l'oeil lubrique et les cheveux flottants;
D'un geste douloureux il se cache le tête;
Il pleure; un long sanglot dans sa gorge s'arrête
Et son oreille est sourde à leurs cris insultants.
 (C. Grandmougin)

[The gleeful, lewd women haunt the poet,
Jeering, with lascivious eyes and flowing hair;
With a pained gesture he hides his face;
He weeps; a long sob remains caught in his throat
And he remains deaf to their insulting shrieks.]

#596 Bacchus enfant.

■ Salon of 1878

Dagnan-Bouveret (Pascal-Adolphe-Jean) né à Paris, élève de M. Gérôme, –Rue du Faubourg-Saint-Honoré, 233.

peinture

#621 Portrait de M. de Rochetaillée.

#622 Manon Lescaut.

Je formai la résolution de l'enterrer et d'attendre la mort sur sa fosse. . . . Il ne m'était pas difficile d'ouvrir la terre dans lieu où je me trouvais: c'était une campagne couverte de sable. Je rompis mon épée pour m'en servir à creuser, mais j'en tirais moins de secours que mes mains.

(L'abbé Prévost, Manon Lescaut)

[I resolved to bury her and to wait for my death on her grave. . . . I had no difficulty in opening the ground where I stood, for it was a sandy plain. I broke my sword to dig [the grave], but I found my hands more useful for the purpose.]

■ Salon of 1879

Dagnan-Bouveret (Pascal-Adolphe-Jean) né à Paris, élève de M. Gérôme, –Rue du Faubourg-Saint-Honoré, 233.

peinture

#810 Une noce chez un photographe.
#811 Portrait de M. G. B. . . .

dessins, cartons, etc.

#3419 Nana, parc Monceaux.

■ Salon of 1880

Dagnan-Bouveret (Pascal-Adolphe-Jean) né à Paris, élève de M. Gérôme, –Rue du Faubourg-Saint-Honoré, 233. Ex.

peinture

#951 Un Accident.

H 1m,45 – L 1m,70.

art monumental et décoratif

#7249 Saint-Herbland.

H 2m,00 – L 1m,70. Pour l'église de Bagneux. –P.S.

■ Salon of 1882

Dagnan-Bouveret (Pascal-Adolphe-Jean) né à Paris, H. C. –Avenue de Villiers, 147.

peinture

#699 Portrait de Mme. G. B. . .
#700 Bénédiction des jeunes époux avant le mariage; coutume de Franche-Comté.

(Appartient à M. Tretiakoff)

■ **Salon of 1884**

Dagnan-Bouveret (Pascal-Adolphe-Jean) né à Paris, H. C. –Avenue de Villiers, 147.

peinture

#636 Portrait de G. Courtois.
#637 Hamlet et les fossoyeurs.

■ **Salon of 1885**

Dagnan-Bouveret (Pascal-Adolphe-Jean) né à Paris, H. C. –Avenue de Villiers, 147.

peinture

#667 Chevaux à l'abreuvoir.
#668 La vierge.

■ **Salon of 1886**

Dagnan-Bouveret (Pascal-Adolphe-Jean) né à Paris, H. C. –Avenue de Villiers, 147.

peinture

#627 Le pain bénit.

 (Appartient à MM. Boussod, Valadon et Cie.)

dessins, cartons, etc.

#2711 Le médecin de campagne.

 (Appartient à MM. Boussod, Valadon et Cie.)

■ **Salon of 1887**

Dagnan-Bouveret (Pascal-Adolphe-Jean) né à Paris, H. C. –Boulevard Bineau, 73.

peinture

#640 Portrait.
#641 Le Pardon; -Bretagne.

■ **Salon of 1888**

Dagnan-Bouveret (Pascal-Adolphe-Jean) né à Paris, H. C. –Boulevard Bineau, 73.

peinture

#685 Paysan breton.
#686 Bernoise.

■ Salon of 1889

Dagnan-Bouveret (Pascal-Adolphe-Jean) né à Paris, H. C. –Boulevard Bineau, 73.

peinture

#680	Madone.
#681	Bretonnes au pardon.

SALONS OF THE SOCIÉTÉ NATIONALE DES BEAUX-ARTS

■ Salon of 1890

Dagnan-Bouveret (P.-A.-J.) né à Paris –73, boulevard Bineau, à Neuilly (Seine). F.

peinture

#233	Portrait de M. S.
#234	Cimetière de Sidi-Kébir (à Blidah, Algérie).
#235	Bords de Rivière.

dessins, cartons, etc.

#1012	Le soir (pastel).
	(Appartient à M. Reilly)
#1013	Étude (pastel).
	(Appartient à M. M.)

■ Salon of 1891

Dagnan-Bouveret (P.-A.-J.) né à Paris –73, boulevard Bineau, à Neuilly (Seine). F.

peinture

#233	Les Conscrits.
#234	Étude de jeune fille.

■ Salon of 1892

Dagnan-Bouveret (P.-A.-J.) né à Paris –73, boulevard Bineau, à Neuilly (Seine). F.

peinture

#283	Portrait.
	(Appartient à M. H. P. . . .)
#284	Portrait d'acteur.
#285	Portrait d'Eugène Burnand.
#286	Sicilienne.
#287	Étude de Breton.

#288 Étude.

#289 Étude de jeune fille.

■ Salon of 1893

Dagnan-Bouveret (P.-A.-J.) né à Paris –73, boulevard Bineau, à Neuilly (Seine). F.

peinture

#276 Dans la prairie.

 (Appartient à M. C. Coquelin)

#277 Dans la forêt.

 (Appartient à M. G. MacCulloch)

#278 Portrait de Mme. L…

#279 Portraits.

■ Salon of 1894

Dagnan-Bouveret (P.-A.-J.) né à Paris –73, boulevard Bineau, à Neuilly (Seine). F.

peinture

#308a Portrait de Mme. S…

#308b Marchande de cierges.

#308c Christ à Gethsémani.

#308d Portrait.

#309e Portrait de J.-A. Muenier.

#310f Portrait de R. de Saint-Marceaux.

#311g Portrait de Mme. Bartet, de la Comédie-Française.

■ Salon of 1895

Dagnan-Bouveret (P.-A.-J.) né à Paris –73, boulevard Bineau, à Neuilly (Seine). F.

peinture

#358bis Les Lavandières.

#358ter Étude de nu.

■ Salon of 1896

Dagnan-Bouveret (P.-A.-J.) né à Paris –73, boulevard Bineau, à Neuilly (Seine). F.

peinture

#365 La Cène.

■ Salon of 1897

Dagnan-Bouveret (P.-A.-J.) né à Paris −73, boulevard Bineau, à Neuilly (Seine). F.

peinture

#361	Portrait de Mme. T. R…
#362	Bretonne (étude dans les tons sombres).
#363	Portrait de Mme. la comtesse de R…
#364	Portrait de Mlle. Diane P…

■ Salon of 1898

Dagnan-Bouveret (P.-A.-J.) né à Paris −73, boulevard Bineau, à Neuilly (Seine). F.

peinture

#340	Le Christ et les pèlerins à Emmaüs.
#341	Portrait de M. J. de S…
#342	Portrait de M. M. C…
#343	Marchande de poissons (Bretagne).
#344	Jeannot.
#345	Bretonne.

■ Salon of 1899

Dagnan-Bouveret (P.-A.-J.) né à Paris −73, boulevard Bineau, à Neuilly (Seine). F.

peinture

#414	Portrait de Mme. L. C…

■ Exposition décennale des Beaux-Arts de 1889 à 1900 (1900)

Dagnan-Bouveret (P.-A.-J.) né à Paris −73, boulevard Bineau, à Neuilly (Seine).

peinture

#533	Bretonnes au Pardon.
#534	Les Conscrits.
#535	La Cène.
#536	Consolatrix Afflictorum.
#537	Lavoir en Bretagne.
#538	Portraits de Mme. D. et son fils.
#539	Portrait de Mme. L. C.

■ Salon of 1901

Dagnan-Bouveret (P.-A.-J.) né à Paris –73, boulevard Bineau, à Neuilly (Seine). F.

peinture

#237 Portrait de Mme. G. M…

■ Salon of 1902

Dagnan-Bouveret (P.-A.-J.) né à Paris –73, boulevard Bineau, à Neuilly (Seine). F.

peinture

#288 Portrait de Mme. P. R…
#289 Portrait de Mme. Camille B…
#290 Portrait de M. J. L. Gérôme.
#291 Portrait de Mme. la comtesse S…
#292 Jésus enfant.

(Appartient à MM. Tooth and Sons.)

#293 Recueillement.

(Appartient à MM. Tooth and Sons.)

■ Salon of 1903

Dagnan-Bouveret (P.-A.-J.) né à Paris –73, boulevard Bineau, à Neuilly (Seine). F.

peinture

#347 Portrait de Mme. R. V…
#348 Portrait de Mme. F…
#349 Portrait de la duchesse de M…
#350 Étude.

■ Salon of 1904

Dagnan-Bouveret (P.-A.-J.) membre de l'Institut, né à Paris, –73, boulevard Bineau (Neuilly-sur-Seine). F.

peinture

#322 Portrait de la duchesse de B…
#323 Sur les cimes.

■ Salon of 1905

Dagnan-Bouveret (P.-A.-J.) membre de l'Institut, né à Paris, –73, boulevard Bineau (Neuilly-sur-Seine). F.

peinture

#336 Portrait de la duchesse de M***.

#337 Portrait de Mme. R…

#338 Jeune vénitienne.

#339 À la fontaine.

■ Salon of 1906

Dagnan-Bouveret (P.-A.-J.) membre de l'Institut, né à Paris, –73, boulevard Bineau (Neuilly-sur-Seine). F.

peinture

#321 Portrait.

#322 Portrait de Mme. la baronne de M…

#323 Étude.

■ Salon of 1907

Dagnan-Bouveret (P.-A.-J.) membre de l'Institut, né à Paris, –73, boulevard Bineau (Neuilly-sur-Seine). F.

peinture

#317 Chimères.

#318 In excelsis.

#319 Portrait.

■ Salon of 1908

Dagnan-Bouveret (P.-A.-J.) membre de l'Institut, né à Paris, –73, boulevard Bineau (Neuilly-sur-Seine). F.

peinture

#280 Portrait de la comtesse de H…

■ Salon of 1909

Dagnan-Bouveret (P.-A.-J.) membre de l'Institut, né à Paris, –73, boulevard Bineau (Neuilly-sur-Seine). F.

peinture

#292 Portrait de la comtesse G…

#293 Portrait de Mlle. M. R…

#294 Portrait de Mlle. C. P…

#295 Danseuse espagnole.

#296 Allégresse.

■ Salon of 1910

Dagnan-Bouveret (P.-A.-J.) membre de l'Institut, né à Paris, –73, boulevard Bineau (Neuilly-sur-Seine). F.

peinture

#308 Ophélie.

#309 Portrait de Mme. R. B…

#310 Portrait de Mme. de B…

■ Salon of 1911

Dagnan-Bouveret (P.-A.-J.) membre de l'Institut, né à Paris, –73, boulevard Bineau (Neuilly-sur-Seine). F.

peinture

#333 Portrait de Mlle. B. O…

#334 Portrait de Mlle. V. O…

#335 Gildys.

■ Salon of 1912

Dagnan-Bouveret (P.-A.-J.), Français, né à Paris, –133, boulevard Bineau, à Neuilly-sur-Seine. F.

peinture

#352 Marguerite au Sabat.

#353 Nocturne.

#354 En prière.

#355 Pêches.

#356 Fruits.

■ Salon of 1913

Dagnan-Bouveret (P.-A.-J.), Français, né à Paris, –133, boulevard Bineau, à Neuilly-sur-Seine. F.

peinture

#297 Portrait de Mme. C. B…

#298 Portrait du général de T…

#299 Esquisse.

#300 Le bénitier.

#301 À Notre-Dame-de-la-Clarté (Bretagne).

■ Salon of 1914

Dagnan-Bouveret (P.-A.-J.), Français, né à Paris, –133, boulevard Bineau, à Neuilly-sur-Seine. F.

peinture

#284 Portrait de Miss D. G…

#285 Marchande de citrons.

#286 Receuillement.

■ 1918. Exposition Organisée sous le patronage de la Ville de Paris au Profit des oeuvres de Guerre de la Société des Artistes Français et de la Société Nationale des Beaux-Arts

Dagnan-Bouveret, à Neuilly-sur-Seine, boulevard Bineau, 133. S NB A.

#139 A Notre-Dame; -en Bretagne.

> (Appartient à M. Nicaise.)

N.B.: Salon catalogs do not always list all of the honors that an artist has won or the years that these honors were awarded. For a more complete list of Dagnan-Bouveret's honors, see Gabriel Weisberg, *The Realist Tradition: French Panting and Drawing, 1830–1900* (Bloomington: Indiana University Press, 1980), 284.

 NOTES

INTRODUCTION

1. *Catalogue des oeuvres de M. Dagnan-Bouveret (peintures)* (Paris: Chez Maurice Rousseau, 1930). The retrospective exhibition included works done from 1869 until 1927.

2. The exception is Jules-Alexis Muenier, also a member of the Institute and a former student of Jean-Léon Gérôme, who remained aware of Dagnan-Bouveret's contribution until his own death in 1942. On both these men, see Archives of the Institut de France, relative to Dagnan-Bouveret and Jules-Alexis Muenier. During the last years of his life, Dagnan-Bouveret was concerned about his legacy. He discussed the matter with family friends, who transcribed his thoughts in an unpublished manuscript known as "Son dernier été—1928," in which his introspective spirit was noted (3–5) and in which his friends, especially the Legrands, are shown to have tried to calm his anxiety about his legacy.

3. Gérôme's opposition to impressionism and to the avant-garde painters being exhibited in French public museums is well chronicled by Gerald Ackerman. See *The Life and Work of Jean-Léon Gérôme with a Catalogue Raisonné* (Paris: Sotheby's, 1986). Gérôme's opinions about the avant-garde, however, seem also to have been attributed by those in opposition to the academic tradition to Gérôme's leading students, such as Dagnan-Bouveret, even if they were not as vociferous in their hatred of modernism as their teacher had been. It was often guilt by association. Also see Mme J. Hubert (Suzanne Legrand), "Essai de jugement" (95–149), in "Notes sur Dagnan-Bouveret I et II," a handwritten document given to the author by a private collector, through the assistance of Jean-David Jumeau-Lafond, which contains Dagnan-Bouveret's scorn for impressionism and the Caillebotte bequest, among other things. The role of the Salons in the early twentieth century as bastions for outmoded traditionalism needs to be carefully reassessed in light of realist and photographic image making in these yearly exhibitions.

4. See *Catalogue des oeuvres*, 19–20.

5. The location of his later works, often portraits, has been severely restricted by the fact that these images are still in the possession of French families who are often not aware of the value of his art. Photographic examples of a number of later portraits by the artist are found in the Archives Départementales de la Haute-Saône, Vesoul, in the *fonds* dedicated to the artist. The actual works, however, are still to be located.

6. For obituaries, see the extensive compilation of this material in the Archives Départementales, Vesoul. Often writers of these notices tried to place the painter's career in a much broader historical context, although, in 1929, this was difficult to establish. See pp. 135–136 for an assessment of some late comments.

7. A Dagnan-Bouveret painting was included in *The Realist Tradition: French Painting and Drawing, 1830–1900* (Cleveland: Cleveland Museum of Art, distributed by Indiana University Press, 1980), representing the first time in recent memory that one of his works had been put on display within a larger historical and aesthetic context. Articles followed, including Gabriel P. Weisberg, "P.A.J. Dagnan-Bouveret and the Illusion of Photographic Naturalism," *Arts Magazine* 56 (March 1982): 100–105, and by 1992 his naturalist aesthetic was fully revealed in Gabriel P. Weisberg, *Beyond Impressionism: The Naturalist Impulse* (New York: Harry N. Abrams, 1992).

8. On the death of the Salon, see Patricia Mainardi, *The End of the Salon: Art and the State in the Early Third Republic* (Cambridge: Cambridge University Press, 1994). Artists were in control of the

Salon by 1883. Two Salons (including that of the Société Nationale des Beaux-Arts) were effectively dominant during the decade 1890–1900, a crucial period for the evolution of the artist's career.

9. While the Salon of the Société Nationale des Beaux-Arts was considered more inclusive and more open to new ideas, and while it generally gave artists more leeway to conduct their own affairs, some, such as the avant-garde critic Octave Mirbeau, did not see any difference between it and the Salon des Artistes Français. He wrote that "le Champ-de-Mars reflète plus exactement peut-être que son concurrent le mercantilisme du peintre et le snobisme de l'amateur. Dans le Champ-de-Mars, on est plus près qu'aux Champs-Elysées du banquier juif, de la cocotte mondaine, du mensonge social, parce que la mode s'y porte davantage." See Octave Mirbeau, *Combats esthétiques 2, 1893–1914,* edited by Pierre Michel and Jean-François Nivet (Paris: Nouvelles Editions Séguier, 1993), 36–37.

10. See Letter of Dagnan-Bouveret to his wife, March 7, 1879, Archives Départementales, Vesoul. He describes his hatred of the commotion on the first day of the Salon; he disliked the ways in which various artists tried to position themselves to outdo their neighbors. Observations on the painter's personality generally support the view that he was urbane, was often quite shy, and kept people at a distance. His modesty was often commented upon. However, he had another side, in which a degree of arrogance and haughtiness reigned. For reference to his personality, see Mme J. Hubert (Suzanne Legrand), "Son dernier été—1928," 6–7, in Notes sur Dagnan-Bouveret I et II.

11. By the time of the artist's stay at the Ecole, the value of the Prix de Rome was openly challenged. (See Philippe Burty, "Les Prix de Rome," *Le Rappel,* [n.d.] 1869, for a discussion of the fallacies associated with obtaining the award.) Reinforced by Gérôme, he recognized that his not obtaining the Prix de Rome was a valuable lesson, since it allowed him to remain more independent in spirit.

12. On the position of genre painting, see Gabriel P. Weisberg, *Redefining Genre: French and American Painting, 1850–1900* (Washington, D.C.: Trust for Museum Exhibitions, 1995). At first, the artist had some difficulty in totally eliminating anecdotal references in his works, as will be discussed later in this book. By the mid-1880s, his anecdotalism, which had resulted in some genre paintings being seen as filled with a series of figural vignettes, became more cohesively integrated.

13. For debates on this material, see Weisberg, *Redefining Genre.*

14. On Gérôme's teaching ability and the role of his international students, see H. Barbara Weinberg, *The American Pupils of Jean-Léon Gérôme* (Fort Worth, Tex.: Amon Carter Museum, 1984). Also see Henri Rameau, *Disciples de Gérôme: P. Dagnan-Bouveret, G. Courtois. L. Girardot. J.-A. Muenier* (Vesoul: l'Imprimerie Portusienne, 1979). The question of artists producing second and third versions of popular Salon successes or having students complete "répliques" of their best-known works is only slowly being examined. A session chaired by Patricia Mainardi at the College Art Association meetings in Philadelphia, 2002, addressed the place and the necessity of understanding the value of these works.

15. On Dagnan-Bouveret's and Muenier's commitment to photography, see Gabriel P. Weisberg, "Jules-Alexis Muenier and Photo-Realist Painting," *Gazette des Beaux-Arts* (February 1993): 101–113.

CHAPTER I ▪ THE EARLY YEARS

1. The artist added his maternal grandfather's surname, Bouveret, to his signature beginning in the 1870s. For the sake of convenience, he will be referred to throughout as "Dagnan-Bouveret." See especially p. 19.

2. The family background of Dagnan-Bouveret is discussed by J. Dampt in "P.A.J. Dagnan-Bouveret (1852–1929)," in *Catalogue des oeuvres,* and enlarged and corrected by Pauline Grisel, "P.A.J. Dagnan-Bouveret à travers sa correspondance" (D.E.A. d'Histoire de l'art, Université Lumière, Lyons II, January 1987). Most of the information contained in Grisel's text was gathered from the correspondence between members of the Dagnan and Bouveret families during the early years of Dagnan-Bouveret's life.

3. Grisel, "P.A.J. Dagnan-Bouveret," 16. While Dagnan-Bouveret's grandfather was depressed over losing money and having to borrow funds, in 1853, Dagnan-Bouveret's father was counseled by his wife, Louise (Dagnan-Bouveret's mother), to continue working on his own, since it appeared as if this would provide a more secure foundation for his family.

4. Ibid.

5. Ibid.

6. Ibid., 17. The history of Bernard Dagnan's private wealth could not be traced, since it involved bank failures in South America. What is apparent is that this was a tragic side to Dagnan-Bouveret's background, making it all the more imperative that he establish himself on his own.

7. See Archives Départementales, Vesoul. The letter is dated February 7, 1867. In it Bernard Dagnan notes that since he has received good reports about his son's character, and since he is not yet certain what he wants to do with his life, he and his associate M. Millet are suggesting that he come to Rio to work in their business: "C'est une chose très rare que l'on offre un avenir ainsi à un garçon qui [est] encore sur le bac [sic] des écoliers, ainsi je te conseille d'accepter de suite."

8. It was because of the friendship with the Legrands that the considerable material they kept on Dagnan-Bouveret's life and work was preserved and eventually given to the Archives Départementales, Vesoul. This considerable holding will be consulted by future scholars interested in expanding their knowledge of Dagnan-Bouveret by examining archival documentation that is now carefully indexed and preserved. For reference, see Dagnan-Bouveret, peintre 12 J.

9. This latter is suggested in Grisel, "P.A.J. Dagnan-Bouveret," 19. The documentation on this point is not clearly established, raising the issue that it could be apocryphal.

10. See Registre d'inscription des élèves de l'Ecole des Beaux-Arts, Ecole des Beaux-Arts, Paris, Archives Nationales, AJ52, 246, for April 29, 1869.

11. On Dagnan, see Archives Nationales, AJ 52, 256, no. 3807, which states that Dagnan-Bouveret was admitted as a student in the painting section of the Ecole Nationale et Spéciale des Beaux-Arts on March 22, 1870. According to Robert Fernier, *Gustave Courtois, 1852–1923* (Paris: Aux dépens de l'auteur, 1943), Courtois went back to the Franche-Comté during the Franco-Prussian War and the following Commune; and he returned to Melun. See also correspondence between the artist and Courtois, Archives Départementales, Vesoul. The earliest letter is dated May 27, 1871.

12. On Bonvin's period in London, see Gabriel P. Weisberg, *Bonvin* (Paris: Editions Geoffroy Dechaume, 1979).

13. The majority of these early drawings are owned by private individuals whose ancestors were on close terms with the artist. They provide a rare glimpse into how an academic painter evolved his ideas by making preliminary drawings or independent studies. Most of these works have not been photographed or recorded.

14. Dagnan-Bouveret often talked of his passion for drawing in letters to family and friends. His letters to Courtois, some of them dated in the early 1870s, speak of his desire to become a perfect draftsman. See letter dated August or September 1871 in which he states: "Je peins souvent, je dessine des plâtres, des animaux, des arbres, des costumes . . . je travaille surtout le dessin dont je veux être maître autant qu'il me sera possible" (Archives Départementales, Vesoul).

15. Compiling a complete inventory of the artist's drawings would be a monumental task. Not only is there the issue of locating them within private collections, but there is the additional problem that many were small and done on very fragile paper.

16. The range of the painter's work is documented in Marie Legrand, "Catalogue chronologique des oeuvres de Dagnan-Bouveret," n.p., a handwritten document given to the author by a private collector, through the assistance of Jean-David Jumeau-Lafond. Some of this documentation (but without specific detail) is also found in *Catalogue des oeuvres.*

17. Marie Legrand, "La vie et les oeuvres," 15, unpublished manuscript, completed after discussions with the artist and from family notes. This document was originally to have been deposited with R. P. Martin Philippe Hubert. Handwritten document given to the author by a private collector, through the assistance of Jean-David Jumeau-Lafond. See note 16 above.

18. For reference to this composition, see Legrand, "Catalogue chronologique."

19. Ibid. No record of this painting or studies for it has been located.

20. The information on the family's loss of inheritance is discussed in Legrand, "La vie," 3–4. Further information on the impossibility of recuperating any of the inheritance is found in a letter dated July 30, 1881, addressed to Dagnan-Bouveret by Horace de Choiseul, Sous-secrétaire d'Etat aux Affaires Etrangères. See family papers located in the Archives Départementales, Vesoul. What the letter shows is that Dagnan-Bouveret pursued the matter until 1881, or at least renewed his efforts after the death of his grandfather in 1881.

21. *Papiers de Famille Dagnan-Bouveret, actes d'Etat-Civil et de tutelle,* February 14, 1874, "Extrait des minutes du Greffe de la Justice de Paix du Dixième Arrondissement de la Ville de Paris." Private collection, France.

22. Grisel, "P.A.J. Dagnan-Bouveret," 35, 44.

23. The early life of Courtois is discussed in an unpublished manuscript by Henri Rameau, "La vie de Gustave Courtois." Considerable information, including phrasing, in this manuscript are taken from Fernier, *Gustave Courtois.*

24. Fernier, *Gustave Courtois*. Corre is still a very small village, where little has changed since the nineteenth century. The house where Dagnan-Bouveret lived and painted, alongside a small stream, was still in existence a few years ago when the author and his wife visited this locale.

25. See *Certificat de mariage*, Corre, October 11, 1879. Mairie de Corre.

26. See Legrand, "Catalogue chronologique." The author and his wife visited this last dwelling of Dagnan-Bouveret, where the space of the studio has been preserved. There is little reference to him in the current building except for a plaque on the outside noting that he had lived and died there. Anne-Marie Walter was born in Quincey, suggesting reasons for returning to this village late in life.

27. The property in Coulevon, which Muenier acquired, had originally been the summer home of Jean-Léon Gérôme. The links between Gérôme and his students were further made evident by the fact that this country house in Coulevon remained in its original state after the death of Muenier and was filled with works of art and artifacts, until the early 1990s, when the author and his wife visited the location with members of the Muenier family. The building still exists today, although it is no longer owned by the Muenier family.

28. There is an undercurrent of homosexuality that colors the relationship between Dagnan-Bouveret and Courtois. Letters from the former to the latter suggest this tendency, even though their often emotionally charged tenor may be only an expression of Dagnan-Bouveret's exalted, and often anxious, state of mind. If they were more than simply friends, it appears that he chose a different path from that of Courtois, who was known as a homosexual. This is attested to by Courtois's lifelong relationship with the artist Karl von Stetten and was confirmed by Jean-Jacques Fernier (Robert Fernier's son) in discussions with the author in Paris and in the France-Comté in the mid-1990s. At the time, Fernier described the ways in which certain homosexual imagery had been mutilated by previous owners of Courtois's work to mask this aspect of his life.

29. This building was still in existence a few years ago. Neuilly was and still is a very fashionable suburb of Paris. The new villa-studio afforded both artists a very good address where they could show work to prospective clients, including influential Americans, who were impressed by what they saw.

30. Fernier, *Gustave Courtois*, 52.

31. For reference to this trip, see Gabriel P. Weisberg, "Jules-Alexis Muenier and Photo-Realist Painting," *Gazette des Beaux-Arts* (February 1993): 101–113.

32. See Donald A. Rosenthal, *Orientalism: The Near East in French Painting, 1800–1880,* exh. cat. (Rochester, N.Y.: Memorial Art Gallery of the University of Rochester, 1982).

33. Letter of Dagnan-Bouveret to Henri Amic, 880225, Archives Départementales, Vesoul (letter of February 28, 1888, Blidah)

34. Letter of Dagnan-Bouveret to Amic, 880106, Archives Départementales, Vesoul (letter of January 6, 1888).

35. The interest in Orientalist photography is noted in Rosenthal, *Orientalism,* 118–125, and especially in *Album de voyage des artistes en expédition au pays du Levant,* exh. cat. (Paris: Réunion des Musées nationaux, 1993).

36. A first son, Jean-Simon Dagnan, was born in October 1881 and died ten days later. The couple's second son, also named Jean, was born in 1883.

37. See Gabriel P. Weisberg, "From Paris to Pittsburgh: Visual Culture and American Taste, 1880–1910," in *Collecting in the Gilded Age: Art Patronage in Pittsburgh, 1890–1910,* exh. cat. (Pittsburgh: Frick Art and Historical Center, 1997).

CHAPTER 2 ■ IN THE ÉCOLE DES BEAUX-ARTS, 1872–1878

1. Letters to family, friends, and colleagues—especially to Gustave Courtois—refer to his desire to master the skill of drawing. See letters in Archives Départementales, Vesoul.

2. For the workshop of Verrocchio, see Jane Schuyler, *Florentine Busts: Sculpted Portraiture in the Fifteenth Century* (New York: Garland, 1976). Also see G. Passavant, *Verrocchio: Sculpture, Paintings and Drawings* (New York: Phaidon, 1969), 203. The author is indebted to Michelle Montgomery for making these connections.

3. On the place of life drawing in the academic curriculum, see Albert Boime, "Curriculum Vitae: The Course of Life in the Nineteenth Century," in *Strictly Academic: Life Drawing in the Nineteenth Century,* exh. cat. (Binghamton: State University of New York, 1974). This catalog does record artists working from sculpture or plaster casts, especially in the case of Ingres (fig. 2).

4. For the discussion of the Ingres drawing, see Gary Tinterow and Philip Conisbee, *Portraits by Ingres: Image of an Epoch* (New York: Metropolitan Museum of Art, 1999), 317. The drawing, dated 1830, was owned by Hippolyte Destailleur in Paris, until 1893; it was later owned by Martine de Béhague, comtesse de Béarn (1870–1939), Paris, who was a collector of Dagnan-Bouveret's works. It is possible that the artist used a reproduction in a book for the basis of his drawing. The author acknowledges the assistance of Michelle Montgomery in locating these references. The drawing by Dagnan-Bouveret, originally slated for the Dahesh Museum of Art's exhibition, was recently stolen from the French collection where it was housed.

5. Given the large number of drawings that have been located pertaining to Dagnan-Bouveret's entire career, the paucity of academic drawings is a curious situation. The archives of the Ecole des Beaux-Arts contain only a few references to these examples.

6. Grisel, "P.A.J. Dagnan-Bouveret," 28. Late in life, as reported by Legrand in "La vie," the painter repudiated this work as an academic effort (43). At first, according to Legrand, the painting was refused by the jury, but on the intervention of Cabanel, it was finally accepted for the 1875 Salon.

7. Reported in Legrand, "La vie," 43, based on Dagnan-Bouveret's retelling of how Courtois called attention to a letter from the government authorizing purchase of the work for eighteen hundred francs.

8. See *Inventaire méthodique, Musée de Melun,* establishing that the painting was in Melun in 1875. Legrand, "La vie," 43, notes that Dagnan-Bouveret selected Melun as the site for the location of the painting so that Gabriel Bouveret would be able to see the work on exhibition.

9. Grisel, "P.A.J. Dagnan-Bouveret," 28. The foreshortening of the figure's leg seems rather tentative and ill conceived.

10. Ibid.

11. Legrand in "La vie" notes that in 1875 Dagnan-Bouveret participated in an Ecole Concours d'esquisse where paintings using religious imagery—*Le Christ lavant les pieds des disciples* (*Christ Washing the Feet of His Disciples*) and *Le Christ rencontrant Simon et André* (*Christ Meeting Simon and Andrew*)—were the selections. His works were not as well positioned as in previous years, since he was devoting time to other works and was immersed in the reception of *Atalanta* at the Salon. A study for the second painting is most likely housed in the collection of the Musée Georges Garret, Vesoul. The reference to a Germanic group of painters heightened the symbolism drawn from recent French history.

12. Legrand, "Catalogue chronologique." The existence of this painting in the Ecole collection attests to its being a prizewinner.

13. Ibid.

14. For a history of the Prix de Rome contest see Philippe Grunchec, *The Grand Prix de Rome, Paintings from the Ecole des Beaux-Arts, 1797–1863* (Washington, D.C.: International Exhibitions Foundation, 1984–1985), 26–27.

15. Ibid., 26

16. For reference to Bastien-Lepage's finished Prix de Rome painting, see *Jules Bastien-Lepage*, exh. cat. (Verdun: Les Musées de la Meuse, 1984), fig. 12. The painting is in the permanent collection of the Musée des Beaux-Arts, Lille. Rather humorously, Bastien-Lepage's head of Achilles in the preliminary drawing seems to resemble a caricaturized portrait of Dagnan-Bouveret, a reference that the painter eliminated in the final version of the painting. The head of Achilles finally conceived does, however, reference an academic model posed in the studio.

17. For further information on Wencker, see Claude Vento (Violette), pseud. [Laincel, Alix], *Les peintres de la femme* (Paris: E. Dentu, 1888).

18. Grunchec, *Le Grand Prix de Rome*, 24–25.

19. Legrand, "Catalogue chronologique."

20. Ibid.

21. Ibid. Legrand is the only one to situate Dagnan-Bouveret's place en loge. The placement en loge was highly competitive, based upon the combined evaluations of all teachers in the Ecole. En loge meant to prepare a work for competition in separate studios.

22. For reference to this discussion, see Legrand, "Catalogue chronologique," 1877, where a handwritten note cites that the Bacchantes were covered over at the request of Weiler. Further evidence that Dagnan-Bouveret did change the painting is noted in Legrand, "La vie," 45, who stated that in a discussion with the artist, he revealed that he had overpainted a "ronde" of Maenads in the distance and replaced them with the landscape that he had painted after visiting Barbizon.

23. *Les métamorphoses d'Orphée*, exh. cat. (Strasbourg: Musée des Beaux-Arts, 1995), 178.

24. In painting over the Maenads, Dagnan-Bouveret also painted out a very licentious and sexually explicit figure—at the front of the procession—that would not have reinforced the note of constrained grief that the figure of Orpheus suggests.

25. Noted in Fernier, *Courtois*, 25, as a quote from a discussion with Jean-Léon Gérôme.

26. Examination of Schommer's career (1850–1935) reveals that he was primarily a second-rate portrait painter during the Third Republic and an artist of little imaginative ability.

27. Today this would be considered a suburb of Vesoul.

28. Fernier, *Courtois*, 24. Dagnan-Bouveret also painted a portrait of Mme de Rochetaillée that remains unlocated.

29. Grisel, "P.A.J. Dagnan-Bouveret," 95.

CHAPTER 3 ▪ RE-CREATING GENRE: MAKING A POPULAR REPUTATION, 1879–1881

1. See Weisberg, *Redefining Genre*. Genre painting, which had once been on the lower rungs of the hierarchy for Salon exhibition, was now at the top, along with portraiture. On Meissonier as an artist who concentrated on historical reconstructions, often on a small scale, see *Ernest Meissonier, Retrospective,* exh. cat. (Lyon: Musée des Beaux-Arts, 1993).

2. For reference to the pre-cinematic effect of some Salon paintings, see *Le XIXe siècle* (Paris: Talabardon et Gautier, 2000), no. 38, with reference to Maurice Leloir's *Manon Lescaut* of 1892 (see discussion below). The impact of French Salon paintings was directly evident in the Chicago Columbian Exposition of 1893 and in the Carnegie International exhibitions in Pittsburgh beginning in 1896.

3. On Gérôme's popularity, see Ackerman, *The Life and Work of Jean-Léon Gérôme*.

4. Dagnan-Bouveret readily admitted that at the beginning of his career he was enthusiastic for the Romantics, including the paintings of Delacroix and the writings of Baudelaire and Musset. His interest in literature included Abbé Prévost. See Jacques Hubert, "Portrait et Caractère," unpublished manuscript, *Coll. Hubert-Legrand*, Bibliothèque d'Art et d'Archéologie, ms. 1097, 79–80.

5. Marie and Suzanne Legrand, "Autour des oeuvres de Dagnan-Bouveret," handwritten document given to the author by a private collector, through the assistance of Jean-David Jumeau-Lafond, 3.

6. For Dagnan-Bouveret and Goupil, see *Index, Droits de Reproduction, Maison Goupil,* 119 (Manon Lescaut, 1878, exclusif). On the 1878 medal, see Legrand, "Catalogue chronologique," n.p. On contact, in 1878, with Goupil, who made a photograph of the work, also see Legrand, "Catalogue chronologique," n.p. The importance of the relationship between Gérôme and Goupil has been emphasized in *Gérome and Goupil: Art and Enterprise,* exh. cat. (Paris: Réunion des Musées Nationaux, 2000–2001).

7. *Index, Droits de Reproduction, Maison Goupil,* 119.

8. This small oil study, on panel, of the doorway section of the room is in a private collection in France.

9. Dagnan-Bouveret to Anne-Marie Walter, January 1, 1879, Archives Départementales, Vesoul.

10. Dagnan-Bouveret to Anne-Marie Walter, undated, 1879, Archives Départementales, Vesoul. Not every reviewer of the painting liked it. Georges Lafenestre, "L'Art au Salon de 1879," *Revue de France* (June 19, 1879): 692–693, believed that with this work Dagnan-Bouveret's abilities diminished every year.

11. Dagnan-Bouveret to Anne-Marie Walter, June 1879, Archives Départementales, Vesoul.

12. Ibid.

13. See *Notice des tableaux donnés à la ville de Lyon par M. Jacques Bernard en 1875, formant le musée qui porte son nom* (Lyon: Imprimerie Louis Perrin, 1881), 19, no. 23. One error remains in this catalog and in the more contemporary catalog of the Lyon museum: the work was said to have been exhibited at the Exposition Universelle of 1878. This is incorrect, as it was shown at the Salon of 1879.

14. Legrand, "La vie," 47. A similar statement is found in Legrand, "Catalogue chronologique," n.p. Gérôme was cautioning Dagnan-Bouveret on losing the seriousness of purpose necessary to create significant artworks and noting that appealing to what a public wanted could undermine the effectiveness of a genre painter. There were also negative comments in the press, including E. Montrosier in *Les Artistes Modernes,* no. 14, "Les peintres de genre," who deplored the fact that an artist of talent had "given in to comical farce." Apparently, the note of satire that Dagnan-Bouveret intended was not appreciated.

15. Fernier, *Courtois,* 26.

16. There are earlier references to small canvases by the painter, usually of single figures, that represented an itinerant beggar or young boy. These works, with little suggestion of an actual environment beyond a nondescript stage backdrop, were only one way in which he was beginning to shift direction in around 1878. An example of this type of painting was recently found in a private collection in the United States.

17. Legrand, "La vie," 49. Legrand identifies the doctor depicted in the image as Dr. Juif, a rather unusual name, and perhaps based on faulty memory rather than actual fact.

18. For reference to this work, see Weisberg, "P.A.J. Dagnan-Bouveret and the Illusion of Photographic Naturalism."

19. The painting represents Dagnan-Bouveret's growing enthusiasm for naturalism, as found in his admiration for the writings of Alphonse Daudet. Cited in Legrand, "La vie," 80.

20. Grisel, "P.A.J. Dagnan-Bouveret," 35.

21. On press reaction, see "Salon de 1880, La galerie des exempts," *Le National*, May 11, 1880, and "Au Salon, scènes populaires," *Le Gaulois*, May 22, 1880, among others.

22. "La peinture de genre," *L'Exposition des Beaux-Arts, Salon de 1880* (Paris, 1880), n.p.

23. Legrand, "Catalogue chronologique", n.p., 1879, lists the variant of *L'accident* as being completed in this year. Legrand noted in "La vie" that Dagnan-Bouveret was asked to make a replica of *L'accident*, but he did not want to reproduce it exactly. He eliminated the cat and changed some of the figures (49–50).

24. See Lilian C. Randall, *Diary of George A. Lucas: An American Art Agent in Paris, 1857–1909* (Princeton: Princeton University Press, 1979), who notes the visits between Samuel Avery and Lucas to Dagnan-Bouveret's studio at the time that *The Accident* was available. Confusion remains about when Avery and Lucas secured the painting and which version of the painting they obtained. For further discussion of issues surrounding the variants of *The Accident*, see Gabriel P. Weisberg, "Un Accident" entry, *Sotheby's Sale Catalogue*, New York, November 1, 1995, lot 155.

25. William R. Johnston, *The Nineteenth Century Paintings in the Walters Art Gallery* (Baltimore: Trustees of the Walters Art Gallery, 1982), 126. Legrand, "Catalogue chronologique," n.p., notes that the size of the Salon painting was considerably larger than the canvas of *The Accident* in the Walters Art Gallery (now the Walters Art Museum). She also questioned whether the Salon painting itself was in the United States. Discussions with William Johnston, at the Walters Art Museum, support the contention of differences in size between the Salon canvas and the work in the Walters collection.

26. See *Le Monde Illustré* (November 5, 1881): 294. A text accompanied the image and was titled "Un charmeur au jardin des Tuileries."

27. See C.D. 2, *Registre des photos, Archives Goupil*, where the work is listed as *Le Charmeur d'oiseaux*.

28. See Patrick Offenstadt, *Jean Béraud: La belle époque, une époque rêvée* (Cologne: Taschen and Wildenstein Institute, 1999), 89 and 246. The "After the Funeral Painting" is dated 1876.

29. See Anne Distel et al., *Gustave Caillebotte, Urban Impressionist* (New York: Abbeville Press, 1995).

30. For further discussion on this, see Frederick Brown, *Zola: A Life* (New York: Farrar Strauss Giroux, 1995).

31. The drawing is noted in Legrand, "Catalogue chronologique," n.p., with no reference to a designated purchaser.

32. For this work, see Kenneth McConkey, *Rural and Urban Naturalism: Masterpieces of Late Nineteenth-Century French and British Painting from the Marchman Collection*, exh. cat. (Santa Fe: Museum of Fine Arts, Museum of New Mexico, in association with Pyms Gallery, London, 1987), 30–33. For earlier reference, see *Rural and Urban Images: An Exhibition of British and French Paintings, 1870–1920*, exh. cat. (London: Pyms Gallery, 1984), 32–35 (entry by Kenneth McConkey). The title of this work seems a twentieth-century invention rather than being linked to anything found in the archives of Dagnan-Bouveret's completed works.

33. On the importance of the laundress as a symbol in French art, see Eunice Lipton, "The Laundress in Late Nineteenth Century French Culture: Imagery, Ideology and Edgar Degas," *Art History* 3, no. 3 (1980): 295–313

34. McConkey identified the Louvre as the setting of the painting; see McConkey, *Rural and Urban Naturalism*, 32–35.

35. Fernier, *Courtois*, 26, citing von Stetten's appearance in 1878.

36. For reference to an earlier period, see Theodore Reff, "Copyists in the Louvre, 1850–1870," *Art Bulletin* 46 (December 1964): 552–559. Dagnan-Bouveret did prepare a number of students, although the dates these individuals worked with him is not fully documented. See Grisel, "P.A.J. Dagnan-Bouveret," 104, for a partial listing of those who studied under the artist's tutelage from the 1880s onward. For reference to a Chinese student who enrolled to study with him in 1919, see *The Art of Xu Beihong*, exh. cat. (Hong Kong: Hong Kong Museum of Art, 1988).

37. For reference to this work, see Albert Kostenevich, *French Art Treasures at the Hermitage: Splendid Masterpieces, New Discoveries* (New York: Harry N. Abrams, 1999), 80–81. The painting has been incorrectly dated to 1891.

38. See Gabriel P. Weisberg and Jane Becker, *Overcoming All Obstacles: The Women of the Académie Julian* (New York: The Dahesh Museum and New Brunswick: Rutgers University Press, 2000).

39. On the back of the canvas at the left, underneath the artist's signature, is a self-caricature that is highly schematic and also quite amusing. Kostenevich, *French Art Treasures*, 405, incorrectly notes that this caricature is of Gustave Courtois. The facial features resemble those of Dagnan-Bouveret. Caricature was another form of parody used by the artist. There are unpublished early caricature drawings in the collection of the Musée Georges Garret, Vesoul. One is close to the artist's self-image in *At the Louvre*.

40. *L'Illustration*, July 14, 1883, engraving by Baude after the original drawing by Dagnan-Bouveret. For reference to the drawing see *Nineteenth Century French Paintings, Drawings, and Sculpture*, exh. cat. (London: Hazlitt, Gooden and Fox, 2001).

41. See Alphonse Daudet, *Oeuvres complètes* (Paris: Charpentier, 1881).

CHAPTER 4 ▪ PHOTOGRAPHIC VERISIMILITUDE: NEW DIMENSIONS
FOR GENRE PAINTING, 1882–1886

1. Among the works exhibited at the 1882 Salon was the *Portrait of Mme Barbey* (Musée Georges Garret, Vesoul). At the time the painting belonged to Georges Barbey, who was a wealthy landowner in Corre and a friend of the Walter family.

2. On the importance of Bastien-Lepage, see William Steven Feldman, "The Life and Work of Jules Bastien-Lepage (1848–1884)" (Ph.D. diss., New York University, 1973), and Weisberg, *Beyond Impressionism*, 61–68. Bastien-Lepage's influence on international naturalism was felt widely and became even more pronounced following his early death in 1884 at age thirty-six.

3. Cited by Kenneth McConkey in his biography of Bastien-Lepage in Weisberg, *The Realist Tradition*, 267. For the original citation, see "The Salon, from an Englishman's Point of View," *Art Journal* 8 (1882): 217.

4. For reference to this influential exhibition, see *Exposition des oeuvres de Jules Bastien-Lepage* (Paris: Ecole Nationale des Beaux-Arts, Hôtel de Chimay, 1885). Also see Louis de Fourcaud, "Exposition des oeuvres de Bastien-Lepage à l'Hôtel de Chimay," *Gazette des Beaux-Arts* 31 (1885): 251–267. Fourcaud was a very influential critic of younger independent artists.

5. Weisberg, *Beyond Impressionism*, 62–63. The author was assisted in the clarification of Bastien-Lepage's use of photographic aides by descendants of his brother Emile. A hunt for glass-plate negatives was carried out in the attics of Bastien-Lepage's home in Damvillers, yielding a number of documentary images and the location of a number of partially empty wooden glass-plate photographic containers.

6. Emile Zola, *Le bon combat*, edited by Gaetan Picon (Paris: Herrmann, 1974), 206.

7. Paul de Saint-Victor, "Le Salon de 1879, IV," *La Liberté*, July 3, 1879.

8. Octave Mirbeau, *Des artistes, peintres et sculpteurs* (Paris: E. Flammarion, 1922), 27–32. The notice first appeared in *La France*, March 21, 1885. Mirbeau wrote: "This effect is most noticeable in *The Potato Gatherers* where the forms—flat and dry, where the draughtsmanship is too self-conscious and the execution too detailed—constitute a detriment to the landscape." Mirbeau's commentary was clearly pointing to a technical process that painters were employing, which he sensed had been used by Bastien-Lepage.

9. See *Catalogue officiel des ouvrages de peinture, sculpture . . . exposés au Palais des Champs Elysées, le 15 Septembre 1883* (Paris, 1883), 52, no. 195. *The Vaccination* was listed as belonging to M. Turner. The Exposition Nationale must not be confused with the Salon, since it took place in September. See Mainardi, *End of the Salon*, for further clarification.

10. This photograph, the only one located for *The Vaccination*, was unclassified and not linked to any painting by Dagnan-Bouveret. See 12 J 81, Archives Départementales, Vesoul. The painting is recorded as being completed in 1882.

11. Letter to M. Walter, 1881, Archives Départementales, Vesoul. Goupil apparently sold the painting to Sergei Tretiakoff for about twenty-five thousand francs. On this point, see Grisel, "P.A.J. Dagnan-Bouveret," 43.

12. For the purchase of this work, see *La peinture française au Musée Pouchkine (Moscou)* (Paris and Leningrad: Editions Cercle d'Art, 1980), inventory number 3483.

13. Legrand, "Autour des oeuvres," 7. Also cited in Legrand, "La vie," 49, who cites the location as the "grande salle du moulin de Corre."

14. An inscription on the back of the canvas documents Dagnan-Bouveret's wife as the model for the bride: "La figure de la mariée est le portrait de ma femme." P.A.J. Dagnan.

15. *Acte de Mariage, between Pascal-Adolph-Jean Dagnan-Bouveret and Anne-Marie Marceline Walter, célébré à Corre, October 11, 1879,* Mairie de Corre. Dagnan-Bouveret did not represent himself as the groom in the painting.

16. Legrand, "La vie," 48. For further discussion, see Marc J. Gottlieb, *The Plight of Emulation: Ernest Meissonier and French Salon Painting* (Princeton: Princeton University Press, 1996).

17. Letter of Jennifer L. Vanim, Department of European Painting and Sculpture, the Philadelphia Museum of Art, December 5, 1995, to the author. Ms. Vanim noted that the work was purchased by John G. Johnson for $1,392, a rather modest price for a contemporary painting at the time.

18. Given the immensity of the archives consulted on Dagnan-Bouveret, and the numerous family letters located, the fact that photography is seldom, if ever, discussed is very curious. Could it be that this was a topic that was never written about? Was the procedure, as used by genre painters and portraitists, a clandestine device?

The use of photographs by students trained in Jean-Léon Gérôme's circle also attracted the American painter Thomas Eakins. This painter surrounded "himself with photographs" as noted in W. Douglass Paschall, "The Camera Artist," in *Thomas Eakins,* ed. Darrel Sewell (Philadelphia: The Philadelphia Museum of Art in association with Yale University Press, 2001), 239–255. Eakins's use of transfer images in the making of paintings began about the same moment at which Dagnan-Bouveret was developing similar techniques in France. For further reference to this complex process, see Mark Tucker and Nica Gutman, "Photographs and the Making of Paintings," in *Thomas Eakins,* 225–238. Both authors note Dagnan-Bouveret in their argument about Eakins.

19. Letter from Dagnan-Bouveret to Courtois, August 7, 1883, Archives Départementales, Vesoul.

20. Grisel, "P.A.J. Dagnan-Bouveret," 32.

21. Ibid.

22. Ibid., 31. Baker purchased one other painting by Dagnan-Bouveret, the famous *The Pardon in Brittany,* now in the Metropolitan Museum of Art.

23. The earlier popularity did not prevent the work from being deaccessioned. When this happened at the Metropolitan Museum of Art (New York), after the painting was given to the museum by George Baker, the work passed through the salesroom of the London dealer Julian Hartnoll. See Julian Hartnoll, *A Selection of Drawings, Oil Paintings and Sculpture* (London: Julian Hartnoll, 1989), no. 10. The painting was saved from disappearing by Ed Wilson, the current owner.

24. Weisberg, *Beyond Impressionism,* 28–31.

25. The interest in the Franche-Comté as a specific area of creativity was noted as early as 1879. For reference, see V. Jeanneney, "Les Franc Comtois au Salon de 1879," *L'Avenir de la Haute-Saône,* Vesoul, 1879.

26. Three photographs related to this work exist, although it is likely that many more were taken.

27. Drawings have been located for almost all the other major Salon paintings by Dagnan-Bouveret save for this composition. A smaller version of this composition, with only one one horse, was also completed as an oil painting in 1884. See *Catalogue of Modern Paintings and Sculpture, Collected by the Late J. W. Kaufman of St. Louis* (New York: American Art Association, 1905), no. 66.

The process that Dagnan-Bouveret evolved in the construction of this painting mirrors, in some ways, the complicated transfer imagery used by Thomas Eakins in his works in the early 1880s. See Tucker and Gutman, "Photographs and the Making of Paintings," for further discussion. A closer, physical examination of the *Horses at the Watering Trough* is seemingly warranted, given the looser technique employed by Dagnan-Bouveret and the exactitude of the transferring of the horses from the photographic sources.

28. Weisberg, *The Realist Tradition,* 231. Also see Dagnan-Bouveret to the Sous-secrétaire d'Etat, July 27, 1885. This letter is preserved in the archives of the Institut Néerlandais, Paris (1973–A313).

29. J. Noulens, "Le Salon de 1885," *La Presse,* May 1, 1885, 368–369.

30. Albert Wolff, "Le Salon," *Le Figaro,* April 30, 1885, 2.

31. Henry Havard, "Le Salon de 1885," *Le Siècle,* May 19, 1885.

32. For Lhermitte, see Monique Le Pelley Fonteny, *Léon-Augustin Lhermitte (1844–1925), catalogue raisonné* (Paris: Editions Cercle d'Art, 1991). Among the first to use religious genre effectively was Edouard Manet, in his works depicting Christ in the 1860s, and his colleague in this decade Théodule Ribot.

33. Albert Wolff, "Le Salon," *Le Figaro* (1885), 2.

34. *Harper's Bazaar* 19, no. 1 (January 2, 1886),13.

35. *Katalog der kgl Neuen Pinakothek in München,* 1914, 27. Also see *Die Malerei auf der Münchener Jubiläums-Kunst-Ausstellung* (Munich, 1888), 177–179.

36. For the date when the work was secured by Maddocks, see Legrand, "Catalogue chronologique," n.p., 1883. Also see Butler Wood, "The Maddocks Collection at Bradford-I," *Magazine of Art* 14 (1890–1891): 298–306. The importance of English private collectors in the dissemination of the taste for naturalism is discussed in Kristi Holden, "George Clausen and Henry Hubert La Thangue: Rural Painting, Urban Patronage," *Apollo* 149, no. 144 (February 1999): 11–19.

CHAPTER 5 ▪ THE INTERNATIONALIZATION OF DAGNAN-BOUVERET, 1887–1893

1. Paul Leroi, "Salon de 1882," *L'Art* 2 (1882): 37–40

2. On Manet, see Michael Fried, *Manet's Modernism; or, The Face of Painting in the 1860s* (Chicago: University of Chicago Press, 1996).

3. On the position of Bastien-Lepage in the Third Republic and how his works were being appropriately marketed in Europe, see Robert Jensen, *Marketing Modernism in Fin-de-Siècle Europe* (Princeton: Princeton University Press, 1994).

4. Ibid., 139. Jensen is too negative in his evaluation of Bastien-Lepage when he states that he "offer[ed] a semblance of modernity with the accessibility, the narrative and pictorial coherence of the academic tradition."

5. Ibid., 161–162. Jensen correctly identifies the Société Nationale as playing a significant role in defining international modernism in the 1890s.

6. The annual exhibition records of the Société Nationale have disappeared. Consultation with members of the organization in the twentieth century has confirmed the lack of historical documentation.

7. A lost *Bretonne écrivant* is listed as being completed in 1886. See Legrand, "Catalogue chronologique," n.p., 1886.

8. On Brittany, see Denise Delouche, *Peintres de la Bretagne; Découverte d'une province* (Paris: Librairie C. Klincksieck, 1977). See also Gabriel P. Weisberg, "Vestiges of the Past: The Brittany 'Pardons' of Late Nineteenth Century French Painters," *Arts Magazine* 55 (November 1980): 134–138.

9. Legrand, "La vie," 47.

10. On the various ways of interpreting these paintings, see Michael Orwicz, "Criticism and Representations of Brittany in the Early Third Republic," *Art Journal* 46 (winter 1987): 291–298.

11. Grisel, "P.A.J. Dagnan-Bouveret," 51. Also see Legrand, "La vie," 60.

12. Grisel, "P.A.J. Dagnan-Bouveret," 51–52. The time period of April to June 1886 is documented in Legrand, "Catalogue chronologique," n.p., under the reference "Vieux Breton de Pont-Croix," 1886.

13. Legrand, "Catalogue chronologique," 53, from a letter to his friend Henri Amic, October 29, 1886.

14. See the file in the Department of Paintings, the Metropolitan Museum of Art, New York, with the date of July–November 1886 being established as the moment when Dagnan-Bouveret worked on this canvas in Ormoy. See also Gretchen Wold, "Some Notes on 'The Pardon in Brittany' by Dagnan-Bouveret," *Metropolitan Museum Journal* 35 (2000): 240, in which the line drawings on the back of the canvas are reproduced for the first time.

15. Grisel, "P.A.J. Dagnan-Bouveret," 53, Letter to Henri Amic, October 29, 1886.

16. This oil sketch is dated and inscribed with the location in Brittany. Wold identifies the site as Pont-Croix, also stating that the costume worn by the old man is identical to what was worn there. See

Wold, *"Some Notes on the 'Pardon in Brittany,'"* 243–244. This oil sketch, painted at Pont-Croix in Brittany, further documents the specific moment when Dagnan-Bouveret was in the region studying the first model for the old man; this was later modified, although the initial conception of the older figure remained constant. The existence of a painting with this figure is recorded in Legrand, "Catalogue chronologique," n.p., 1886.

17. Legrand, "La vie," 65.

18. *Le Monde,* May 7, 1887.

19. As noted by Orwicz, "Criticism and Representations of Brittany," 291.

20. Paul Heusy, *Le Radical,* May 18, 1887, as quoted in Orwicz, "Criticism and Representations of Brittany," 292.

21. Orwicz, "Criticism and Representations of Brittany," 293.

22. George Lafenestre, "Le Salon de 1887," *L'Art* 81 (1887): 636–637.

23. Paul Mantz, "Le Salon IV," *Le Temps,* May 29, 1887.

24. Legrand, "Catalogue chronologique," n.p., 1886.

25. For other Breton paintings that were in America, see Knoedler and Company Archives, New York.

26. Letter of Adrienne L. Jeske, research assistant, Department of European Painting, the Art Institute of Chicago, May 7, 2001. The exact date the painting entered the Palmer Collections is unknown. See also Wold, "Some Notes on the 'Pardon in Brittany,'" 237–246.

27. This painting seems to have generated little commentary in Salon reviews and provides a sharp comparison with the intense discussion that had emerged over Dagnan-Bouveret's *Pardon in Brittany* in 1887.

28. Grisel, "P.A.J. Dagnan-Bouveret," 55, notes that the artist purchased the costume for his wife, painting her in a garment that meant much to him.

29. Kenneth McConkey notes the significance of his working from a specific racial type from Brittany, an engagement similar to that of other artists (Gauguin, Bernard, Lhermitte). See *Life and Landscape* (London: Pyms Gallery, 1991), 20–23.

30. A Brittany trip is recorded in Grisel, "P.A.J. Dagnan-Bouveret," 53, as reported in a letter from Dagnan-Bouveret to Henri Amic, September 1, 1886. Dagnan-Bouveret sent this letter from Ormoy, commenting on Courtois's painting of *La Vierge,* which he saw "after his return from Brittany." Letter preserved in the Archives Départementales, Vesoul.

31. No photographic evidence of models posed in Brittany has been found. However, Dagnan-Bouveret's interest in photography at this time has been well established. McConkey cites a photographic basis in this painting; *Life and Landscape,* 20. The other small Brittany paintings of single figures are ascribed to 1887. See Legrand, "Catalogue chronologique," n.p., 1887.

32. Dagnan-Bouveret exhibited *Etude du cimetière de Sidi Khebir* at the 1890 Salon. See Legrand, "Catalogue chronologique," n.p., 1888. There were also a large number of photographs made of this same site. For more information on this trip, see letters of Dagnan-Bouveret to Henri Amic, 1887–1888, Archives Départementales, Vesoul.

33. Grisel, "P.A.J. Dagnan-Bouveret," 55–56.

34. The impact of the Near East was stronger on Muenier, who exhibited large Orientalist paintings in the Paris Salon and sent one work with this theme to the World's Columbian Exhibition in Chicago in 1893.

35. Grisel, "P.A.J. Dagnan-Bouveret," 56. Anne-Marie again served as the model for this figure.

36. Legrand, "La vie," 66.

37. Grisel, "P.A.J. Dagnan-Bouveret," 56, notes the existence of two photographs for this work in the Archives Départementales, Vesoul, one showing a young woman holding a long stick, which could serve as a candle in the finished work.

38. Hollister Sturges, *Jules Breton and the French Rural Tradition,* exh. cat. (Omaha, Neb.: Joslyn Art Museum, 1982), 119.

39. Ibid. Letter from Dagnan-Bouveret to Henri Amic, April 7, 1889, Archives Départementales, Vesoul, describing the success of the painting at the Mirliton.

40. On photorealism, see Weisberg, *Beyond Impressionism.*

41. For reference to photography at the 1889 Exposition Universelle, see L.B., "La photographie à l'Exposition," *L'Illustration,* August 31, 1889, 170–171.

42. Grisel, "P.A.J. Dagnan-Bouveret," 57, drawn from Dagnan letters to Amic, July 2, 1887.

43. Grisel, "P.A.J. Dagnan-Bouveret," 58, who identifies the mechanical measuring device in the photograph without providing a specific name for the tool.

44. As noted in a letter dated July 1887 to Henri Amic.

45. See *La Vie Moderne, Nineteenth-Century French Art from the Corcoran Gallery,* exh. cat. (with an essay by Lilien F. Robinson) (Washington, D.C.: Corcoran Gallery of Art, 1983), 38–39.

46. Letter from Dagnan to Amic, October 18, 1887.

47. Grisel, "P.A.J. Dagnan-Bouveret," 59.

48. For this work, see Christie's, New York, May 6, 1998, lot 119.

49. See *Cosmopolitan* 18 (March 1895): 537.

50. Legrand, "La vie," 68.

51. *Catalogues des oeuvres* (1930).

52. Legrand, "La vie," 69.

53. Ibid.

54. "Salon de 1889," *Le Courrier Français,* May 5, 1889, 4.

55. Mémor, "Salon de 1889," *Le Dimanche Illustré,* May 5, 1889, 284–285, including a full-page engraving of the painting. A similar sentiment was expressed about the figures by Camille de Roddaz, "Travers l'Exposition Universelle," *L'Art* 1 (1889): 192.

56. Georges Lafenestre, "Le Salon de 1889," *Revue des Deux-Mondes* 93 (1889): 646–649. An interest in the commitment to independent landscape imagery was reinforced by André Michel, "Exposition du Cercle de l'Union artistique," *Journal des Débats,* April 11, 1889.

57. Albert Wolff, "Le Salon," *Le Figaro,* April 30, 1889, 1.

58. See Louis de Fourcaud, *Le Gaulois,* April 30, 1889, and Roger Marx, *Le Voltaire,* May 1, 1889. These opinions are discussed in Orwicz, "Criticism and Representations of Brittany," 293–294.

59. Paul Mantz, "La vie à Paris, le tour du Salon," *Le Temps,* April 30, 1889, 3.

60. Walter Armstrong, "Current Art, the Salon," *The Magazine of Art* 12 (1889): 418.

61. Grisel, "P.A.J. Dagnan-Bouveret," 78, who cites a M. Subercazeaux as the source of the commission.

62. Letter of Dagnan to Amic, October 23, 1888, Ormoy, Archives Départementales, Vesoul.

63. Lafenestre, "Le Salon de 1889," 647–648. Lafenestre was much taken by the "atmosphère verdâtre." An enthusiastic review of this painting was written by Olivier Merson, "Salon de 1899," *Le Monde Illustré* (January–June 1889): 290. He noted: "L'expression tendre de la Vierge est rendue avec une grande force de vérité."

64. See Alfred de Lostalot, "Salon de 1889," *Gazette des Beaux-Arts* 3, no. 2 (1889): 15.

65. See "Madonna by Dagnan-Bouveret," *Century Magazine,* no. 2 (December 1891): 280–281.

66. For reference to this stained-glass window, see Alastair Duncan, *Tiffany Windows* (New York: Simon and Schuster, 1980), 20, fig. 8.

67. For a brief discussion, see *Peinture et Art Nouveau,* exh. cat. (Nancy: Musée des Beaux-Arts, 1999), 59–60.

68. See *Sotheby's New York,* Sale, October 22, 1996, lot 310, for reference to this work. This painting was also reproduced in *L'Illustration* on May 7, 1892, 51, as a work shown at the 1892 Salon. The artist had received a commission from England for these paintings and he wanted to meet this obligation, which had been on hold for at least two years. See Dagnan-Bouveret to Henri Amic, September 22, 1891, Archives Départementales, Vesoul. The identity of the individual who had commissioned the works was not given in the letters. It is unknown whether he was planning another large Breton scene when he completed these works.

69. Dagnan-Bouveret to Henri Amic, September 22, 1891.

70. Dagnan-Bouveret to Henri Amic, Ormoy, April 5, 1892, or August 1892 (date indecipherable). Archives Départementales, Vesoul.

71. Grisel, "P.A.J. Dagnan-Bouveret," 76.

72. See *Catalogue des tableaux modernes par Bastien-Lepage, Berne-Bellecour, . . . Cazin . . . Dagnan-Bouveret, . . . composant la Collection C. Coquelin* (Paris: Galerie Georges Petit, June 9, 1906), 30, no. 33, as *La gardeuse de vache.*

73. Legrand, "La vie," 11, quoting Dagnan-Bouveret's account of what he tried to convey in this work.

74. The painting is signed and dated at the lower left: P.A.J. Dagnan-B. Ormoy, 1892.

75. A sticker on the back of the painting notes the fact that this work was shown in 1909 while still in the possession of Mrs. George McCulloch, who was living at 184 Queens Gate, in southwest London. For reference to this exhibition at Burlington House, see *Illustrated Catalogue, Royal Academy Winter Exhibition, the McCulloch Collection of Modern Art* (London: Virtue, 1909).

76. Legrand, "La vie," 71.

77. This point is also documented by the painting itself. A United States Customs sticker, affixed to the back of the canvas, noted that it had been shipped to the exhibition in San Francisco.

78. For reproductions of the now lost portraits of Mr. and Mrs. McCulloch, see *Illustrated Catalogue, Royal Academy Winter Exhibition* (1909), 3 and 5.

79. Ary Renan, "Salon de la Société Nationale des Beaux-Arts—Exposition de 1893 aux Champs de Mars, Peinture," *Supplément au Journal Le Temps,* May 9, 1893, 5–6.

80. A. Pallier, "Le Salon de 1893, Champs de Mars, Les Poètes," *La Liberté*, May 9, 1893, 2. Dagnan-Bouveret was discussed in this section of the review alongside works by Ary Renan, Edmond-François Aman-Jean, Léon Frédéric, Burne-Jones, and Gaston Latouche.

81. Lucien Bourdeau, "Description d'oeuvres exposées aux Salons de 1893," *Revue Encyclopédique,* no. 65 (August 15, 1893): 821–823.

82. Dagnan-Bouveret to Henri Amic, Ormoy, June 30, 1893, Private collection, Paris.

83. In examining this work, it appears that the artist was mixing pastel with oil paint in an experimental way. Perhaps this is one reason why the work was not completed.

CHAPTER 6 ▪ TRANCENDENT SPIRITUALITY, 1894–1900

1. On this aspect, see Bruno Foucart, *Le renouveau de la peinture religieuse en France (1800–1860)* (Paris: Arthena, 1987). Also see Elizabeth Kashey, "Religious Art in Nineteenth-Century France," 1–30, and Francis X. Flood, "The Catholic Church in Nineteenth-Century France," 31–69, in *Christian Imagery in French Nineteenth-Century Art, 1789–1906,* exh. cat. (New York: Shepherd Gallery, 1980). For further reference, see Lisa Small, *Telling Tales II: Religious Images in Nineteenth Century Academic Art* (New York: Dahesh Museum of Art, 2001).

2. On the construction of the Sacré-Coeur and its role as a type of pilgrimage monument in the center of Paris, see Raymond Jonas, "Sacred Tourism and Secular Pilgrimmage: Montmartre and the Basilica of Sacré-Coeur," in *Montmartre and the Making of Mass Culture,* ed. Gabriel P. Weisberg (New Brunswick: Rutgers University Press, 2001), 94 ff. On the ways in which church and state battled for the control of religious imagery, see Michael Paul Driskell, *Representing Belief: Religion, Art, and Society in Nineteenth Century France* (University Park: Pennsylvania State University Press), 1992.

3. See Henri Mazel, "Tendances religieuses de l'art contemporain," *L'Art* 51 (1891): 45–56.

4. Ibid., 54.

5. On this revolt, see Rose G. Kinsley, "'The Annunciation': The Ideal in Modern Art," *Art Journal* 63 (1901): 8.

6. See pp. 97–99.

7. This painting is noted by Legrand, "Catalogue chronologique," n.p., as having been purchased by Mme de Béhague, comtesse de Béarn, in Paris.

8. R. P. Sertillanges, "La peinture religieuse aux expositions de 1894," *Revue Thomiste,* no. 3 (July 1894): 346. The artist also completed a reduction of this painting for M. Worth.

9. Ibid.

10. The painting is now housed in the Musée d'Arras. However, since it was partially destroyed and has been heavily restored, the original impact of this expansive work has been greatly lessened. The painting was shown at the 1896 Salon.

11. Legrand, "La vie," 73.

12. Ibid.

13. Grisel, "P.A.J. Dagnan-Bouveret," 80. These collections contained works that needed to be studied at first hand.

14. For further reference, see Charles Grandmoujin, *Le Christ, drame sacré en 5 tableaux. . .* (Paris: Théâtre-Moderne, March 12, 1892). Grandmoujin, a friend of the painter's from the Franche-Comté, undoubtedly exerted a strong influence on him in various ways, especially through his writings.

15. For reference to F. Holland Day's interest in Passion plays around 1900 see *F. Holland Day,* exh. cat. (Amsterdam: Van Gogh Museum, 2000). The international ramifications of Day's photography, in the wider circle of religious painting in Europe, needs further clarification.

16. Dagnan-Bouveret to Henri Amic, letters dated September 4 and 21, 1895, Archives Départementales, Vesoul.

17. The drawing was set above the entranceway to Jules-Alexis Muenier's studio in the country house at Coulevon, where the author saw it in the mid-1990s. The drawing occupied an honored position that suggests that Muenier had a high regard for his friend's composition of *The Lord's Last Supper.*

18. Grisel, "P.A.J. Dagnan-Bouveret," 83. The artist received a stipend until the end of his life on the sale of reproductions of this image. See *Registre,* Goupil, 1896, 32.

19. Legrand, "Catalogue chronologique," n.p., 1896, for notation of the "réduction de la Cène."

20. Gustave Geffroy, *La vie artistique,* vol. 5 (Paris: H. Floury, 1897), 163–164. For the actual review, see "Le Salon du Champs de Mars, le Salon I," *Le Journal,* April 24, 1896, 5.

21. L.B., "Beaux-Arts, la critique et les Salons de 1896," *Revue Encyclopédique* 6 (1896): 503.

22. George Lafenestre, "La peinture aux Salons de 1896," *Revue des Deux-Mondes* 135 (1896): 897–933. The length of the discourse on this painting is extensive, as the reviewer examined the painting from various standpoints: historical, religious, and stylistic.

23. René Maizeroy, "Le Salon du Champs de Mars (notes et sensations)," *Gil Blas,* April 24, 1896, 1. For further commentary on the extensive press discussion surrounding *La Cène* (*The Lord's Last Supper*), see Gabriel P. Weisberg, "From Paris to Pittsburgh: Visual Culture and American Taste, 1880–1910," in *Collecting in the Gilded Age: Art Patronage in Pittsburgh, 1890–1910* (Pittsburgh: Frick Art and Historical Center, 1997), 269–270. In actuality this was what Dagnan-Bouveret had hoped to achieve through his study of Passion plays and their actors.

24. "Les Beaux-Arts à l'Exposition Universelle," *Revue Politique et Littéraire Revue Bleue* 13 (May 19, 1900): 615.

25. Legrand, *Autour des oeuvres de Dagnan-Bouveret,* 46, based upon a reference from Madeleine Zillhardt, *Louise Catherine Breslau et ses amis* (Paris: Editions des Portiques, 1932), 95. Upon seeing Zillhardt and friends at the Salon, in front of Dagnan-Bouveret's work, Degas is supposed to have made the following humorous and derogatory comment on the *Last Supper:* "It is the lower Seine," adding with the smile of a young child having made a joke: "what a terrible pun!" The fact that Dagnan-Bouveret read, and knew, most of the Salon reviews of his paintings is supported by the fact that he and his friends clipped out the reviews and pasted them in appropriate scrapbooks. This was a practice that most academic artists followed in the nineteenth century, often employing clipping services to make sure that the majority of the reviews were located, saved, and sent to the artist. Copies of many of these reviews are preserved in the Archives Départementales, Vesoul.

26. Laure Stasi, "Le mécénat de Martine de Béhague, comtesse de Béarn (1870–1939): Du symbolisme au théâtre d'avant-garde," *Bulletin de la Société de l'histoire de l'art français* (Paris: Société de l'Histoire de l'Art français, 2000), 337–354. Although the painting was not a commission, its theatrical effect was well understood by Martine de Béhague; she placed the work near the stage in her townhouse, so that it could have an impact on theatrical performers of all types as they presented their plays or tableaux-vivants.

27. Weisberg, *Collecting in the Gilded Age,* 270 ff.

28. Grisel, "P.A.J. Dagnan-Bouveret," 83–84.

29. "Dagnan-Bouveret's New Picture," *London Times,* December 21, 1897.

30. Ibid.

31. For a slightly different English title for the painting, see "'Christ and the Disciples at Emmaus' by P.A.J. Dagnan-Bouveret," published by Arthur Tooth and Sons' Galleries, 5 and 6 Haymarket, S.W., London, undated, Archives Départementales, Vesoul. The original French text, ostensibly written by the artist, is appended to this document.

32. Weisberg, *Collecting in the Gilded Age,* 272.

33. "$100,000. for a Painting," *Pittsburgh Post,* February 3, 1898, 2.

34. Frank Marshall White, "Frick Painting Shows a Bold, Artistic Idea," *Pittsburgh Post,* February 6, 1898.

35. Weisberg, *Collecting in the Gilded Age,* 273. This type of attack was aimed at Frick's role as a capitalist and the common knowledge that he hated the working class.

36. Louis de Fourcaud, "Les deux Salons de 1898, III La Société nationale des Beaux-Arts," *Le Gaulois,* April 30, 1898, Supplément.

37. A. Pallier, "Les Salons de 1898—à propos de peinture religieuse—M. Dagnan-Bouveret–M. Roybet–M. Melchers, Duhem, Roger–Mlle. d'Anethem–M. Deschamps etc.," *La Liberté,* May 11, 1898.

38. Léo Claretie, "Les deux Salons XIII à la Société nationale des Beaux-Arts, " *L'Evénement,* May 1, 1898, 1.

39. Weisberg, *Collecting in the Gilded Age,* 274.

40. *Catalogue, the Third Annual Exhibition held at the Carnegie Institute* (November 3, 1898, till January 1, 1899) (Pittsburgh, 1898), cat. no. 85, and listed as "Presented to the Carnegie Institute by Mr. and Mrs. H. C. Frick, 1898."

41. "The Gallery Is Open Today," *Pittsburgh Post,* November 3, 1898, 1.

42. For two of the more complete preliminary drawings, see Weisberg, *Collecting in the Gilded Age,* cat. nos. 102 and 103.

43. On the difficulty in producing the smaller copy, see Grisel, "P.A.J. Dagnan-Bouveret," 83–84.

44. Weisberg, *Collecting in the Gilded Age,* 275–276.

45. Dagnan-Bouveret to Anne-Marie, December 1897, Archives Départementales, Vesoul, as quoted in Grisel, "P.A.J. Dagnan-Bouveret," 85.

46. Dagnan-Bouveret to Henri Amic, n.d., after July 10, 1898, Private collection, Paris.

47. The date is found on the back of the composition. This work corresponds to one cataloged by Legrand in "Catalogue chronologique," n.p., and is identified as a study for the *Consoling Madonna* of 1898.

48. Dagnan-Bouveret to Madame Bartet, July 15, 1898, as quoted in Legrand, "Autour des oeuvres de Dagnan-Bouveret," 21, 23, 25.

49. Weisberg, *Collecting in Gilded Age,* 277–278.

50. On the Décennale exhibition, see *La Presse,* May 2, 1900. The installation focused on works done since 1889 over a ten-year period to demonstrate that French creativity was still at its peak.

51. See Marcel Fouquier, "Les Beaux-Arts à l'Exposition . . . L'Exposition décennale, Le Grand Palais/A travers les Salles, Salle II—Le Sanctuaire de M. Dagnan-Bouveret," *Le Rappel,* May 2, 1900.

52. Fouquier, "Les Beaux-Arts à l'Exposition," 1.

53. Gaston Stiegler, "Au Grand Palais, Exposition décennale," *L'Echo de Paris,* May 2, 1900, 2.

54. Charles Holman Black, "Art at the Exibition, France," *English and American Gazette of Paris,* October 20, 1900.

55. Maurice Demaison, "A travers l'Exposition décennale," *Le Figaro Illustré,* 1900, no. 123, 134.

56. Robert Vallier, "Les Beaux-Arts à l'Exposition, au Grand Palais.—La Décennale," *La République Française,* August 22, 1900, 1.

57. For a discussion of Laredo Taft's attack on Dagnan-Bouveret in Pittsburgh, see Gabriel P. Weisberg, *Collecting in the Gilded Age,* 276. On Dagnan-Bouveret's 1900 awards, see *Catalogue des oeuvres,* 20; Legrand, "Catalogue chronologique," n.p.

58. Boime, *The Academy and French Painting,* (1971), 3–5.

59. Ibid., 4

60. Frontis, "Notes Parisiennes, à l'Académie des Beaux-Arts," *L'Evénement,* October 22, 1900, 1.

61. Ibid. It was clear that his being a student of Gérôme's was a considerable positive element.

62. *Procès Verbal,* Samedi, October 27, 1900, Archives de l'Institut, Académie des Beaux-Arts, 2E20, 240.

63. Ibid.

64. November 6, 1900, Ministère de l'Instruction Publique et des Beaux-Arts, Boîte 5E69, Institut de France.

65. *Album du Gaulois, Dagnan-Bouveret,* 1900, Académie des Beaux-Arts/Institut de France.

CHAPTER 7 ▪ ON THE INSIDE LOOKING OUT, 1901–1929

1. See Mme J. Hubert, "Dernier été de Dagnan-Bouveret," 3.

2. Dagnan-Bouveret's commissions for public buildings must be seen within the context of other commissions awarded to academic painters to decorate the major buildings of Paris.

3. See Société Nationale des Beaux-Arts, Salon 1909, *Etudes: Dessins et pastels, P.A. J. Dagnan-Bouveret* (Paris: G. de Malherbe Imprimerie, 1909). This small catalog of a special exhibition held in room VIII of the annual exhibition listed 133 separate numbers. Almost all the works were drawn from private collections, including those of individuals for whom the artist had already painted portraits. It was a singular exhibition that gave importance to the category of preparatory studies and finished pastels, supporting the belief that these were a significant part of his total production. This exhibition also generated a major review in the *Gazette des Beaux-Arts*. See Georges Lafenestre, "Exposition d'études, dessins et pastels de M. Dagnan-Bouveret à la Société Nationale des Beaux-Arts," *Gazette des Beaux-Arts* 1 (1909): 465–480.

4. Dagnan-Bouveret had exhibited with regularity at the Carnegie International exhibitions in Pittsburgh after 1896 and his works were collected by Henry Clay Frick, generating interest in his compositions in sections of the United States.

5. See Art Institute of Chicago, *Catalogue of the Works of P. A.J. Dagnan-Bouveret, a Loan Exhibition* (March 1–24, 1901) (Chicago, 1901), n.p. This exhibition catalog is little more than a listing and the text more of a promotional piece than anything else. It would not have provided regional critics with any understanding of the painter's creative significance.

6. Ibid. These were tinted photographs that conveyed an artistic quality to the image.

7. For some of the reviews, see *Chicago Post,* March 2, 1901; *Chicago Times-Herald,* March 3, 1901 (with a reproduction of Dagnan's *Pilgrimage in Brittany*); (Chicago) *Inter-Ocean,* March 3, 1901; and the *New York Commercial Advertiser,* March 22, 1901.

8. *Inter-Ocean,* March 3, 1901.

9. There were to be no other independent exhibitions in the United States of his work while he was alive. The only other recorded exhibition of work by him in America occurred in 1915, when *In the Forest* was sent to San Francisco for the Panama Pacific Exhibition.

10. Ackerman, *The Life and Work of Jean-Léon Gérôme,* 172.

11. Grisel, "P.A.J. Dagnan-Bouveret," 96.

12. Ibid. The range of Dagnan-Bouveret's late portraits seems highly repetitive and based on the use of portrait photographs as aids. For reproductions of some of these works, see *Catalogue des oeuvres, Portrait de Maréchal Joffre* (1920) and *Portrait du Maréchal Foch* (1922).

13. Archives, Passy Cemetery, Paris, from the information provided on the Dagnan-Bouveret tomb.

14. Grisel, "P.A.J. Dagnan-Bouveret," 87.

15. Ibid.

16. The author has learned of the existence of this correspondence. Since these letters span a very broad period of time, they will undoubtedly clarify a number of family issues that affected the artist's life and work after 1900.

17. Grisel, "P.A.J. Dagnan-Bouveret," 88.

18. Legrand, "Catalogue chronologique," n.p., 1920. The painting is still in this church.

19. Grisel, "P.A.J. Dagnan-Bouveret," 89.

20. Dagnan-Bouveret eventually left himself out of the final composition.

21. Legrand, "Autour des oeuvres de Dagnan-Bouveret," 76–77, on *Via Dolorosa*. It is noted here that the painter had no visitors to his studio because he wanted to keep the way in which he worked secret.

22. Ibid.

23. On Dagnan-Bouveret's portrait of Childs Frick, see Weisberg, *Collecting in the Gilded Age,* 279–280.

24. Legrand, "Catalogue chronologique," n.p., 1907.

25. Ibid. Very few landscapes are documented in Marie Legrand's catalog; it is not known how many he actually produced.

26. The term "academic Impressionist" was coined by Ackerman in relation to Dagnan-Bouveret and Muenier. See Ackerman, *The Life and Work of Jean-Léon Gérôme,* 144.

27. The date on this painting was recently identified by Nicole Myers, in a letter to the author, as 1908.

28. For a similar landscape by Muenier, albeit undated, see Gabriel P. Weisberg, "The French Anti-Modernist Connection: Several French Academicians in the Todd Collection," in *The Legacy of Albert*

May Todd, exh. cat. (Kalamazoo, Mich.: Kalamazoo Historic Conservancy for the Preservation of Art, 2000), 39–43.

CONCLUSION

1. Grisel, "P.A.J. Dagnan-Bouveret," 101.

2. Ibid., 102.

3. Ibid.

4. Prince Bojidar Karageorgevitch, "Dagnan-Bouveret," *Magazine of Art* 16 (1893): 121–125.

5. William A. Coffin, "Dagnan-Bouveret," *Century Magazine* 48, no. 1 (May 1894): 3–15.

6. See *Modern French Masters: A Series of Biographical and Critical Reviews by American Artists,* edited by John C. Van Dyke (New York: Century, 1896), article on P.A.J. Dagnan-Bouveret, 1852–, by William A. Coffin.

7. Ibid., 242.

8. Rowland Strong, "Living French Artists, Dagnan-Bouveret in His Studio at Neuilly," *New York Times Saturday Review*, March 1899, 174.

9. Ibid.

10. Louis Gillet, "Un maître de la peinture moderne: M. Dagnan-Bouveret," *Lecture pour Tous, Revue Universelle et Populaire, Illustrée,* no. 1 (October 1911): 27–38.

11. Robert Fernier, "Dagnan-Bouveret, 1852–1929," *Franche-Comté Monts Jura Haute Alsace* no. 122 (September 1929): 174. Also see Maurice Hamel, "Salon de 1889. La Peinture," *Gazette des Beaux-Arts* 1 (1889): 448–449, where the writer notes that "Dagnan-Bouveret cherche la beauté et le caractère dans l'expression précise des moeurs et des types populaires."

12. René Bazin, "Couleur du temps, Dagnan-Bouveret," *Le Figaro,* August 21, 1929; Pierre l'Ermite, "La mort de l'artiste," *La Croix,* July 13/14, 1930. The latter article appeared at the end of his retrospective exhibition in Paris a year after his death.

13. On the exhibition, see *Catalogue des Oeuvres.* Ninety-two works, from all phases of his career, were put on public display.

14. Albert Flament, "Tableaux de Paris et d'ailleurs," *La Revue de Paris* 37, no. 3 (1930): 708–709.

15. See "Dagnan-Bouveret," *Neuilly Journal,* June 14, 1930, 1–2.

16. Henri Corbel, "Dagnan-Bouveret," *Neuilly Journal,* June 21, 1930, 1–2. The author has carefully examined the Hôtel de Ville in Neuilly without having located the works supposedly done by Dagnan-Bouveret for this building.

17. René Brecy, "Chronique des Arts, Dagnan-Bouveret—Ernest Laurent," May 11, 1930 (journal unidentified in clipping located in Archives Départementales, Vesoul). Since members of the Ecole des Beaux-Arts were undoubtedly behind the 1930 hanging and selection, it is apparent they placed the emphasis on the works that had made the artist's reputation and that they believed deserved to be better known than they were in 1930.

18. Chang Ming Peng, "Pascal Adolphe Jean Dagnan-Bouveret: Recherches sur la formation d'un langage pictural," Mémoire de maîtrise, Université de Paris IV, 1990. In this thesis Peng tried to establish ways in which a formal analysis could be developed that would permit discussion of the artist's pictorial structure. Peng also compares the artist's genre paintings with those by Bastien-Lepage and with the writings of the naturalist authors. This work has not been published and is known only to a few specialists. The independent articles on Dagnan-Bouveret were prepared by the author, often published in *Arts Magazine,* and are cited in the bibliography in this volume.

19. See John R. Hinde, *Jacob Burckhardt and the Crisis of Modernity* (Montreal: McGill-Queen's University Press, 2000), 20. The growth of antimodernist studies is just in its infancy. Reconsideration of the academic tradition must be couched within the larger cultural and societal context of this theory.

20. Jacob Burckhardt, *The Civilization of the Renaissance in Italy* (Harmondsworth: Penguin Books, 1990). On Burckhardt's study, see Hinde, *Jacob Burckhardt and the Crisis of Modernity,* 21. See also Lionel Gossman, "Antimodernism in Nineteenth-Century Basel: Franz Overbeck's Antitheology and J. J. Bachhofen's Antiphilology," *Interpretation* 16 (1989): 359–389.

21. Paul Mantz provides a balanced and sympathetic assessment of Dagnan-Bouveret's genre and naturalist works in "La peinture française—V," *Gazette des Beaux-Arts* 2 (1889): 528–530.

SELECTED BIBLIOGRAPHY

Ackerman, Gerald M. *The Life and Work of Jean-Léon Gérôme with a Catalogue Raisonné.* Paris and London: Sotheby's, 1986.

Album de voyage des artistes en expédition au pays du Levant. Paris: Réunion des Musées Nationaux, 1993.

The Art of Xu Beihong. Hong Kong: Hong Kong Museum of Art, 1988.

Bazin, René. "Couleur du temps, Dagnan-Bouveret." *Le Figaro,* August 21, 1929.

Boime, Albert. "Curriculum Vitae: The Course of Life in the Nineteenth Century." In *Strictly Academic: Life Drawing in the Nineteenth Century.* Binghamton: State University of New York, 1974.

Catalogue des oeuvres de M. Dagnan-Bouveret (peintures). Paris: Chez Maurice Rousseau, 1930.

Catalogue des tableaux modernes par Bastien-Lepage, Berne-Bellecour, . . . Cazin . . . Dagnan-Bouveret . . . composant la collection C. Coquelin. Paris: Galerie Petit, 1906.

Catalogue of Modern Paintings and Sculpture, Collected by the Late J. W. Kaufman of St. Louis. New York: American Art Association, 1905.

Catalogue of the Works of P. A. Dagnan-Bouveret: A Loan Exhibition. Chicago: Art Institute of Chicago, 1901.

Christian Imagery in French Nineteenth Century Art, 1789–1906. New York: Shepherd Gallery, 1980.

Coffin, William A. "Dagnan-Bouveret." *Century Magazine* 48 (May 1894): 3–15.

Collecting in the Gilded Age: Art Patronage in Pittsburgh, 1890–1910. Pittsburgh: Frick Art and Historical Center, 1997.

Delouche, Denise. *Peintres de la Bretagne: Découverte d'une province.* Paris: Librairie C. Klincksieck, 1977.

Distel, Anne, et al. *Gustave Caillebotte, Urban Impressionist.* New York: Abbeville Press, 1995.

Driskell, Michael Paul. *Representing Belief: Religion, Art, and Society in Nineteenth-Century France.* University Park: Pennsylvania State University Press, 1992.

Ernest Meissonier: Retrospective. Lyon: Musée des Beaux-Arts, 1993.

Etudes: Dessins et pastels. P.A.J. Dagnan-Bouveret. Paris: G. de Malherbe Imprimerie, 1909.

Exposition des oeuvres de Jules Bastien-Lepage. Paris: Ecole Nationale des Beaux-Arts, Hôtel de Chimay, 1885.

F. Holland Day. Amsterdam: Van Gogh Museum, 2000.

Feldman, William Steven. "The Life and Work of Jules Bastien-Lepage (1848–1884)." Ph.D. diss., New York University, 1973.

Fernier, Robert. "Dagnan-Bouveret, 1852–1929." *Franche-Comté Monts Jura Haute Alsace,* no. 122 (September 1929): 174.

―――. *Gustave Courtois, 1852–1923.* Paris: Published by the author, 1943.

Foucart, Bruno. *Le renouveau de la peinture religieuse en France (1800–1860).* Paris: Arthena, 1987.

Fried, Michael. *Manet's Modernism; or, The Face of Painting in the 1860s.* Chicago: University of Chicago Press, 1996.

Geffroy, Gustave. *La vie artistique.* Vol. 5. Paris: H. Floury, 1897.

Gérôme and Goupil: Art and Enterprise. Paris: Réunion des Musées Nationaux, 2000–2001.

Gillet, Louis. "Un maître de la peinture moderne: M. Dagnan-Bouveret." *Lecture pour Tous: Revue Universelle et Populaire Illustrée,* no. 1 (October 1911): 27–38.

Gottlieb, Marc J. *The Plight of Emulation: Ernest Meissonier and French Salon Painting.* Princeton: Princeton University Press, 1996.

Grandmoujin, Charles. *Le Christ, drame sacré en 5 tableaux. . . .* Paris: Théâtre-Moderne, 1892.

Grisel, Pauline. "P.A.J. Dagnan-Bouveret à travers sa correspondance." D.E.A. d'Histoire de l'Art, Université Lumière, Lyon II, 1987.

Grunchec, Philippe. *The Grand Prix de Rome: Paintings from the Ecole des Beaux-Arts, 1797–1863.* Washington, D.C.: International Exhibitions Foundation, 1984–1985.

Gutman, Laura. "147, avenue de Villiers." In *Edelfelt, Paris.* Åbo, Finland: Konstmuseum-Tikanojas Konthem, 2001.

Gutman-Hanhivaara, Laura. "Edelfelt à Paris, l'itinéraire d'un artiste." *La Revue du Musée d'Orsay,* no. 14 (spring 2002): 72–79.

Hinde, John R. *Jacob Burckhardt and the Crisis of Modernity.* Montreal: McGill-Queen's University Press, 2000.

Holden, Kristi. "George Clausen and Henry Hubert La Thangue: Rural Painting, Urban Patronage." *Apollo* 149 (February 1999): 11–19.

Illustrated Catalogue, Royal Academy Winter Exhibition, the McCulloch Collection of Modern Art. London: Virtue, 1909.

Jensen, Robert. *Marketing Modernism in Fin-de-Siècle Europe.* Princeton: Princeton University Press, 1994.

Johnston, William R. *The Nineteenth Century Paintings in the Walters Art Gallery.* Baltimore: Trustees of the Walters Art Gallery, 1982.

Jonas, Raymond. "Sacred Tourism and Secular Pilgrimage: Montmartre and the Basilica of Sacré-Coeur." In *Montmartre and the Making of Mass Culture.* Edited by Gabriel P. Weisberg. New Brunswick, N.J.: Rutgers University Press, 2001.

Jules Bastien-Lepage. Verdun: Les Musées de la Meuse, 1984.

Karageorgevitch, Prince Bojidar. "Dagnan-Bouveret." *Magazine of Art* 16 (1893): 121–125.

Kinsley, Rose G. "'The Annunciation': The Ideal in Modern Art." *Art Journal* 63 (1901): 8.

Kostenevich, Albert. *French Art Treasures at the Hermitage: Splendid Masterpieces, New Discoveries.* New York: Harry N. Abrams, 1999.

Lafenestre, Georges. "Exposition d'études, dessins et pastels de M. Dagnan-Bouveret à la Société Nationale des Beaux-Arts." *Gazette des Beaux-Arts* 1 (1909): 465–480.

Le Pelley Fonteny, Monique. *Léon Lhermitte (1844–1925).* Paris: Editions Cercle d'Art, 1991.

McConkey, Kenneth. *Rural and Urban Naturalism: Masterpieces of Late Nineteenth Century French and British Painting from the Marchman Collection.* Santa Fe: Museum of Fine Arts, Museum of New Mexico, in association with Pyms Gallery, London, 1987.

Mainardi, Patricia. *The End of the Salon: Art and the State in the Early Third Republic.* Cambridge: Cambridge University Press, 1994.

Mazel, Henri. "Tendances religieuses de l'art contemporain." *L'Art* 51 (1891): 45–56.

Les métamorphoses d'Orphée. Strasbourg: Musée des Beaux-Arts, 1995.

Mirbeau, Octave. *Des artistes, peintres et sculpteurs.* Paris: E. Flammarion, 1922.

———. *Combats esthétiques 2, 1893–1914.* Edited by Pierre Michel and Jean-François Nivet. Paris: Nouvelles Editions Séguier, 1993.

Modern French Masters: A Series of Biographical and Critical Reviews by American Artists. Edited by John C. Van Dyke. New York: Century, 1896.

Nineteenth Century French Paintings, Drawings, and Sculpture. London: Hazlitt, Gooden and Fox, 2001.

Notice des tableaux donnés à la ville de Lyon par M. Jacques Bernard en 1875. Lyon: Imprimerie Louis Perrin, 1881.

Offenstadt, Patrick. *Jean Béraud: La belle époque, une époque rêvée.* Cologne: Taschen and Wildenstein Institute, 1999.

Orwicz, Michael. "Criticism and Representations of Brittany in the Early Third Republic." *Art Journal* 46 (winter 1987): 291–298.

Peinture et Art Nouveau. Nancy: Musée des Beaux-Arts, 1999.

La peinture française au Musée Pouchkine (Moscou). Paris: Editions Cercle d'Art, 1980.

Peng, Chang Ming. "Pascal-Adolphe-Jean Dagnan-Bouveret: Recherches sur la formation d'un langage pictural." Mémoire de maîtrise, Université de Paris IV, 1990.

Rameau, Henri. *Disciples de Gérôme: P. Dagnan-Bouveret, G. Courtois, L. Girardot, J.-A. Muenier.* Vesoul: L'Imprimerie Portusienne, 1979.

Randall, Lilian C. *Diary of George A. Lucas: An American Art Agent in Paris, 1857–1909.* Princeton: Princeton University Press, 1979.

The Realist Tradition: French Painting and Drawing, 1830–1900. Cleveland: Cleveland Museum of Art; distributed by Indiana University Press, 1980.

Rosenthal, Donald A. *Orientalism: The Near East in French Painting, 1800–1880.* Rochester, N.Y.: Memorial Art Gallery of the University of Rochester, 1982.

Rural and Urban Images: An Exhibition of British and French Paintings, 1870–1920. London: Pyms Gallery, 1984.

Sertillanges, R. P. "La peinture religieuse aux expositions de 1894." *Revue Thomiste,* no. 3 (July 1894): 346.

Small, Lisa. *Telling Tales II: Religious Images in Nineteenth-Century Academic Art*. New York: Dahesh Museum of Art, 2001.

Stasi, Laure. "Le mécénat de Martine de Béhague, comtesse de Béarn (1870–1939): Du symbolisme au théâtre d'avant-garde." *Bulletin de la Société de l'Histoire de l'Art Français* (2000): 337–354.

Strong, Rowland. "Living French Artists: Dagnan-Bouveret in His Studio at Neuilly." *New York Times Saturday Review* (March 1899): 174.

Sturges, Hollister. *Jules Breton and the French Rural Tradition*. Omaha, Neb.: Joslyn Art Museum, 1982.

La Vie Moderne: Nineteenth-Century French Art from the Corcoran Gallery (with an essay by Lilien F. Robinson). Washington, D.C.: Corcoran Gallery of Art, 1983.

Weinberg, Barbara H. *The American Pupils of Jean-Léon Gérôme*. Fort Worth, Tex.: Amon Carter Museum, 1984.

Weisberg, Gabriel P. *Beyond Impressionism: The Naturalist Impulse*. New York: Harry N. Abrams, 1992.

———. "The French Anti-Modernist Connection: Several French Academicians in the Todd Collection." In *The Legacy of Albert Todd*. Kalamazoo, Mich.: Kalamazoo Historic Conservancy for the Preservation of Art, 2000.

———. "Jules-Alexis Muenier and Photo-Realist Painting." *Gazette des Beaux-Arts* 121 (February 1993): 101–113.

———. "P.A.J. Dagnan-Bouveret and the Illusion of Photographic Naturalism." *Arts Magazine* 56 (March 1982): 100–105.

———. *Redefining Genre: French and American Painting, 1850–1900*. Washington, D.C.: Trust for Museum Exhibitions, 1995.

———. "Vestiges of the Past: The Brittany 'Pardons' of Late Nineteenth-Century French Painters." *Arts Magazine* 55 (November 1980): 134–138.

Wold, Gretchen. "Some Notes on 'The Pardon in Brittany' by Dagnan-Bouveret." *Metropolitan Museum Journal* 35 (2000): 240.

Zola, Emile. *Le bon combat*. Edited by Gaetan Picon. Paris: E. Flammarion, 1922.

 # PHOTO CREDITS

Marilyn Aitken
The Art Institute of Chicago, Imaging Department
Bayerische Staatsgemäldesammlungen, Munich
Jean-Loup Charmet, Paris
Charles Choffet, Besançon
Bruno Cohen, Chaalis
Corcoran Gallery of Art
Chrysler Museum of Art, Norfolk, Virginia
Dahesh Museum of Art, New York
Ecole Nationale Supérieure des Beaux-Arts, Paris, Service Photographique
Frick Art and Historical Center, Pittsburgh
The Metropolitan Museum of Art, New York
Musée des Beaux-Arts, Montreal
Musée des Beaux-Arts, Nancy
Musée Municipal, Melun
Musées d'Art et d'Histoire, Chambéry
Museu Calouste Gulbenkian, Lisbon
Museum of Fine Arts, Boston
Suzanne Nagy-Kirchhofer, Paris
The Philadelphia Museum of Art
Phox Photo Simon, Vesoul
Réunion des Musées Nationaux, Paris/Art Resource, New York
Sotheby's, New York
The State Hermitage Museum, St. Petersburg
The State Pushkin Museum of Fine Arts, Moscow
Studio Christian Kempf, Colmar
The Walters Art Museum, Baltimore

 INDEX

 ABOUT THE AUTHOR

GABRIEL P. WEISBERG is a professor of art history at the University of Minnesota, Minneapolis. Dr. Weisberg has published extensively on French nineteenth- and early twentieth-century art; among his publications are a series of works directly linked with his study of Dagnan-Bouveret's imagery. These include *The Realist Tradition: French Painting and Drawing, 1830–1900* (Indiana University Press and the Cleveland Museum of Art, 1980); *Beyond Impressionism: The Naturalist Impulse* (Harry N. Abrams, 1992); and *Overcoming All Obstacles: The Women of the Académie Julian* (co-author) (Rutgers University Press and the Dahesh Museum, New York, 1999).

DATE DUE